IMAGES
of America

BREMEN AND
NORTH CENTRAL
INDIANA

IMAGES
of America

BREMEN AND NORTH CENTRAL INDIANA

Tammy (Kuhn) Venable

ARCADIA
PUBLISHING

Copyright © 2001 by Tammy (Kuhn) Venable
ISBN 978-1-5316-1269-6

Published by Arcadia Publishing
Charleston, South Carolina

Library of Congress Catalog Card Number: 2001089142

For all general information contact Arcadia Publishing at:
Telephone 843-853-2070
Fax 843-853-0044
E-Mail sales@arcadiapublishing.com
For customer service and orders:
Toll-Free 1-888-313-2665

Visit us on the Internet at www.arcadiapublishing.com

CONTENTS

ACKNOWLEDGMENTS

This book would not have been possible without the assistance and support of the following people (in no specific order):

My grandparents, Lester and Nellie Kuhn, who provided me with great opportunities. They raised me from the time I was three years old until I married my husband. Without them, my life would never have been so complete. They also provided me with family photographs and stories of the Bremen area. My uncle, Glenn Kuhn, who has always been there for me whether he wanted to or not. My father, John Kuhn, who provided me with much information about the Lakeville area. My mother, Dee Anna Fuchs-Weaver, who provided me with early photographs of the Lakeville, South Bend, Bourbon, and other areas. My husband, Michael Venable, who lived with a messy desk for the main portion of the writing of this book. My children, Ashley and Lacey Venable, who left me alone to work on the book when necessary. My friend, Anette Crandall, who helped me rewrite and edit bits and pieces of this book to make it understandable. My boss at the St. Joseph County 4-H Fairgrounds, Frank Ronchetti, for allowing me the time necessary to work on the book, and for his contribution of photographs of the Mishawaka area. My newfound friend, Don Schneider of Don's Barber Shop in Bremen, who allowed me the opportunity to scan all the photographs he has collected over the years and also provided me with stories for each picture. To Bill Helmlinger, for his stories about the photographs at Don's Barber Shop. To my great aunt Virginia Young-Julian, for providing me with answers to many questions about photographs I obtained. To Duwaine Elliott, Bremen Town Operations Manager, for his help in obtaining historical information about Bremen through the town records. To my 11th grade English teacher, Russell Flatt, for telling me to write a book. It took me 16 years to do it, but I did it. And finally, last but most definitely not least, the citizens of the town of Bremen for keeping such excellent records of the history of this great town. I hope this book will be kept in the hearts and homes of all the citizens of each of the communities listed in this book. I dedicate this book to the people on this page, may God bless you all.

INTRODUCTION

This pictorial history, mainly of Bremen, Indiana, was written for the purpose of showing photographic accounts of the Bremen area through the early years. The town of Bremen was incorporated in 1871. Bremen and the surrounding communities have a rich history and a great sense of community, which made it possible for the author to accumulate the materials within. The information in this book was obtained from sources such as town records, newspapers, citizens, organizations, and pamphlets.

The first residents living in Marshall County were believed to have been the mound builders (Indians). Indians of the Miami Confederacy claimed this part of Indiana later. The Potowatomi Indians invaded the area and lived here until the spring of 1838, when they were removed by General Tipton. In September of 1935, most of the land in Marshall County was offered for sale in LaPorte, where the Government Land Office was located. Many choice pieces of land were sold for $4–$5 per acre. The County Commissioners of Marshall County held their first organizational meeting on May 2, 1836. German Township was organized on May 11, 1838, and the first settlement in German Township was Clayton, which was founded in 1837 by Lanthrop M. Taylor and Henry Augustine.

Those listed as settlers of German Township prior to 1840 were Abraham Augustine, Francis Bashford, David Brothers, George Beiler, Peter Beiler, Michael Bariger, Henry Bariger, Uriah Chandler, Siemon Elles, John Ellis, Henry D. Fitz, Peter Fisher, Bolser Hess, Bolser Hess Jr., Jacob Heckaman, Uhlra Helm, Peter Harsock Jr., Peter Harsock Sr., William Hughs, Robinson Hughs, Edward Hanson, Jacob Koontz, George Lashbaugh, George Listenberger, John A. Lashbaugh, Jacob Laudeman, John A. Leeper, Jacob Leeper, George Metcalf, Jacob McIntaffer, Michael Moritz, Edward M. Page, Daniel Ringle, John Ringle, John Ranstead, Charles Rhides, George Surges, John Steel, George Stine, John Wilkinson Sr., John Wilkinson Jr., Henry Yockey, and Jacob Yockey.

The main streets were first layered with gravel in 1898, and then paved with brick in 1913. A street sweeper was purchased in 1918, and streets are still swept today. Dietrich's store was used as a court when necessary to enforce the law in the late 1800s. The police department were issued their first uniforms in 1927. The annual "Fireman's Festival," which is still celebrated today, began in 1950 and has always been held during the week of July 4th.

The nearby towns and cities are also an important part of the Bremen Community. They provide industry, shopping, links to relatives and entertainment for those who live and work in Bremen. You'll find little bits and pieces of information about nearby communities in chapters four and five of this book. It is the hope of the author that the information that was found about the pictures within is correct and the readers of this book will find interest in the details of them. Enjoy!

One

BREMEN
THE 1800s

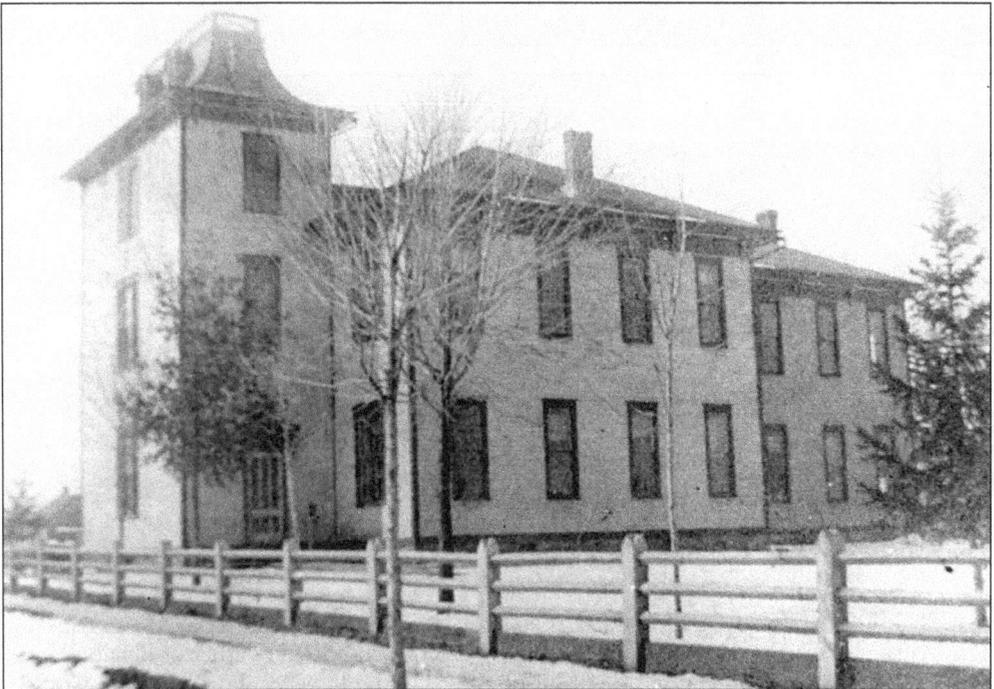

BREMEN'S FIRST STRUCTURE. Built in 1853 by Mr. Christian Seiler, this was the first school structure built in Bremen. It was located on the corner of Montgomery and Bike Streets. This photo is looking northeast. The first teacher of this school was Mr. George Pomeroy. The building was enlarged several times until a new school was necessary. (Courtesy of Don Schneider, Don's Barber Shop.)

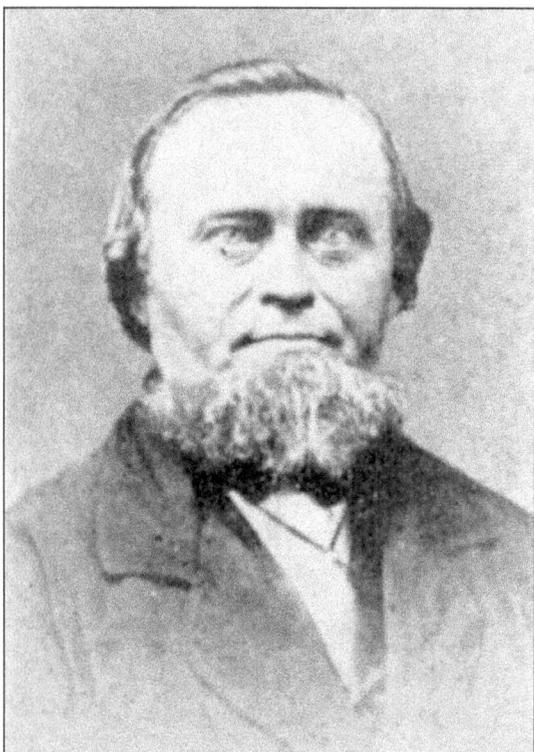

A WALK TO CHICAGO. A highlight of the period before the establishment of the Missouri Synod Lutheran Churches in this area was in April of 1847, when Rev. George K. Schuster walked from Bremen to Chicago with a lay delegate to the organization meeting of the Missouri synod, which was from April 25 to May 9. Pastor Schuster ministered to congregations in Kosciusko and Marshall Counties, but his post office address was Mishawaka, Indiana. He organized St. Peter Lutheran Church in Mishawaka in 1847, which is discussed more thoroughly in chapter four. (Courtesy of Frank Ronchetti.)

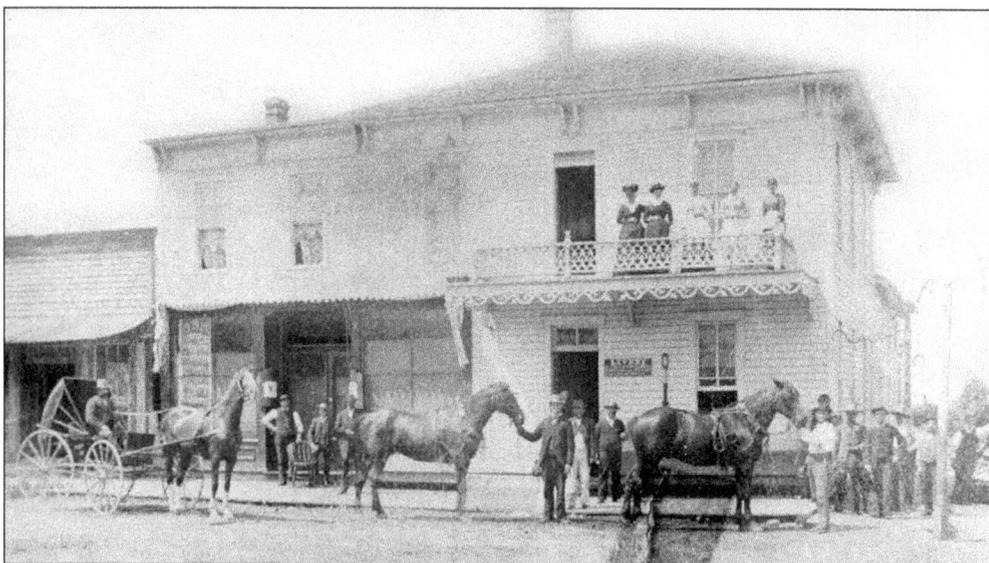

THE AMERICAN HOUSE HOTEL. The hotel, located on the northwest corner of Plymouth and North Center Streets, was built in 1867. The door next to the "Livery" sign was the hotel office. The double doors to the left was the opening to Frank Walter's Saloon. The sign on the pole on the corner read, "American House" as well as "Frank Walters' Crescent Saloon." The livery stable was connected to the hotel on the north end. It was moved in 1909 to 409 N. Marshall Street and was used for a grocery store by John Beyler and later by Butch Zentz. This photo was taken sometime between 1870 and 1880. (Courtesy of Don Schneider, Don's Barber Shop.)

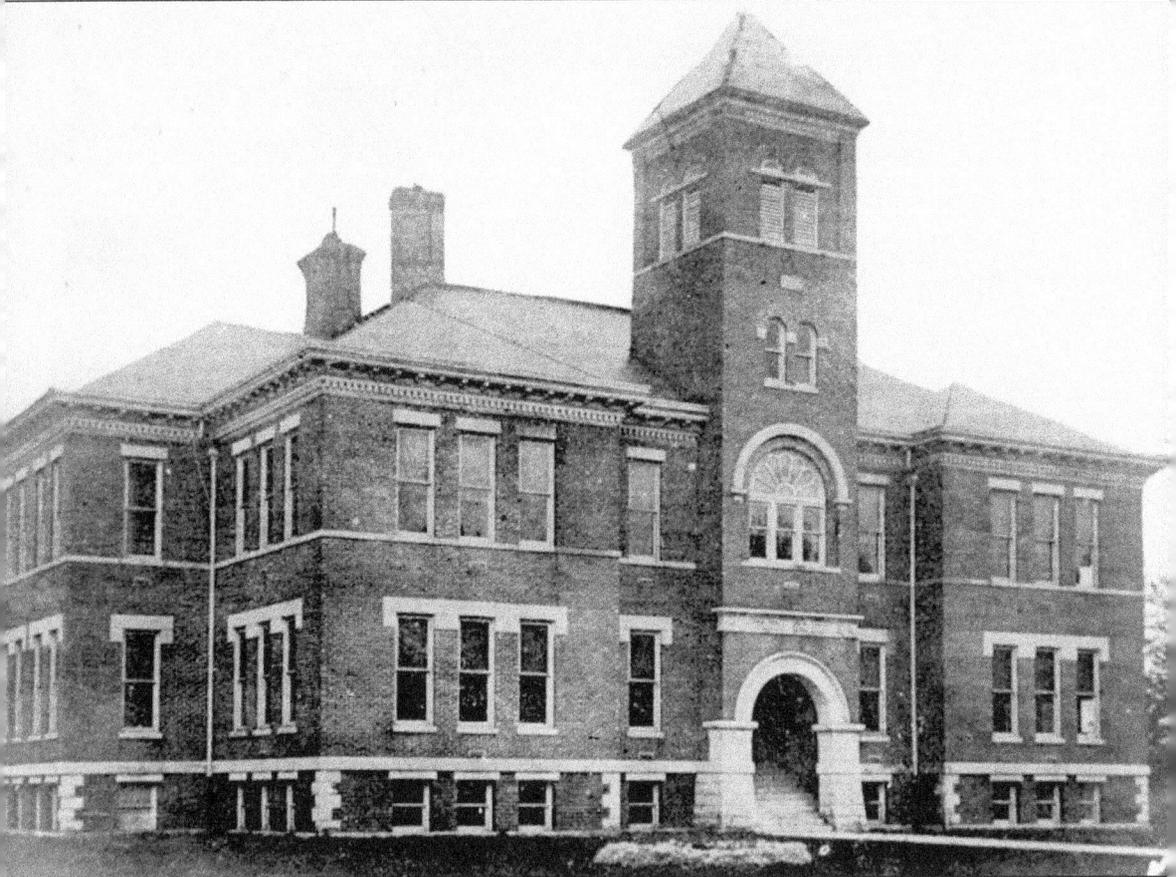

SECOND SCHOOL STRUCTURE, 1907. The second school structure built in Bremen was located in the same place as the first, on the corner of Montgomery and Bike streets. This one was built in 1907. The school was accredited in 1915 by the North Central Association. This photo is looking northeast. (Courtesy of Don Schneider, Don's Barber Shop.)

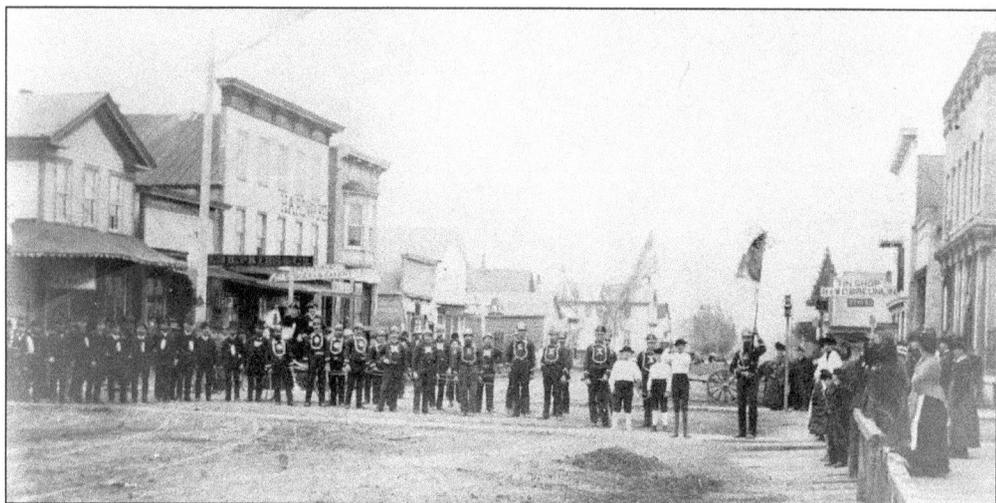

BREMEN VOLUNTEER FIRE DEPARTMENT RETURNING FROM THE MICHIGAN HOSE TOURNAMENT, 1885. Hose Tournaments, or Waterball competitions, have been a part of Bremen's history since the mid to late-1800s. (Courtesy of Don Schneider, Don's Barber Shop.)

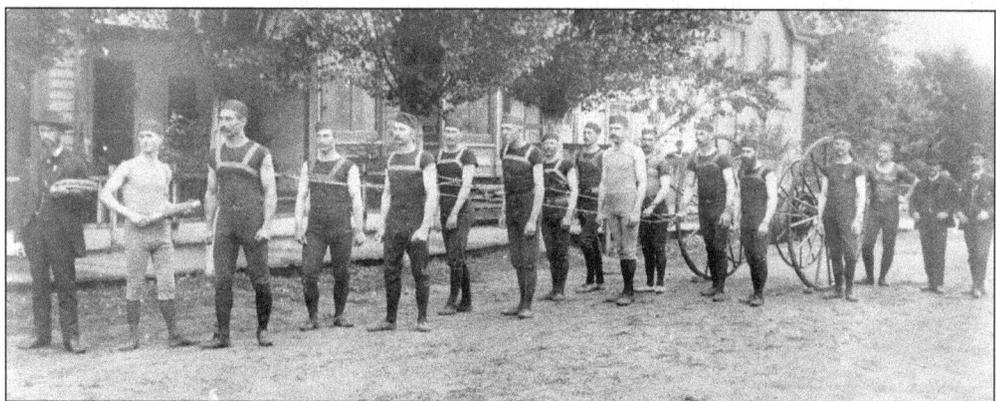

THE EAST SIDE OF THE 100 BLOCK OF SOUTH JACKSON STREET, 1886. The Bremen Fire Department responded to a fire call. Pictured here are: H. Schilt, J. Walter, J. Brougher, Charles Koontz, Charles Hans, G. Leher, ? Stinmetz, Bill Roth, ? Amoeher, ? Heckaman, ? Mochel, W. Fries, ? Wahl, ? Walter, ? Heine, Josh Walter, and P. Dietrich. (Courtesy of Don Schneider, Don's Barber Shop.)

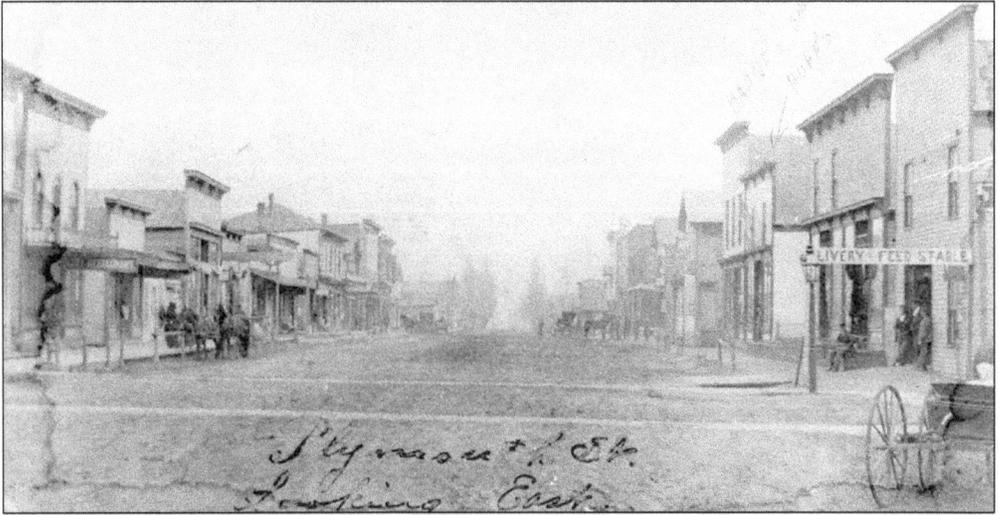

CORNER OF PLYMOUTH AND JACKSON STREETS, LOOKING EAST, IN BREMEN, 1888. If you look on the right side of this photo, you can see the Livery Stable. (Courtesy of Don Schneider, Don's Barber Shop.)

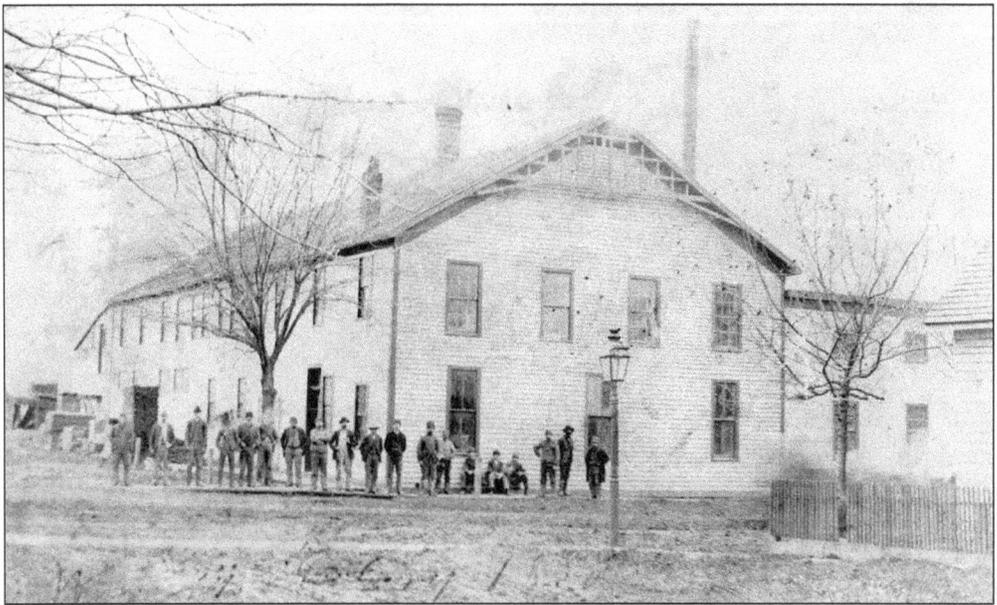

WRIGHT'S BENDING FACTORY, 1888. This structure stood on the southwest corner of Plymouth and Whitlock Streets in Bremen. It was a bent-wood factory that was built in 1869 by John J. Wright. By 1890, it was the largest employer in the area. Today this structure is gone, and there are residences lining the streets in its place.(Courtesy of Don Schneider, Don's Barber Shop.)

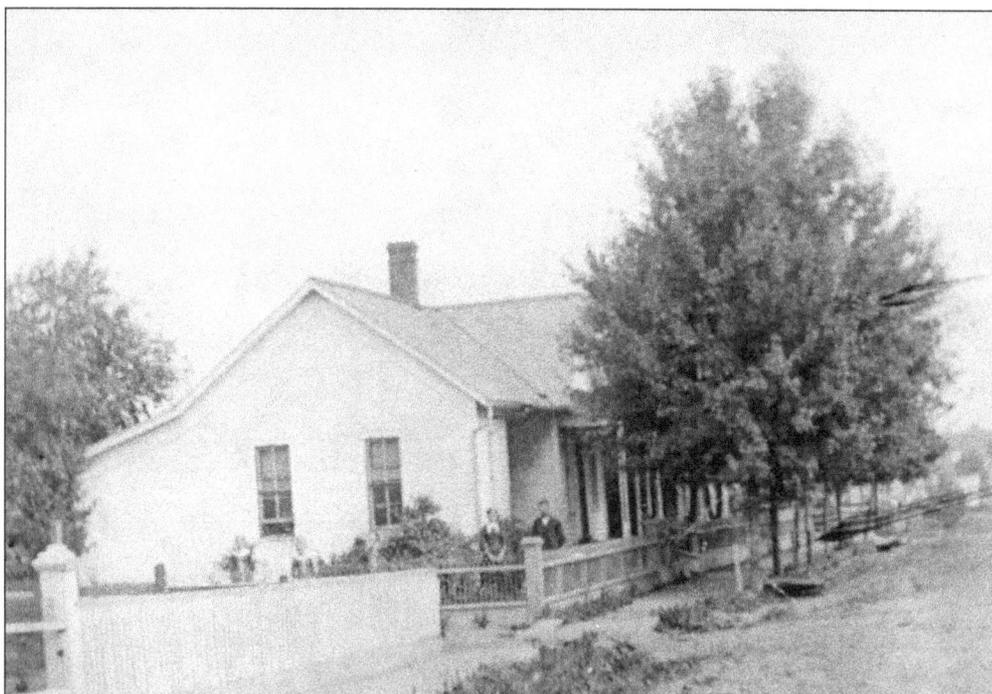

THE 200 BLOCK OF CENTER STREET LOOKING NORTH, 1888. (Courtesy of Don Schneider, Don's Barber Shop.)

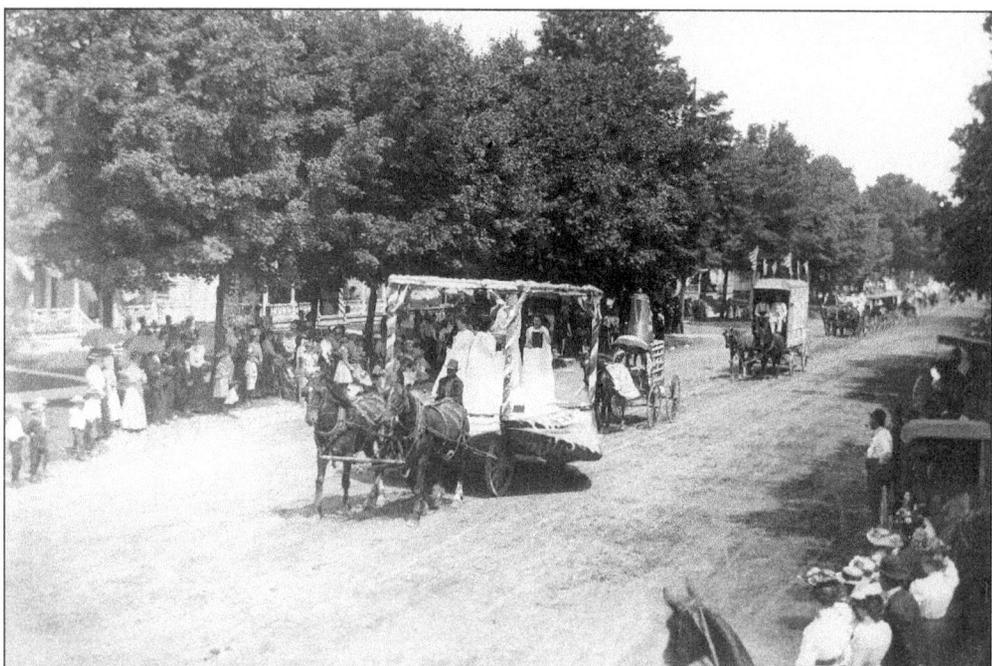

PARADE BETWEEN 1886–1900. Here you can see how beautiful the tree-lined streets made the town look. At this time, the streets were not paved. (Courtesy of Don Schneider, Don's Barber Shop.)

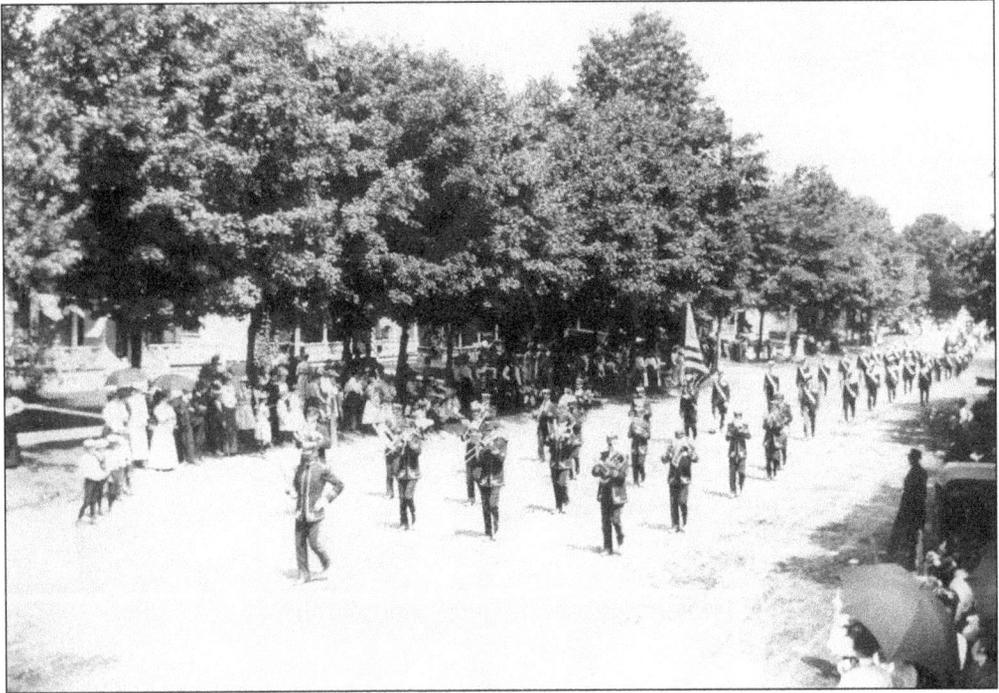

PARADE BETWEEN 1886–1900. This photo was also taken during the same parade. It shows the Bremen band performing. (Courtesy of Don Schneider, Don's Barber Shop.)

DIETRICH-BOWEN HOUSE. This home previously owned by former Governor, Otis R. Bowen, is on the National Register of Historic Places. This structure is registered as the "Dietrich-Bowen House." It still stands at 304 North Center Street in Bremen. (Courtesy of Lester and Nellie Kuhn.)

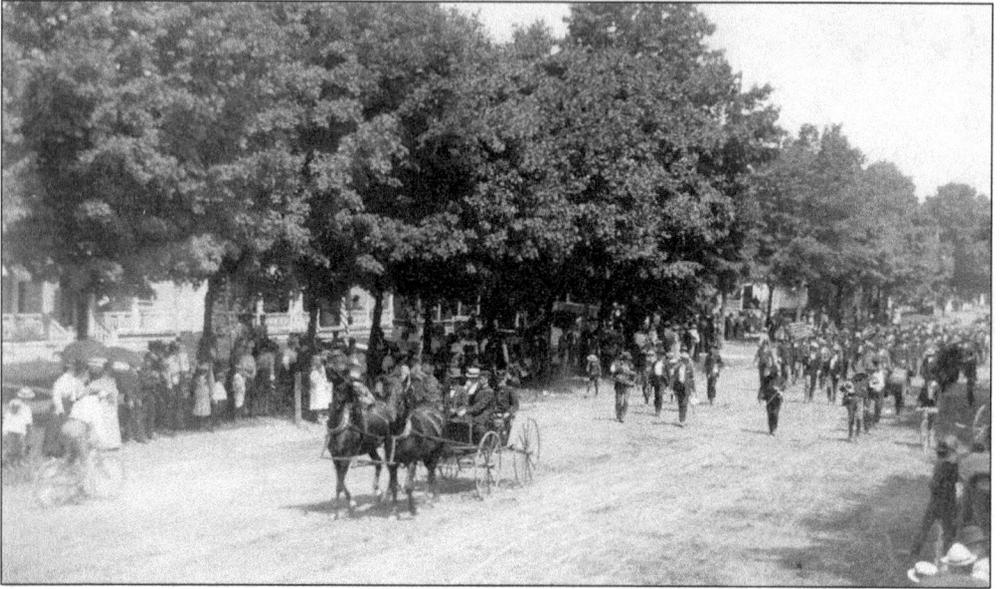

PARADE BETWEEN 1886–1900. (Courtesy of Don Schneider, Don's Barber Shop.)

DOWNTOWN BREMEN BETWEEN 1886–1900. You can see the American House Hotel on the right. (Courtesy of Don Schneider, Don's Barber Shop.)

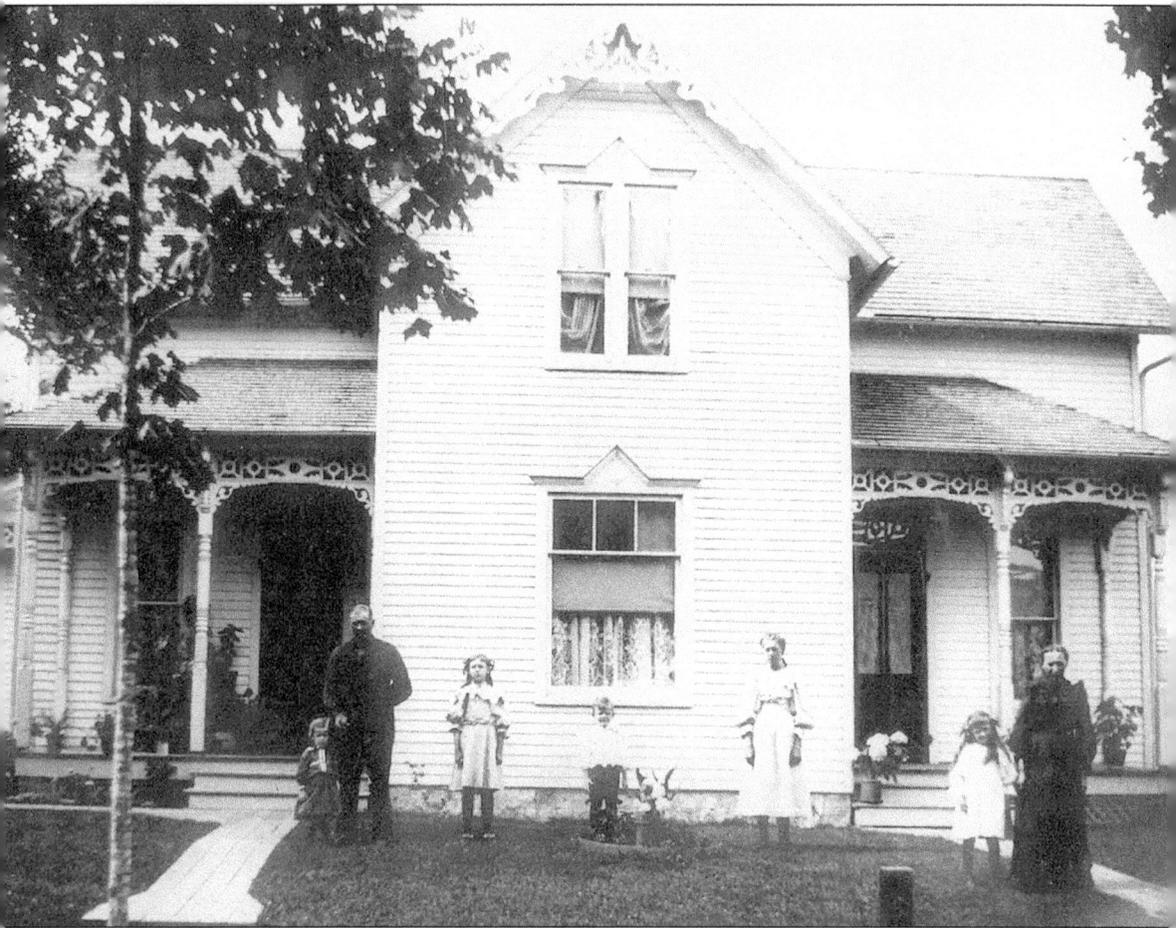

HOUSE, TAKEN BETWEEN 1886–1900. This house is still located on South Center Street near St. Paul's Lutheran School. (Courtesy of Don Schneider, Don's Barber Shop.)

PHOTO TAKEN SOMETIME BETWEEN 1886–1900. (Courtesy of Don Schneider, Don's Barber Shop.)

Two

Bremen
In the Early 1900s

110 West South Street in Bremen, 1900. This picture shows Isabella (Aurand) Gephart-Warner (1845–1919) and her dog, "Sykie." Isabella was Mim Mishler's great-grandmother. (Courtesy of Don Schneider, Don's Barber Shop.)

HOUSE ORIGINALLY LOCATED ON THE SOUTHEAST CORNER OF PLYMOUTH AND SOUTH WASHINGTON STREETS. It was moved to the 400 block of Maple Street. A new one was built in the old location in 1900. (Courtesy of Don Schneider, Don's Barber Shop.)

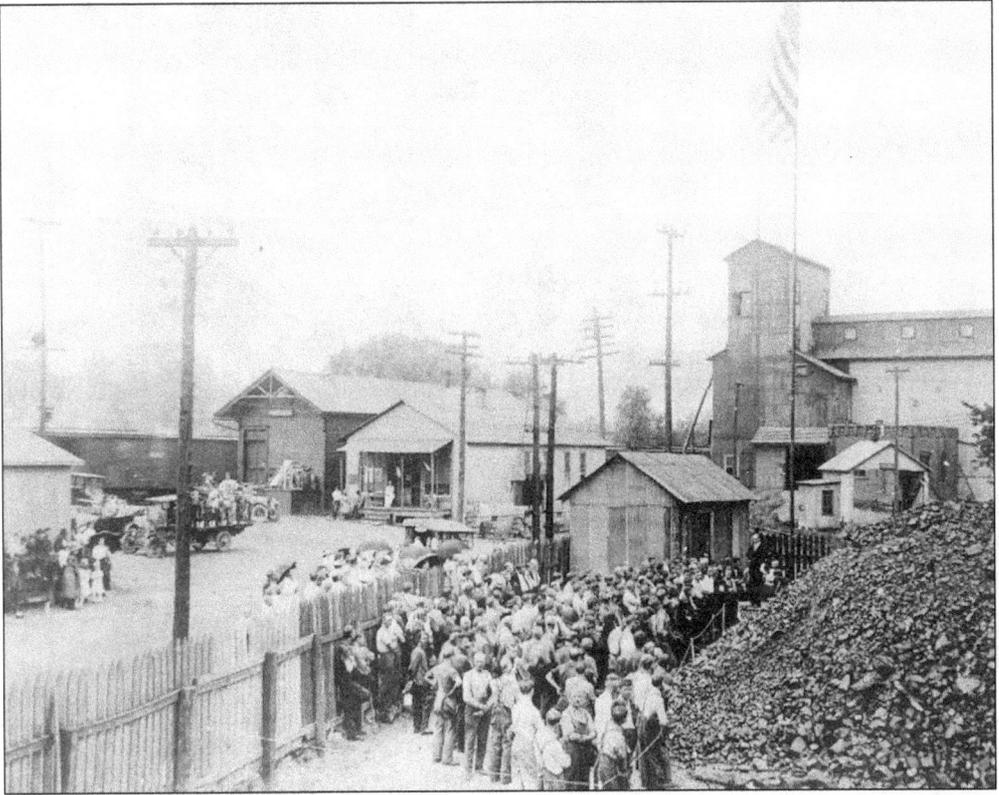

BREMEN ELEVATOR, EARLY 1900. It is a southwesterly view just north of the railroad tracks. (Courtesy of Don Schneider, Don's Barber Shop.)

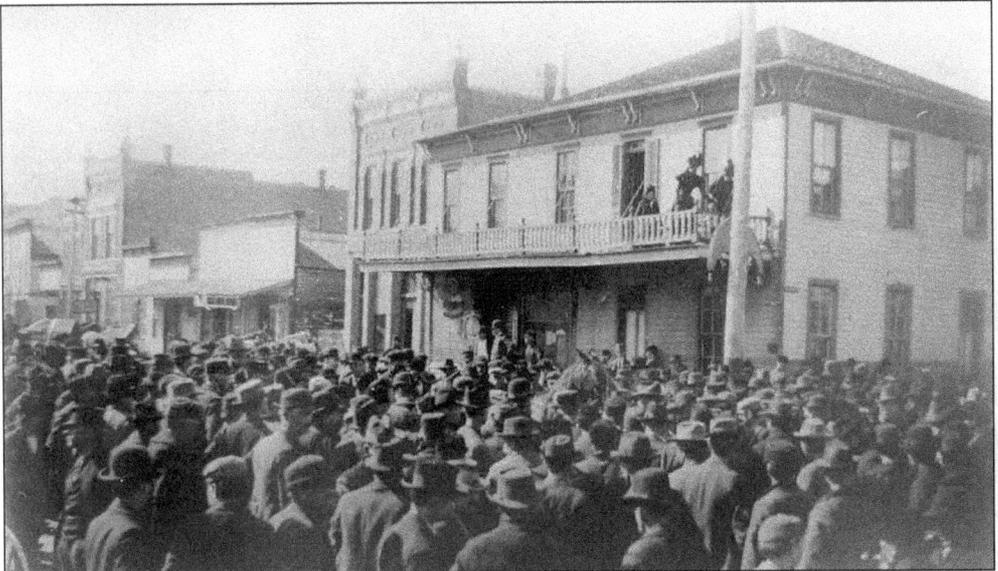

AMERICAN HOUSE HOTEL. The Hotel is shown here with an unknown event, possibly a town meeting. It is located on the corner of Plymouth and Center Streets. (Courtesy of Don Schneider, Don's Barber Shop.)

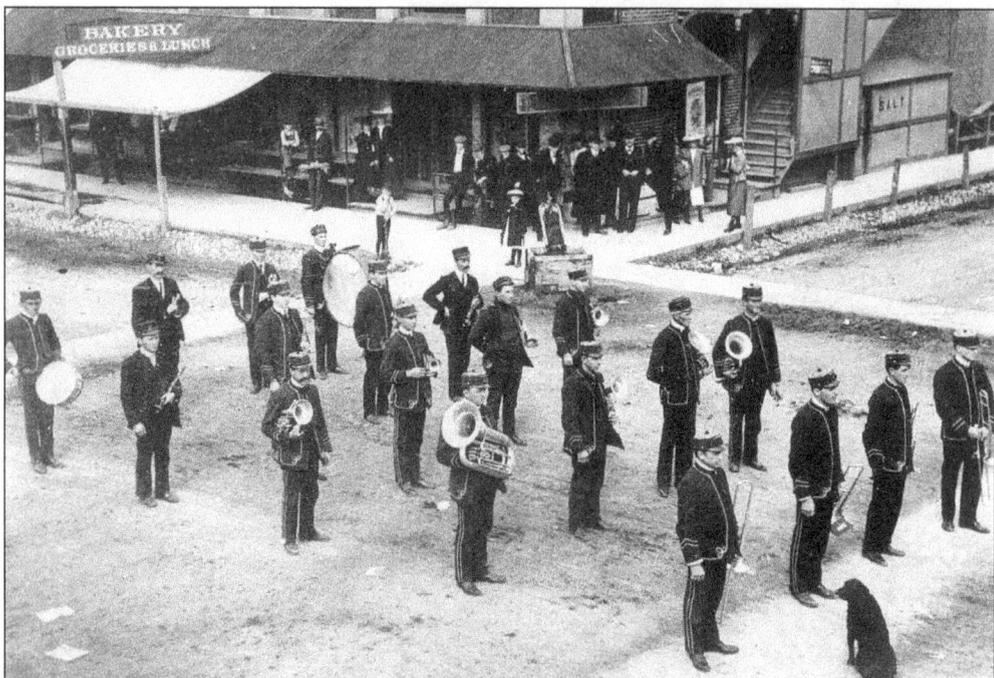

PLYMOUTH AND JACKSON STREETS, 1903. This view of Plymouth and Jackson Streets in 1903 shows the center of town just one block from where the center is located today. Seen here is the Memorial Day Parade in Bremen. The corner was known as "Wright's Corner" back at that time. The photo was taken in front of the old town pump. (Courtesy of Don Schneider, Don's Barber Shop.)

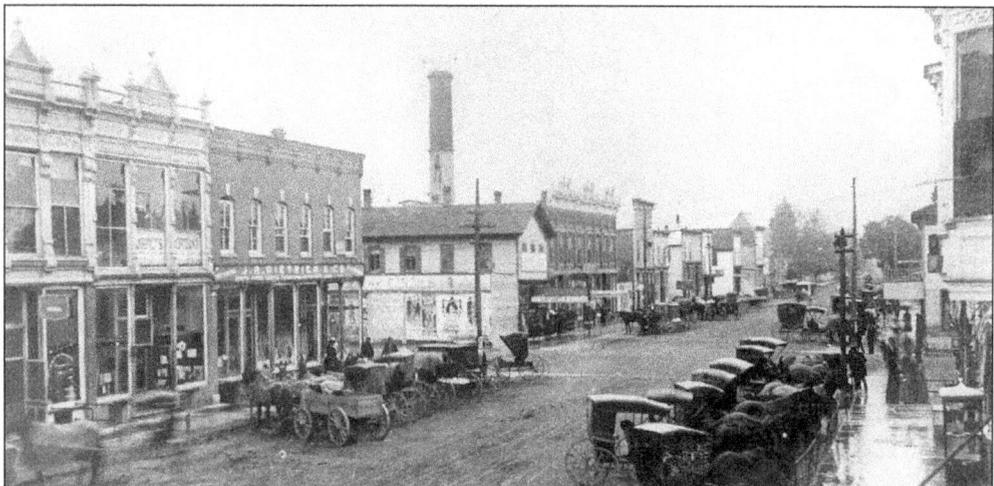

VIEW OF DOWNTOWN BREMEN, 1905. Photo shows the 100 block of East Plymouth Street looking southwest. There is a view of the famous Bremen Water Tower, or Standpipe, in the background. (Courtesy of Don Schneider, Don's Barber Shop.)

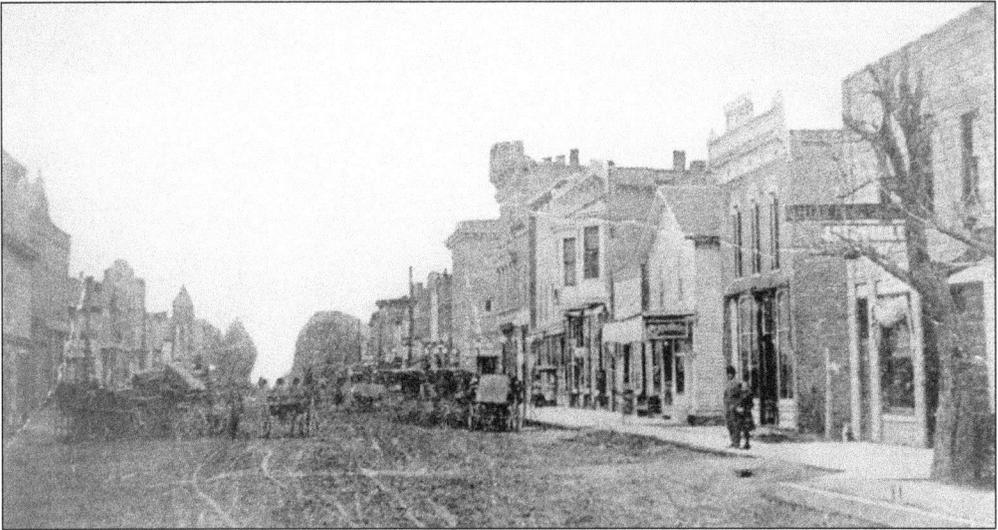

100 Block of East Plymouth Street Looking West, 1905–1910. (Courtesy of Don Schneider, Don's Barber Shop.)

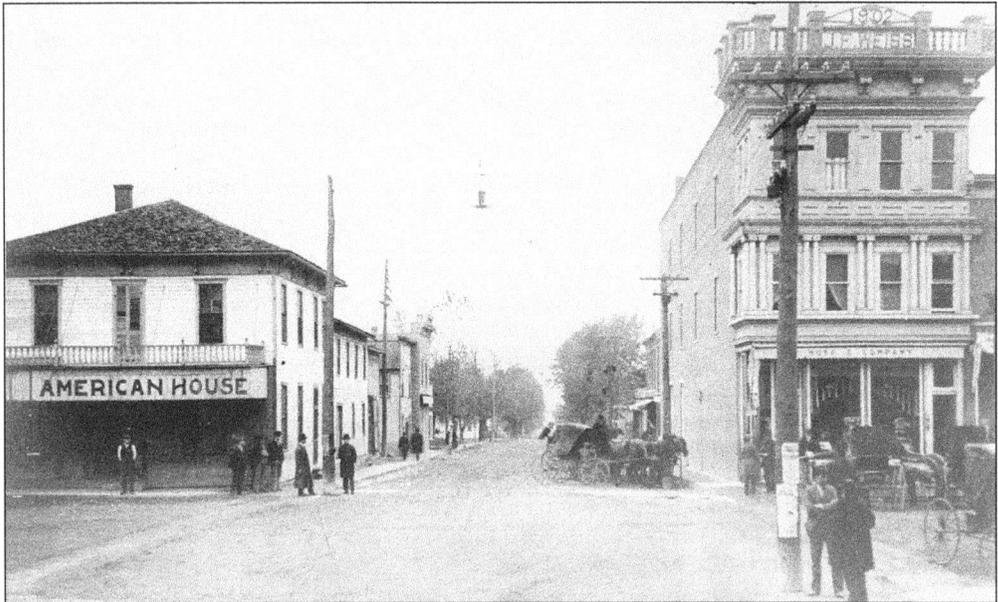

Corner of Plymouth and Center Streets looking north, Between 1902–1908. It shows the American House Hotel on the left. (Courtesy of Don Schneider, Don's Barber Shop.)

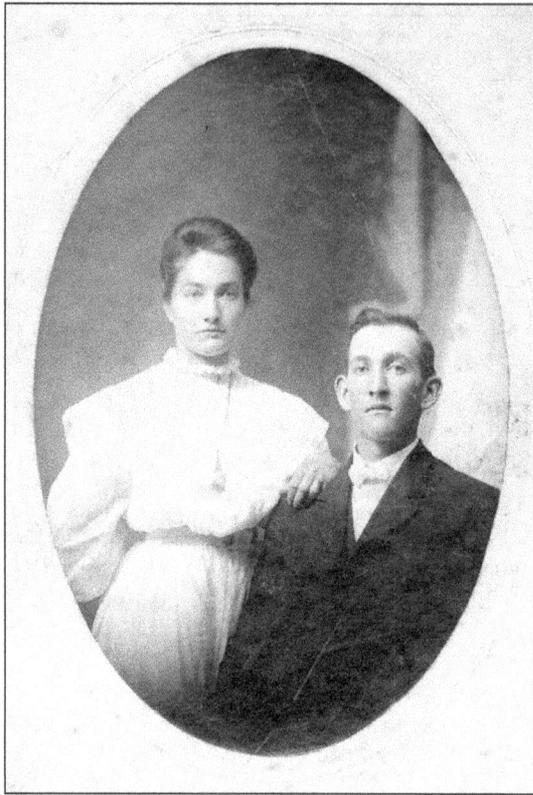

On March 17, 1907, Milton Young and Clara Ethel Dougherty, pictured here, married on Ethel's parents' farm in Bremen. Ethel wrote the following essay in 1904 at Bremen High School where she graduated:

"The town of Bremen is situated 13 miles northeast of Plymouth and about 90 miles east of Chicago. It is situated upon the north fork of the Yellow River. When it was first established it was called New Bremen, the name being given by George Pomeroy and Joseph Geiselman who thought the name appropriate as it was of German origin, and a large portion of the early settlers were German speaking people.

The first settlements were made in 1836. Some of the first families were Hardzog, Heim, Weis, Beyler, Koontz, Yockey, and Ringle. At that time the place was in a woods. A short time after these families settled, others came, and soon a village was formed.

In 1846, a post office was established and named Brothersville, in honor of David Brothers, the first postmaster. In 1848, George Pomeroy and John Bush bought Mr. Brothers' one acre of land. Mr. Bush built a log cabin on his share where he resided for two years. He then sold his possessions to John Parker, a Quaker by faith, and a shoemaker by trade. So Mr. Parker became the first shoemaker of the place. He was afterwards succeeded by Philip Kanegar.

Mr. Pomeroy erected upon his share a frame building which he used for a variety store, and here he held the post office, which was changed in 1848 from Brothersville to New Bremen. Mr. Pomeroy was also the first notary public of the place. About this time Joseph Geiselman bought a lot from Peter Heim. Here he erected a log blacksmith shop. It stood where the present business place of J.R. Dietrich & Company stands. Two years later he built the first frame dwelling of Bremen. In 1807 Gottlieb Armacher built a log cabin which was the first tailor shop. He afterwards sold his possessions to Joseph Biel who started a bakery and saloon.

John Soice purchased a log cabin and opened up the first harness shop. The first surveying and laying out of the place was done in 1851. At this time, George Beyler surveyed 48 lots.

From this time on the town was called Bremen. The name of the post office was also changed to Bremen which name it assumes to this day. Afterwards there were additions made by several different persons.

The town was not incorporated until 1871. It was then divided into six districts, the officers being a clerk and treasurer, a Marshall, an assessor, and six trustees. A year later the town was redistricted and the number of districts was changed from six to three, but later other changes were made and at the present time there are four districts giving four wards, each having a trustee.

In 1852, Jacob Kiefer came here and started the first wagon shop in the village. In 1854, John Dietrich Sr. and family moved to this place and started the first cabinet shop. In 1856, the Biel Brothers started a tannery just east of town, where now the old building may be seen but it is old and dilapidate. Their father opened up the first drug store of Bremen.

Christian Schilt and Samuel Schmachtenberger erected in 1857 the first grist mill at Bremen. They operated the mill till 1863, when they dissolved partnership and Mr. Schilt became the sole proprietor. The mill has now passed into the hands of his son William F. Schilt.

At the present there is only one hotel called the Garver House. In 1865 Jacob Knobloch erected a large hotel, but in 1879 it was consumed in flames.

Perhaps the most important industry established in Bremen is the Bentwood factory, owned and operated by J.J. Wright. The factory was erected in 1869, and manufacturers used Bentwood material for the building of carriages, houses, fencing, and other things.

The Holland Radiator Works is also another important factory situated in the north end of town. The only planing and shingle mills of Bremen were built about 1882 by Knoepfle and Vollmer who are running the mill to this day.

For the last 20 years, Schlosser Brothers have owned and operated the Cottage Grove Creamery, just south of Bremen. The creamery was at first small but has grown to be one of the best of creameries.

There was but little merchandise done until after the completion of the Baltimore and Ohio Railroad. At this time there are three dry goods stores also carrying general merchandise. One is that of John J. Wright, which is managed by his son William Wright; one is that of Fred Ponader; and the other belongs to J.R. Dietrich and Company. Besides these there are several dry goods stores and grocery stores.

In 1889, the Union Bank was established. It has proved to be a successful and important establishment. The only railroad going through the place is the Baltimore and Ohio. Although this is the only one touching Bremen, it gives the town an outlet both to the east and to the west.

The growth of Bremen in population has been steady. It has grown to have a population of nearly 2,000. Among the population of this town and township there are represented the German, English, Swiss, Polish, Scottish, Irish, and others, but the most predominant is the German.

Then these early settlers were not unmindful of the necessity of church, and early began to establish churches. The religious denominations that have an existence in Bremen are Lutheran, Evangelical, Presbyterian (or German Reform), United Brethren, Congregational, and Catholic. The Lutheran was the first to be established, which was in 1845. This church now has the largest membership of any in the town. The others have also a good sized membership.

Bremen is blessed too with most excellent schools. The first school building was erected in 1853. The building was a one story frame and was bought by George Pomeroy. Five years later the school population had increased so much that more school room was necessary. In 1858 another addition was made. Again in 1871, the school building was improved and was made a two story building. In 1880 another two story addition was made in which condition it may be seen at the present day. The school is a regular graded school with a high school department. But this building is about to be abandoned, and a new brick one erected.

Among the secret societies of Bremen are the Masonic, Rathbone Ladies, Maccobees, Knights of Pithias, and Womans Relief Corps and others of less importance.

The fire department of Bremen was organized September 8, 1874. The town has a building for the fire department apparatus, which consists of an excellent hand engine, two horse carts and 1,200 feet of hose, and a hook and ladder wagon. There are 85 members of the department, divided into four divisions: an engine company, a hook and ladder company, and two hose companies. The town also has an electric light and water works plant.

About 1872, the first newspaper was published by the Macombers Brothers, and was known as the *Bremen Clipper*. It continued but a short time. In 1876, the *Bremen Gazette* was published, but it too was of short duration. Its place was taken by the *Bremen Banner*. The *Bremen Enquirer* was next established and published by Brook & Bowman in 1885. It has existed ever since that year.

I have traced a few of the principal events of Bremen, so while it has been slow in growth, it may yet be called one of the best towns in Northern Indiana." (Photo courtesy of Lester & Nellie Kuhn. Essay courtesy of Curtis Rowe.)

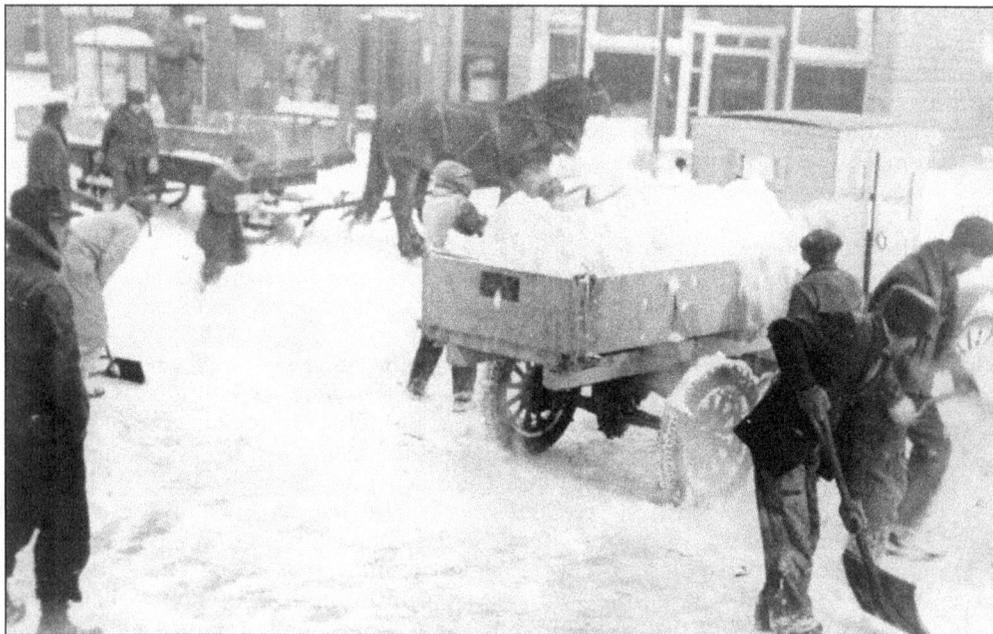

LOOKING NORTHEAST AT THE 100 BLOCK OF SOUTH CENTER STREET, PRIOR TO 1910. It looks as though the entire town pitched in to get the town unburied from a heavy snow. (Courtesy of Don Schneider, Don's Barber Shop.)

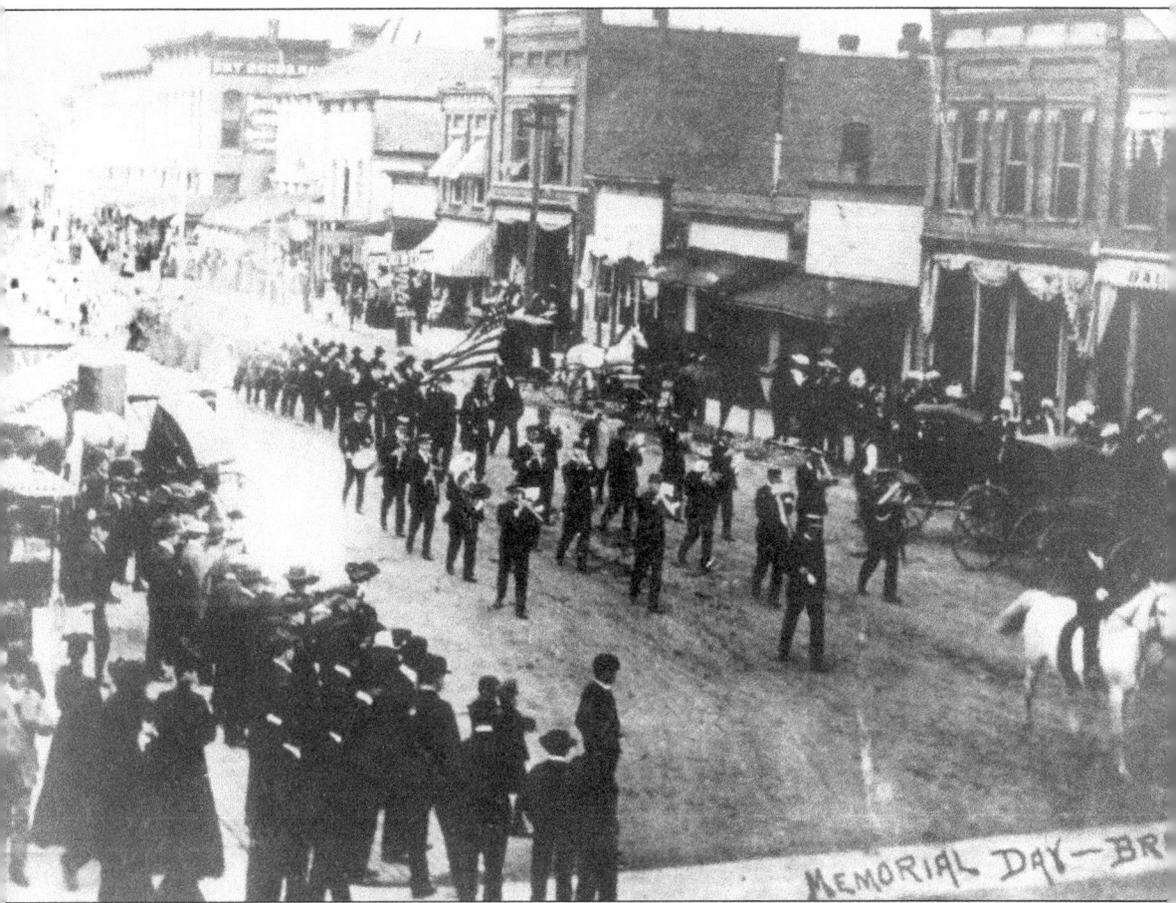

PARADE NEARS CENTER STREET IN BREMEN, 1907. (Courtesy of Don Schneider, Don's Barber Shop.)

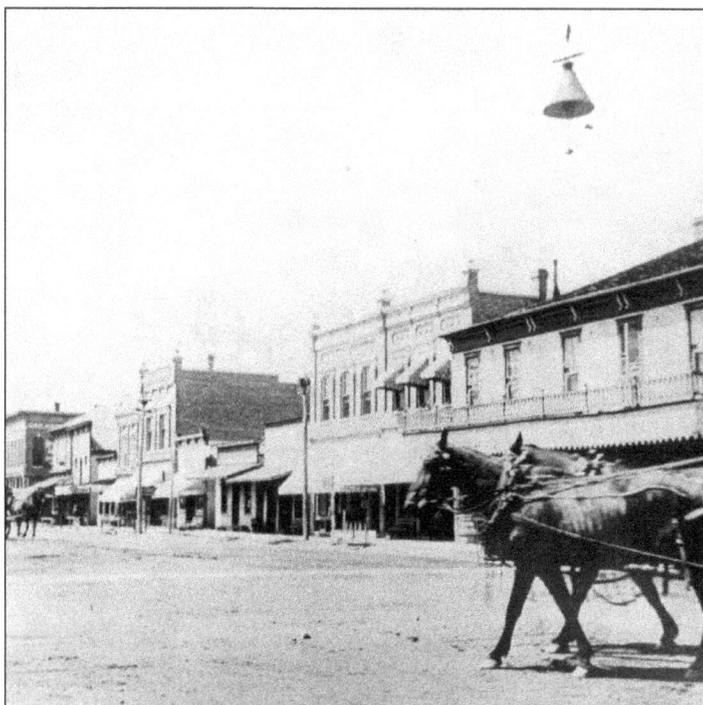

PLYMOUTH AND CENTER STREETS LOOKING WEST, BETWEEN 1900–1910. Notice the street light up in the top right corner of the photograph. (Courtesy of Don Schneider, Don's Barber Shop.)

ERV SEILER. His son's name was Marv. The photo shows the northeast corner of Plymouth and North Center Street looking southeast. Photo was taken sometime between 1900–1908. (Courtesy of Don Schneider, Don's Barber Shop.)

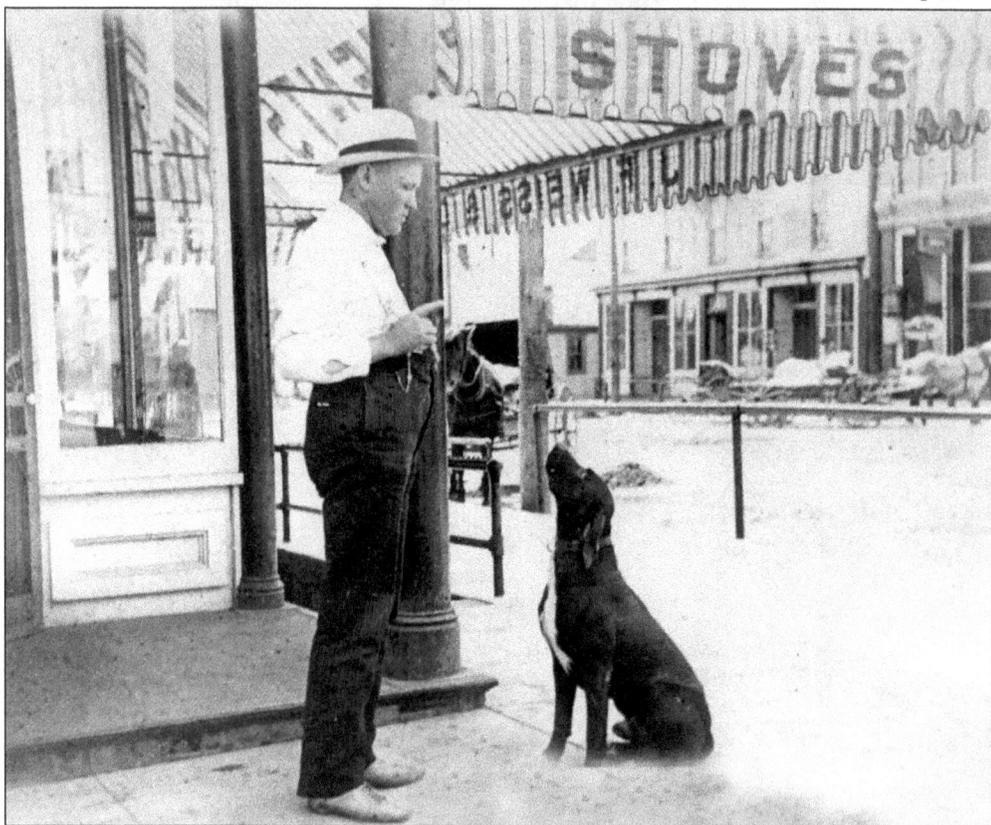

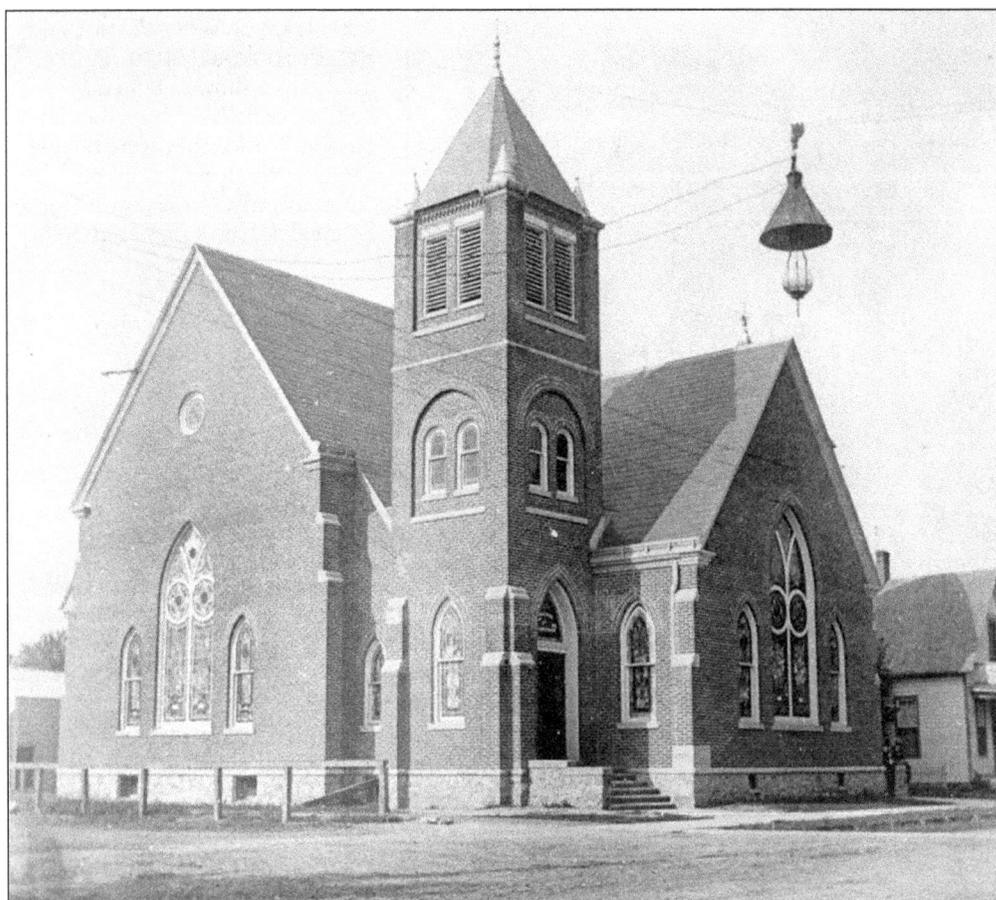

SALEM UNITED METHODIST CHURCH ON THE CORNER OF MONTGOMERY AND PLYMOUTH STREET, LOOKING SOUTHWEST. This photo was probably taken sometime between 1910 and 1915. (Courtesy of Don Schneider, Don's Barber Shop.)

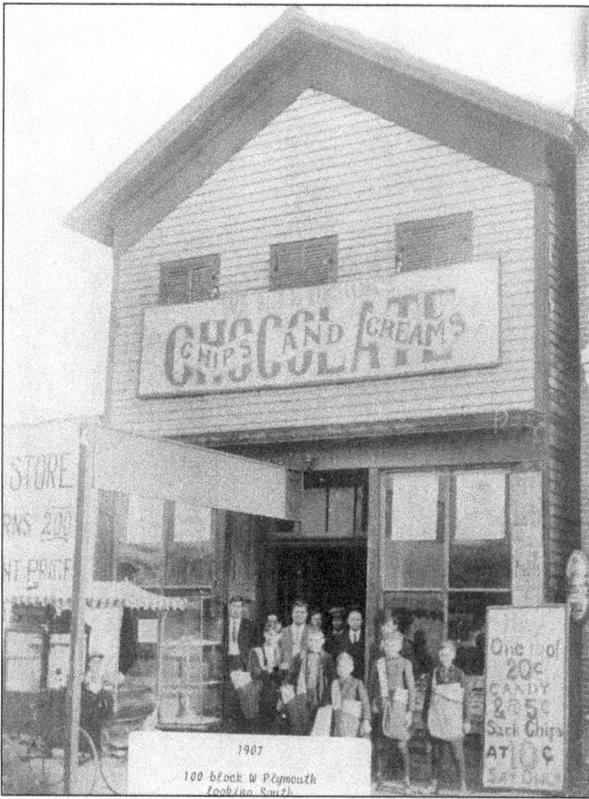

100 BLOCK OF WEST PLYMOUTH STREET LOOKING SOUTH. This candy store shows a bunch of newspaper delivery boys standing outside. Notice they were having a sale on candy and chips on Saturday only. (Courtesy of Don Schneider, Don's Barber Shop.)

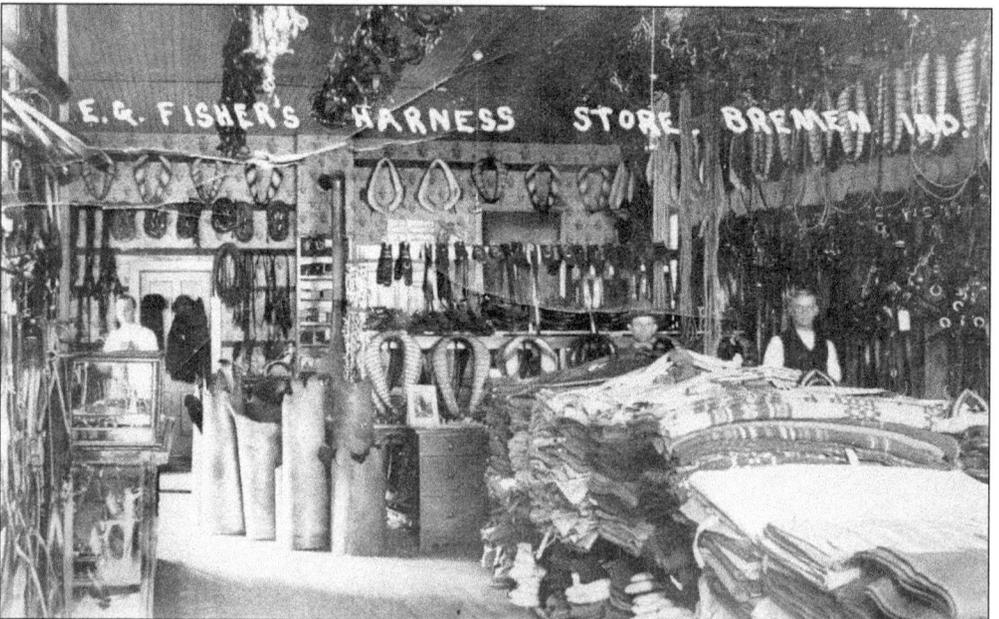

INSIDE E.G. FISHER'S HARNESS STORE IN BREMEN. The store, as seen in 1908, was located on the 100 block of West Plymouth Street (south side). (Courtesy of Don Schneider, Don's Barber Shop.)

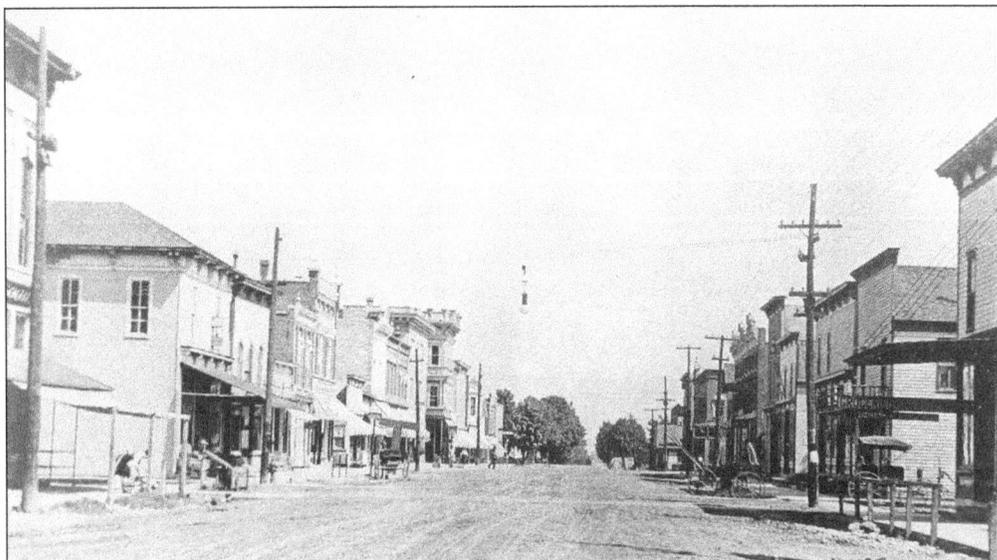

LOOKING EAST ON THE 200 BLOCK OF WEST PLYMOUTH STREET, C. 1910. (Courtesy of Don Schneider, Don's Barber Shop.)

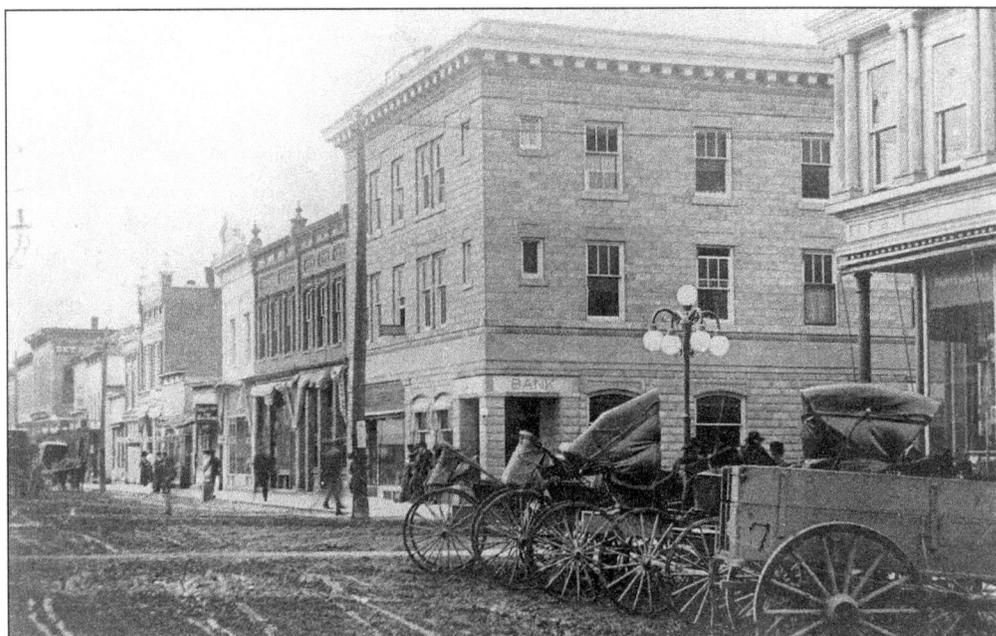

NORTH SIDE OF PLYMOUTH STREET AT CENTER, LOOKING NORTHWEST. This photo was probably taken around 1910. (Courtesy of Don Schneider, Don's Barber Shop.)

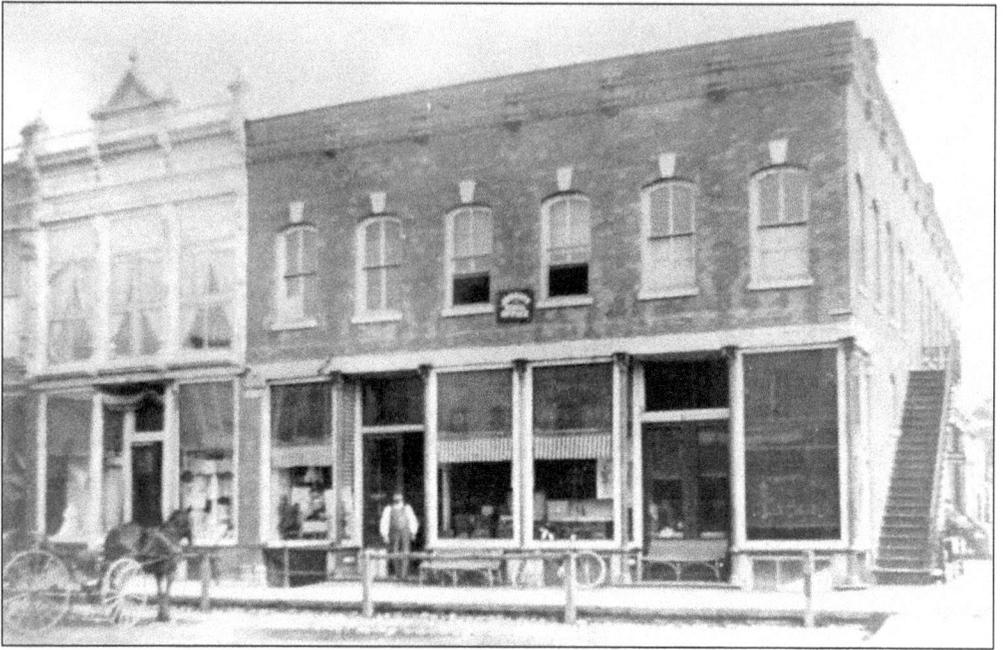

THE DIETRICH BUILDING. The Dietrich Building stood on the southeast corner of Plymouth and Center Streets. This photo was taken around 1910. (Courtesy of Don Schneider, Don's Barber Shop.)

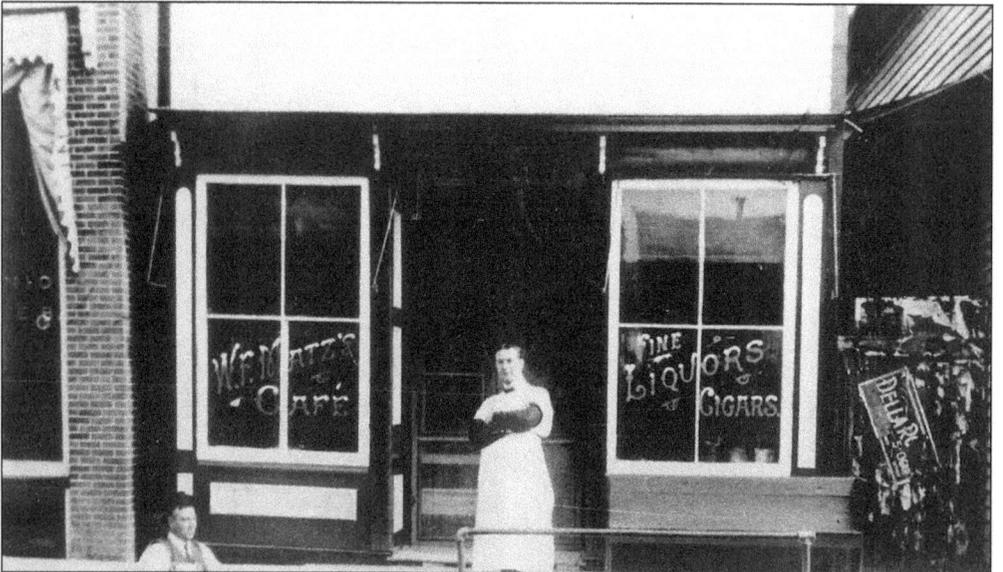

W.F. MATZ'S CAFÉ. W.F. Matz's Café on the 100 block of East Plymouth Street stood on the north side of the street. The window states they sell fine liquors and cigars. The bartender must be the one posing for the photograph. (Courtesy of Don Schneider, Don's Barber Shop.)

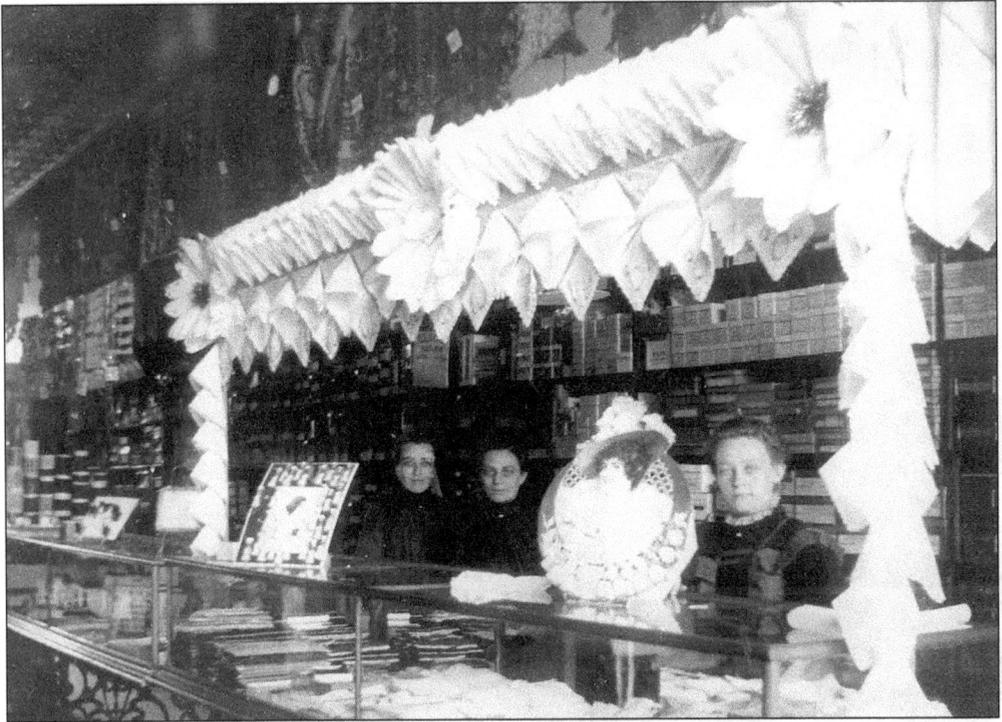

INSIDE OF J.R. DIETRICH AND COMPANY GENERAL MERCHANDISE STORE, 1910. The sales clerks stop working for a minute to have this photo taken. (Courtesy of Don Schneider, Don's Barber Shop.)

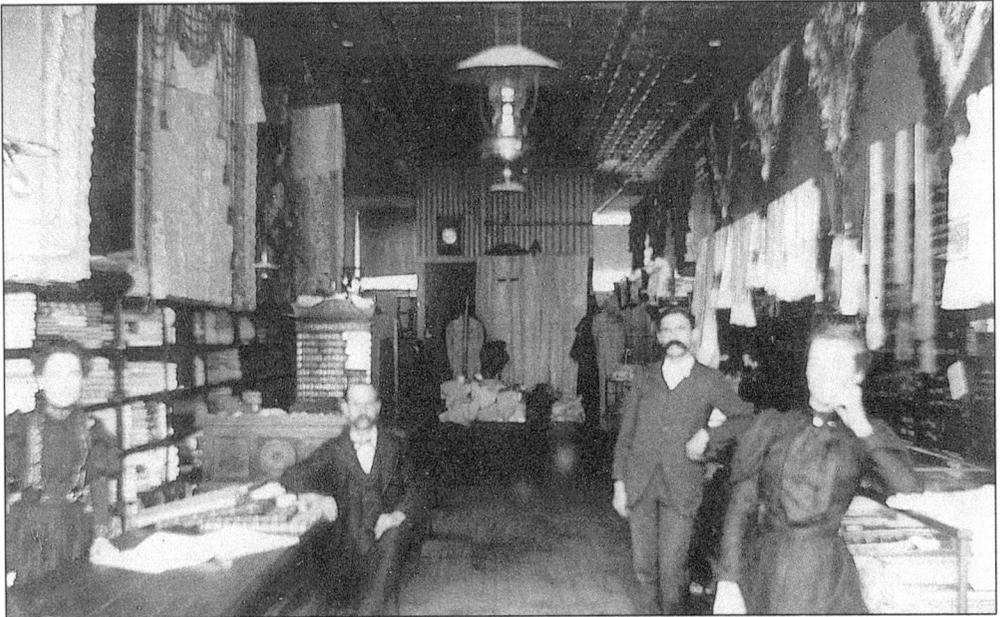

ENTIRE INSIDE OF THE J.R. DIETRICH AND COMPANY GENERAL MERCHANDISE STORE. This photo was probably taken around 1910. (Courtesy of Don Schneider, Don's Barber Shop.)

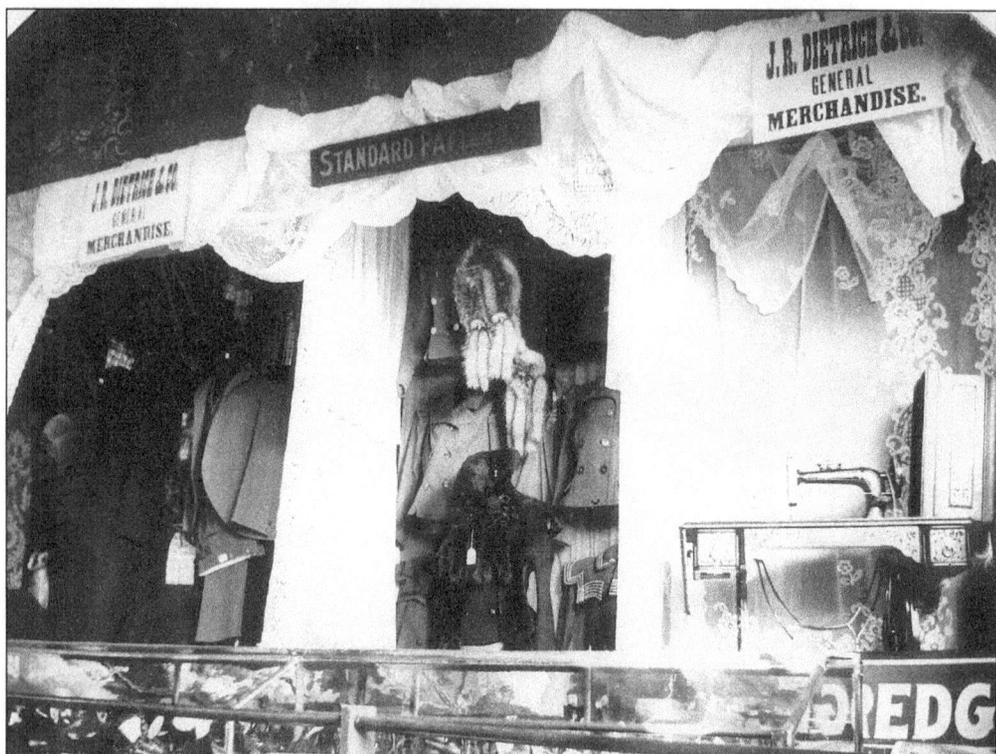

A COUNTER VIEW OF THE **J.R.** DIETRICH GENERAL MERCHANDISE STORE AROUND 1910.
(Courtesy of Don Schneider, Don's Barber Shop.)

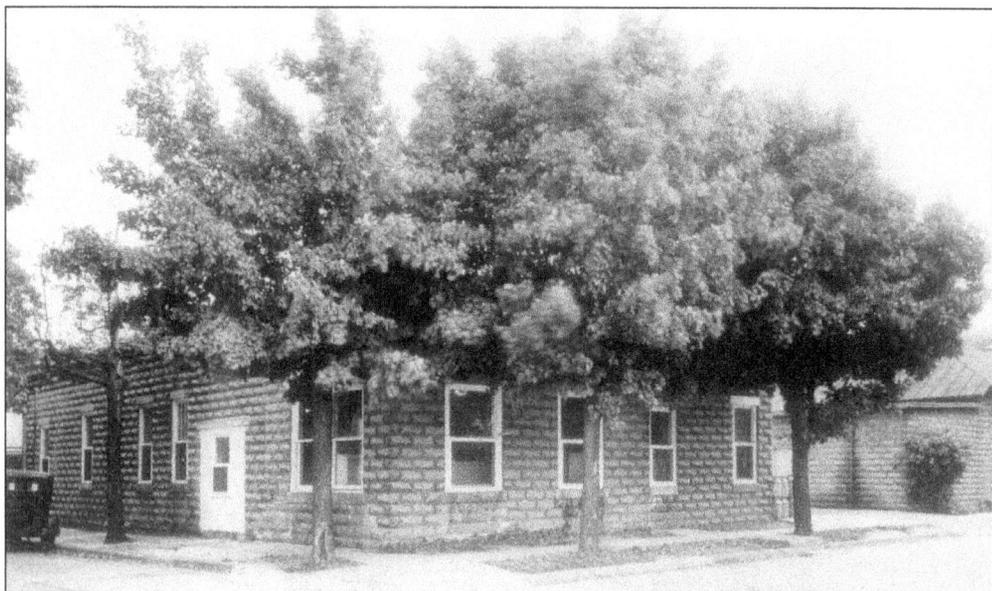

SCHLOSSER CREAMERY BUILDING. The Schlosser Creamery Building was located on South
Center Street and East South Street in the southeast corner. This photo was probably taken
between 1908–1910. Built in 1884, the creamery was still operating in the 1930s. (Courtesy of
Don Schneider, Don's Barber Shop.)

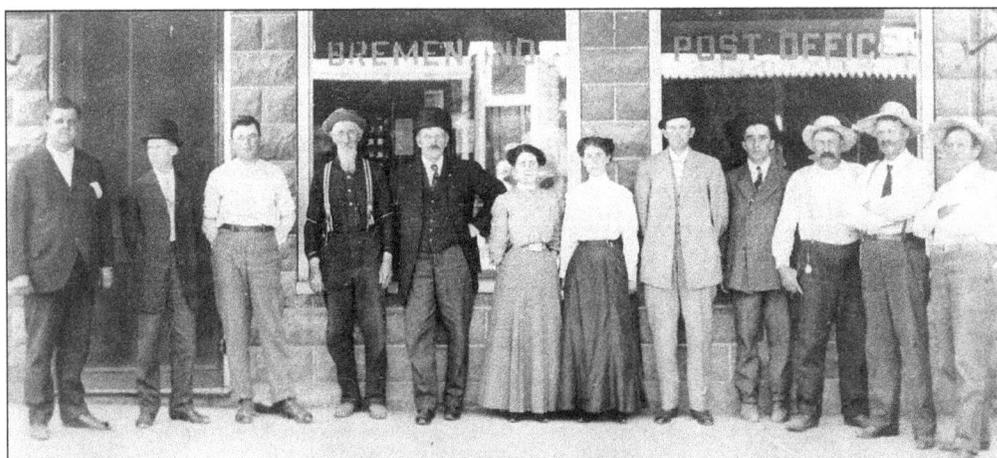

THE BREMEN POST OFFICE BETWEEN 1908–1912. At that time, the post office stood on the 100 block of North Center Street on the west side. Later a new post office was erected just north of that location where it still stands today. Those pictured here are (from left to right): Postmaster William Helmlinger; Deputy Carrier Elmer Eslinger; Deputy Carrier George Kipfer; Carrier, office and Railroad Station Balcer Mangers; Rural Carrier Samuel Slaubenner; Clerk Rose Kauffman; Deputy Carrier Laura Ranstead; Rural Carrier E.L. Kipfer; Rural Carrier Clem Ewald; Rural Carrier Warley Ramstead; Rural Carrier Perry Young; and Rural Carrier Howard Templeton. (Courtesy of Don Schneider, Don's Barber Shop.)

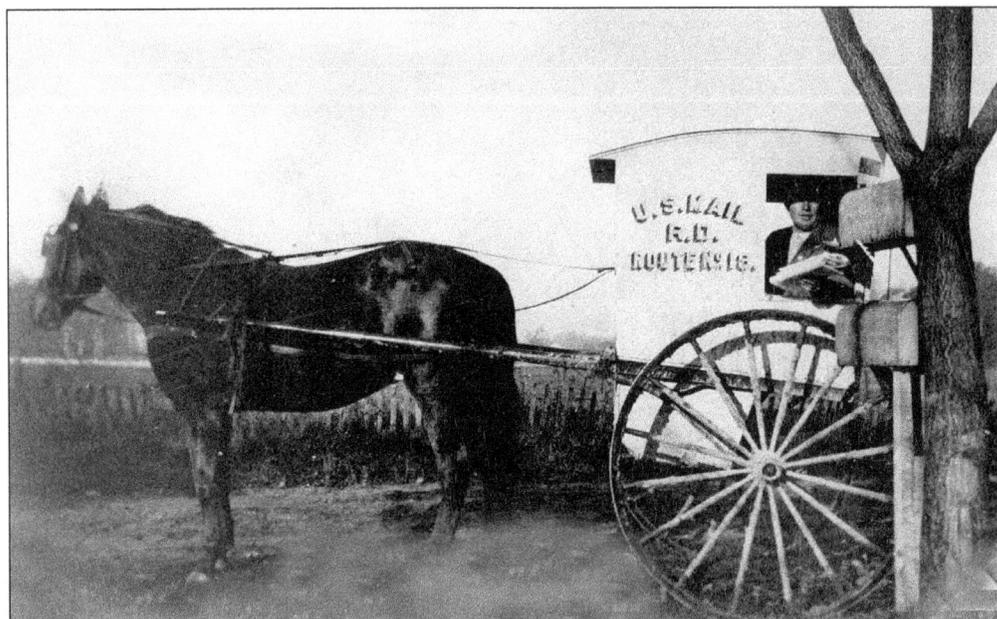

GEORGE KIPFER DELIVERING THE MAIL FOR THE BREMEN POST OFFICE. He was in charge of rural delivery Route #19. The post office was established in 1846 by David Brothers. He ran the post office for two years. In his honor, the village was named Brothersville. It wasn't long before a native of New York, George Pomeroy, and Josiah Geiselman, who ran a store in Clayton, moved to Brothersville where Geiselman ran a blacksmith shop and Pomeroy took over operation of the post office. (Courtesy of Don Schneider, Don's Barber Shop.)

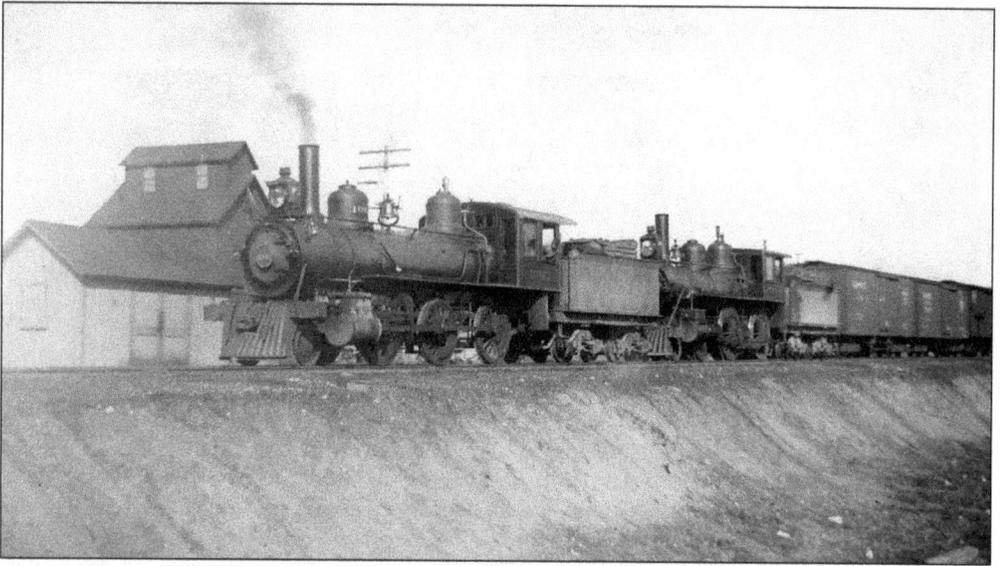

TRAIN RUNNING ON THE B&O RAILROAD, 1910. The B&O came to Bremen in 1874. (Courtesy of Don Schneider, Don's Barber Shop.)

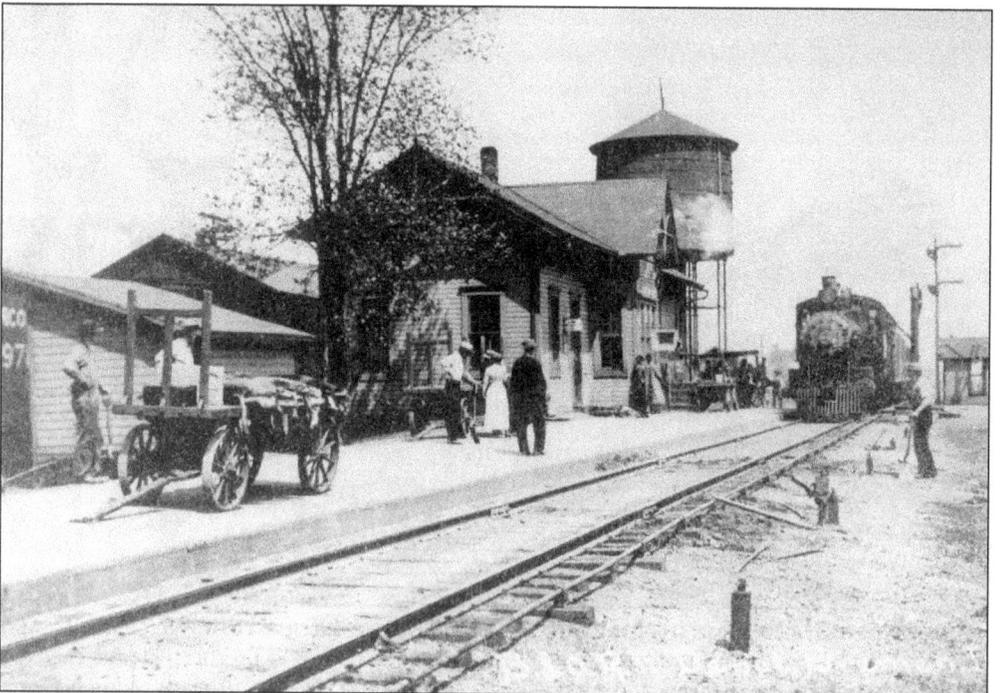

THE RAILROAD DEPOT AT NORTH CENTER STREET. This view is the north side of the tracks looking east. This photograph was taken between 1900–1910. (Courtesy of Don Schneider, Don's Barber Shop.)

THE 100 BLOCK OF E. PLYMOUTH STREET LOOKING SOUTHWEST, 1910. (Courtesy of Don Schneider, Don's Barber Shop.)

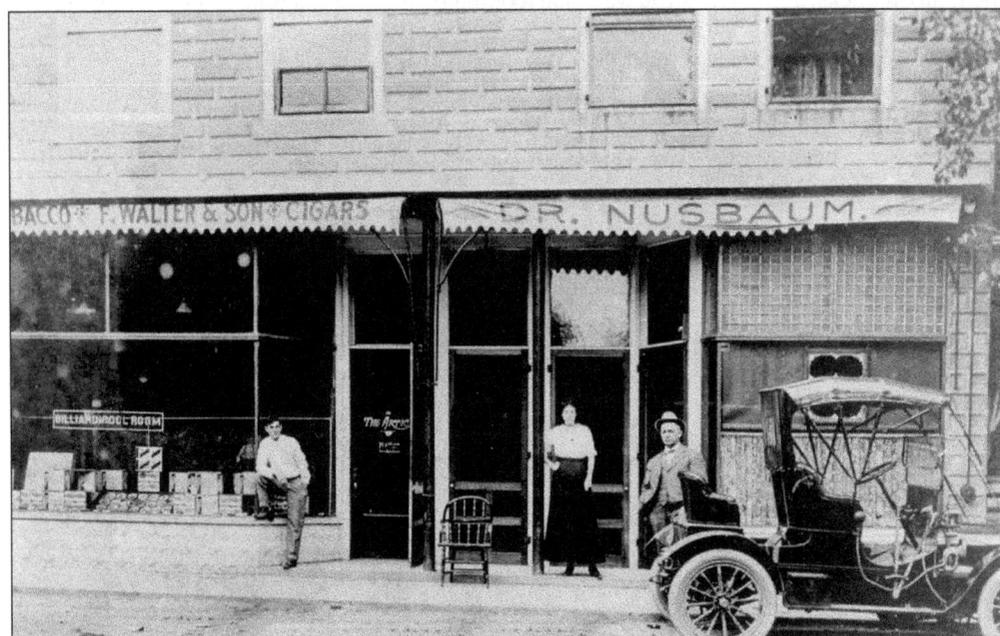

F. WALTER & SON. This building, which housed two businesses in 1910, was located on the 100 block of N. Center Street, looking west. The business on the left says, "F. Walter & Son." They advertised selling tobacco, cigars, and the sign in the lower window states it was a Billiard and Pool Room. The name on the door says, "The Arctic." This building later became known as "The Flower Basket." Dr. Nussbaum's office is on the right. (Courtesy of Don Schneider, Don's Barber Shop.)

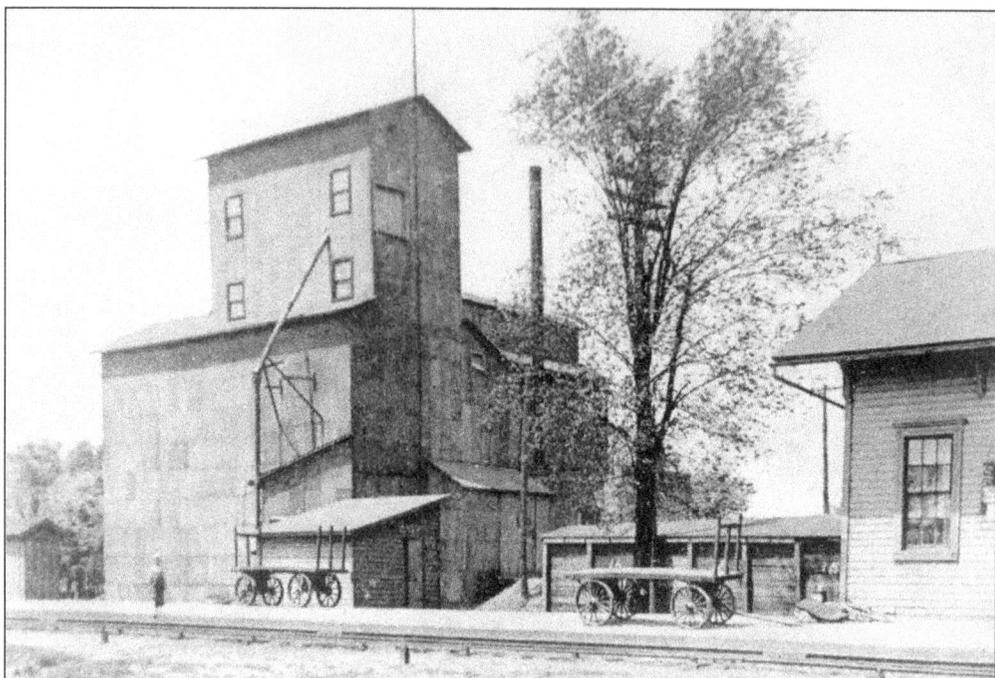

THE BREMEN ELEVATOR IN 1910. The elevator still stands today in the same location, north of the railroad tracks. This view is the west side looking behind the old Railroad Depot. (Courtesy of Don Schneider, Don's Barber Shop.)

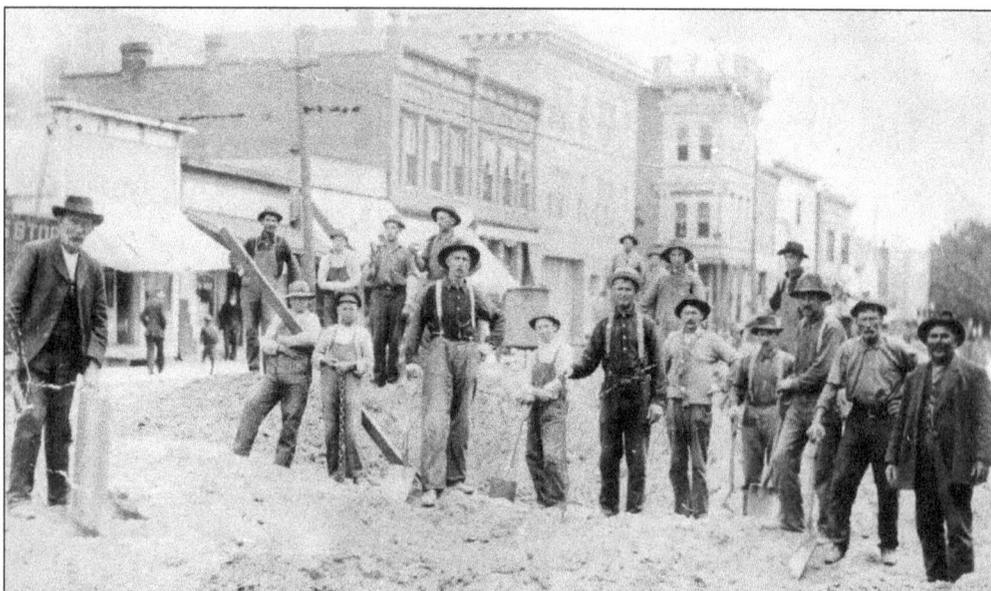

THE 100 BLOCK OF CENTER STREET C. 1910. It looks as if these people were breaking ground for an improvement on the streets. (Courtesy of Don Schneider, Don's Barber Shop.)

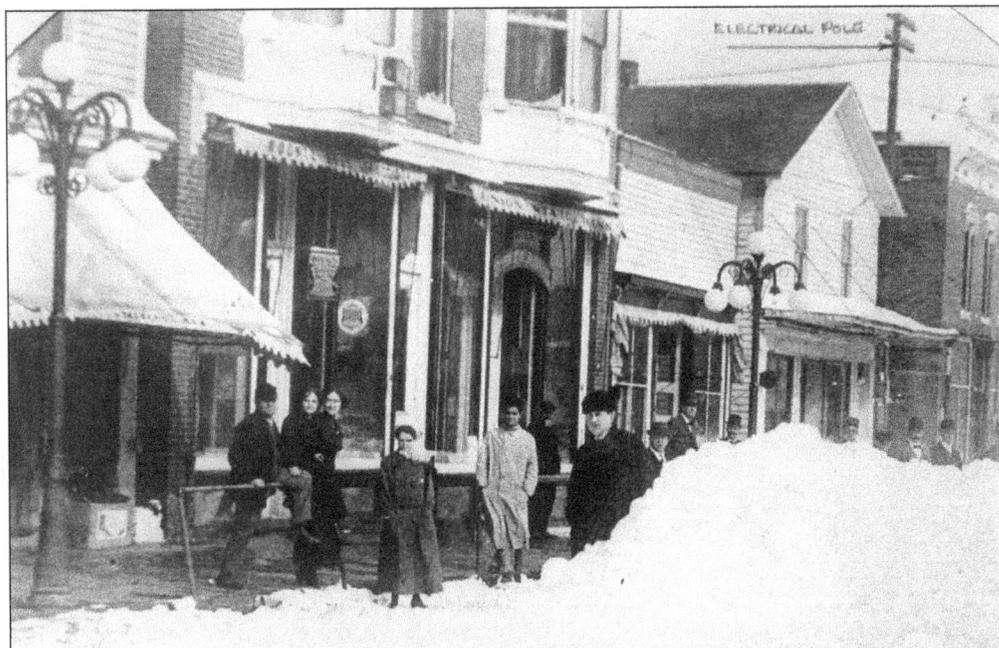

"ELECTRIC POLE." It is unknown what year this photo was taken, but if you look to the top right of the photo, you'll see an electrical pole. The pole is at the alley just one half block east of Center Street, looking to the north side of Plymouth Street. (Courtesy of Don Schneider, Don's Barber Shop.)

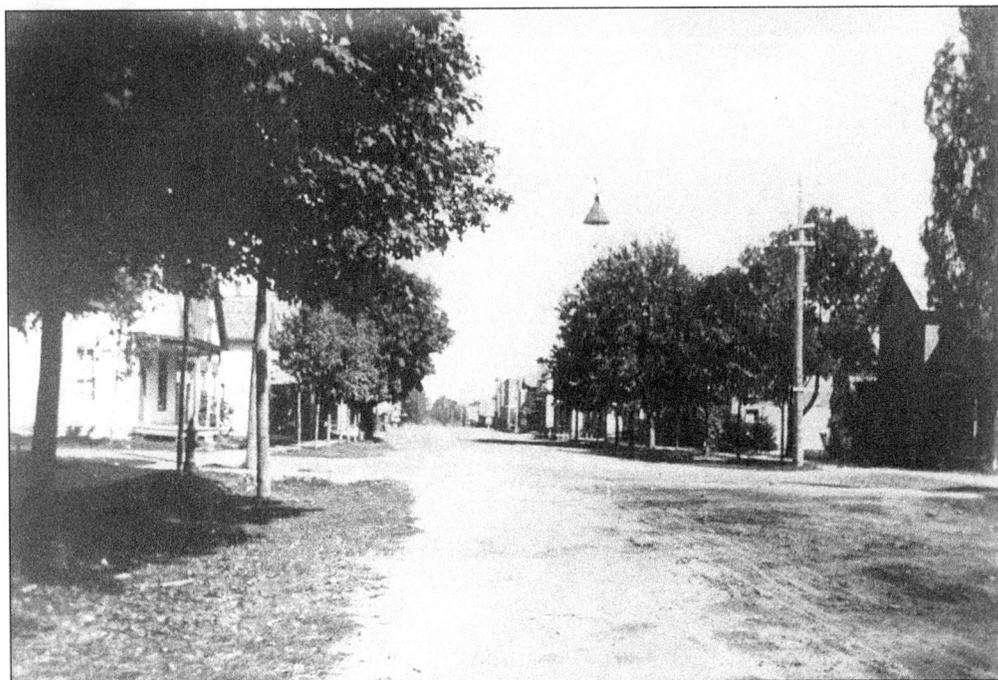

A 1910 VIEW OF THE 300 BLOCK OF WEST PLYMOUTH STREET LOOKING EAST. (Courtesy of Don Schneider, Don's Barber Shop.)

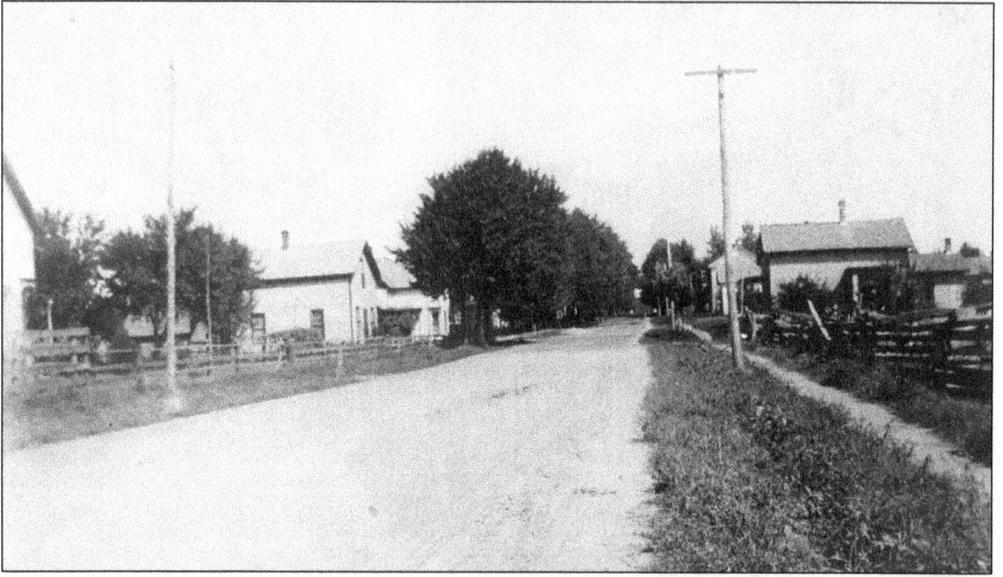

THE 500 BLOCK OF SOUTH CENTER STREET LOOKING NORTH, 1910. This is just one block north of where the St. Paul's Lutheran School stands today. (Courtesy of Don Schneider, Don's Barber Shop.)

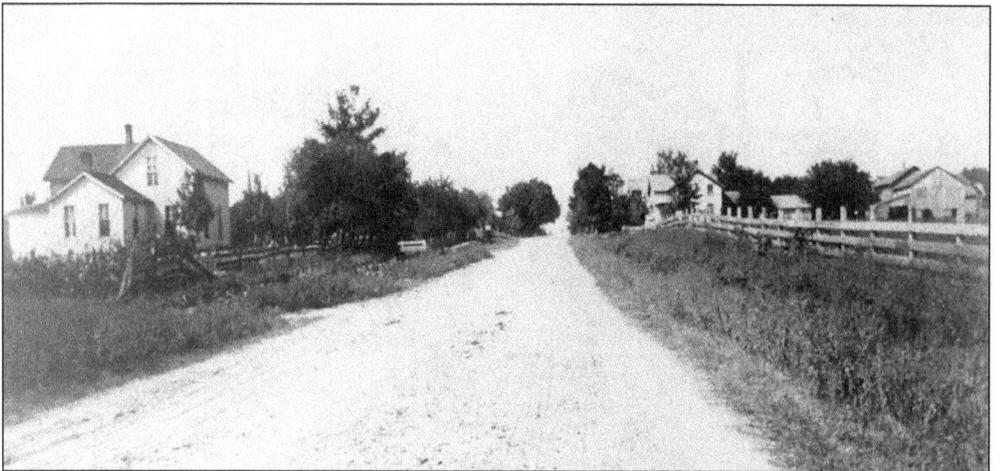

LOOKING WEST AT THE 500 BLOCK OF EAST PLYMOUTH STREET. This photo was taken in 1910. (Courtesy of Don Schneider, Don's Barber Shop.)

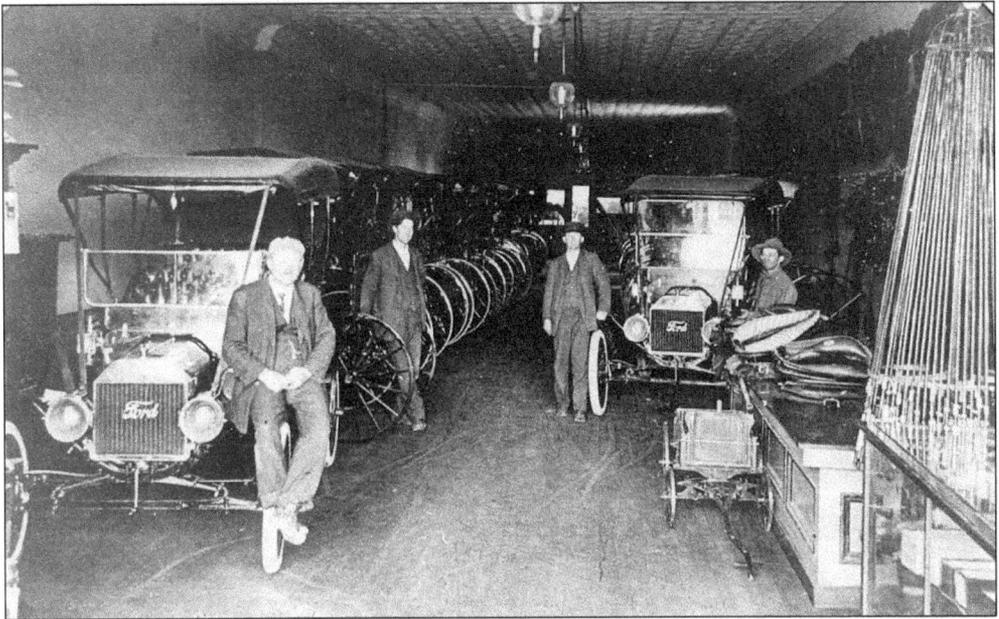

DOERING'S BUGGY AND CAR SHOP IN 1910. Doering's was located on the 100 block of South Center Street on the east side. Quite a different site from today's car dealerships. (Courtesy of Don Schneider, Don's Barber Shop.)

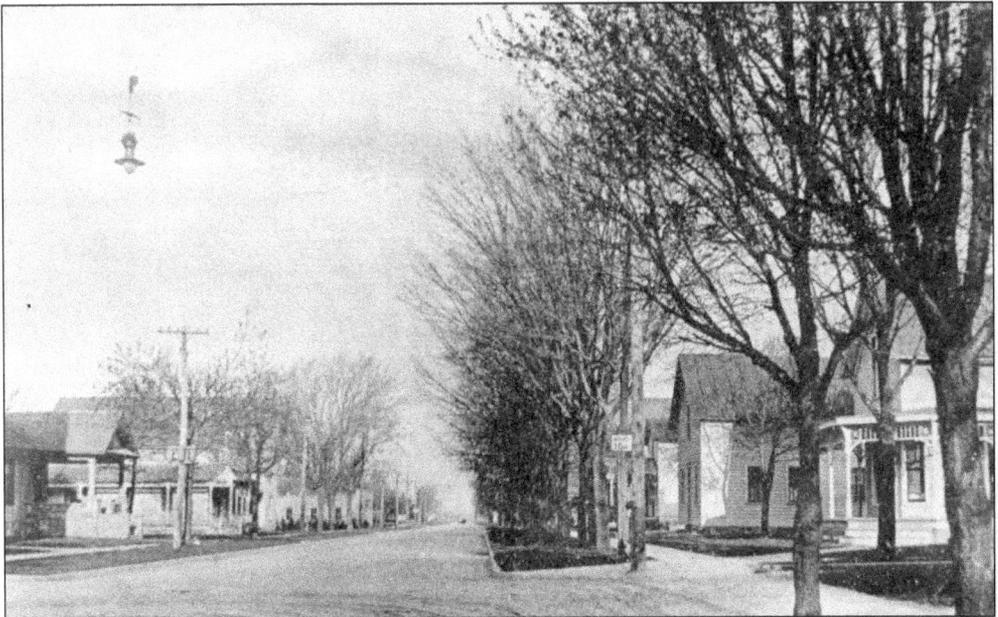

A 1910 PHOTOGRAPH OF THE 200 BLOCK OF W. PLYMOUTH STREET LOOKING WEST. (Courtesy of Don Schneider, Don's Barber Shop.)

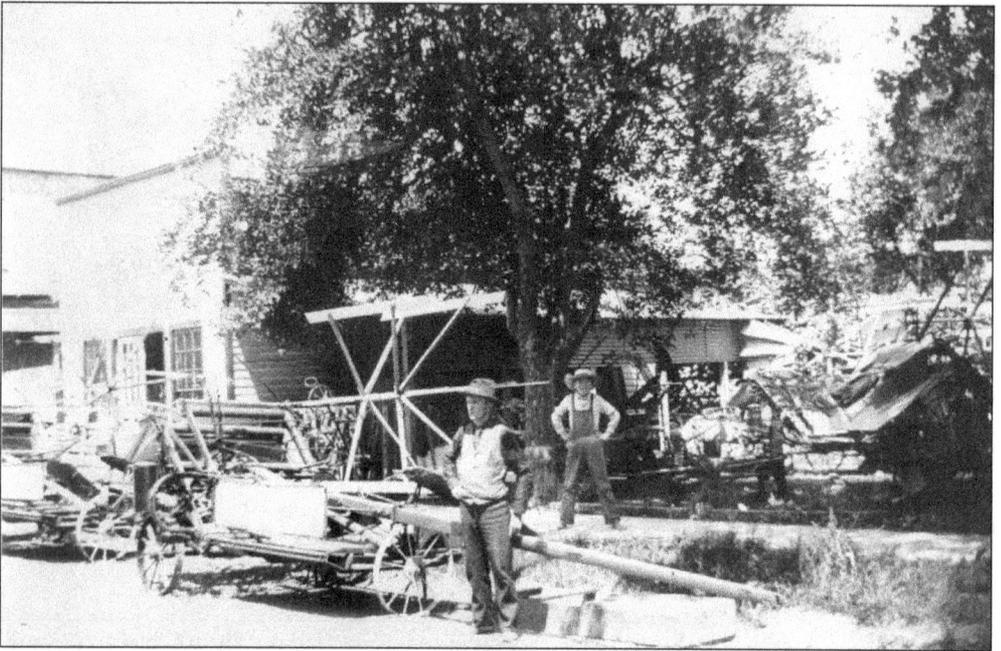

A FARM IMPLEMENT STORE LOCATED AT THE 100 BLOCK OF SOUTH CENTER STREET ON THE EAST SIDE. This photo was taken around 1910. (Courtesy of Don Schneider, Don's Barber Shop.)

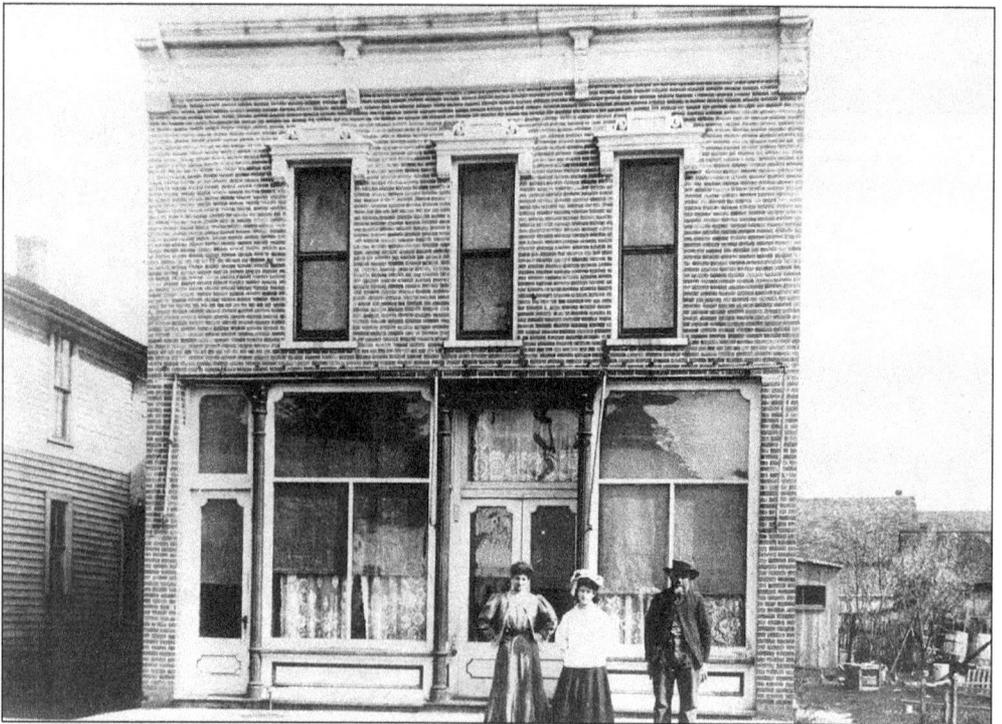

THE BALSLEY BUILDING. This building stood on the 100 block of East Plymouth Street on the north side. This photo was taken in 1910. (Courtesy of Don Schneider, Don's Barber Shop.)

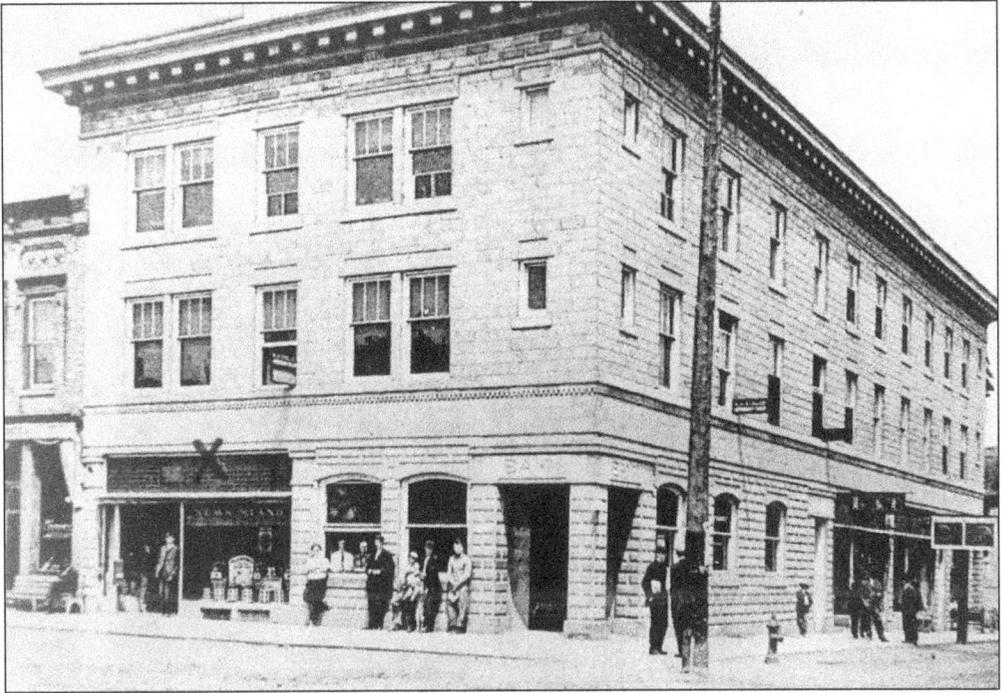

A Bank, Hotel, and More. This building, which stands at the corner of Plymouth and Center Streets in the northwest corner, at one time held a bank, hotel, and various other businesses. Later in the 1990s, the town of Bremen purchased the building and renovated it for a home for the elderly. This photo was taken around 1910. (Courtesy of Don Schneider, Don's Barber Shop.)

A 1910 Photo of Lester Kuhn in a Dress. It was the fashion to clothe boys in dresses until they were approximately two years of age. (Courtesy of Lester and Nellie Kuhn.)

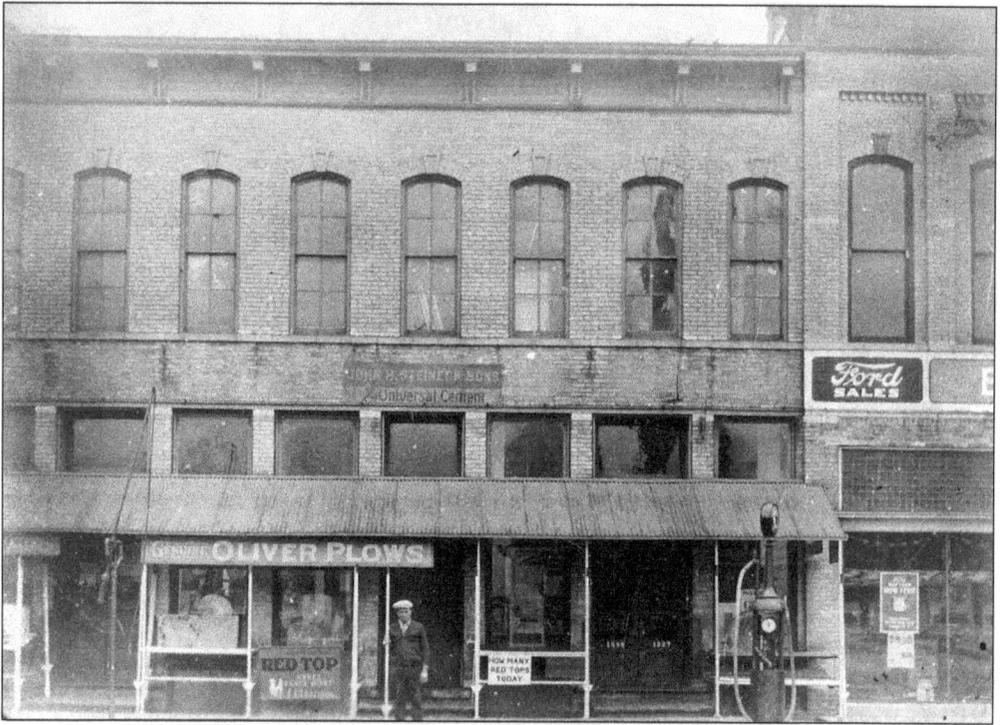

THE 200 BLOCK OF WEST PLYMOUTH STREET LOOKING NORTH SOMETIME BETWEEN 1910–1915. The sign on the left states, "Genuine Oliver Plows" and "How many red tops today." On the right side is Polson's Ford Motor Company, which was built by George Wright. Notice the gas pumps right on the street curb. (Courtesy of Don Schneider, Don's Barber Shop.)

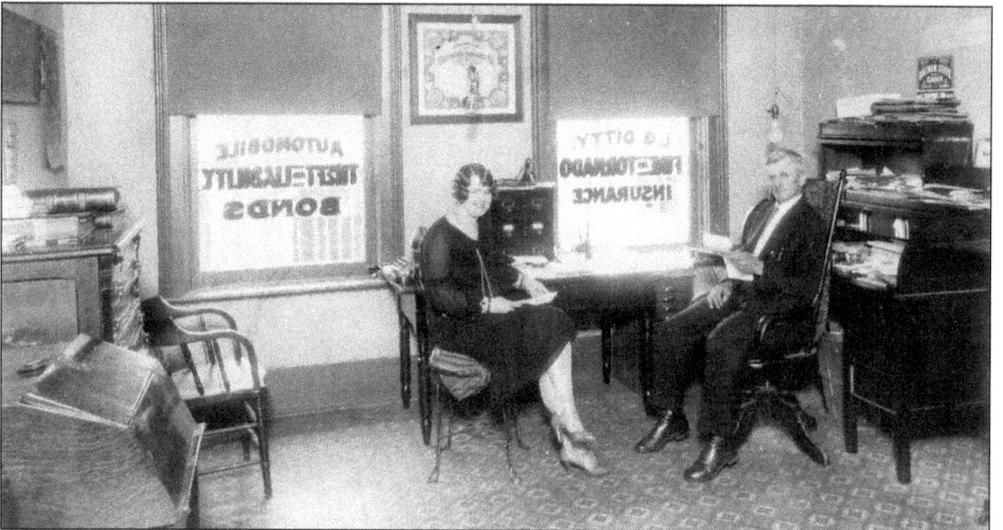

THE OFFICES IN THE UPSTAIRS PORTION OF THE DIETRICH BUILDING. Jenette Dar Hans sits on the left. The man on the right is unknown. The window on the left says "Automobile Theft & Liability Bonds" and the window on the right says "L.G. Ditty, Fire & Tornado Insurance." It is believed that this photo was taken between 1910–1918. (Courtesy of Don Schneider, Don's Barber Shop.)

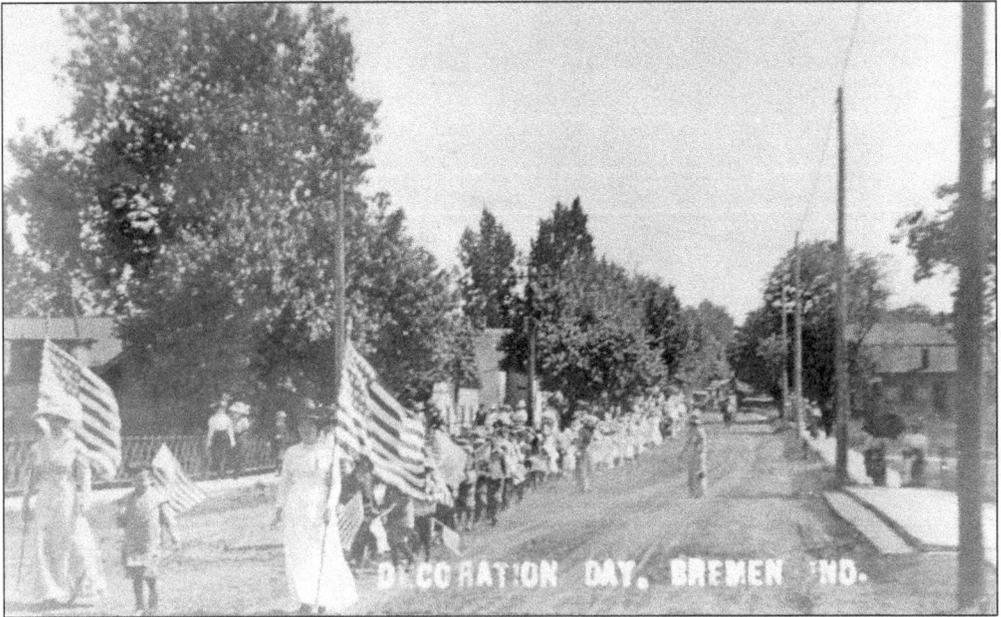

THE DECORATION DAY PARADE C. 1910–1914. This picture is looking south from the railroad tracks on North Center Street. (Courtesy of Don Schneider, Don's Barber Shop.)

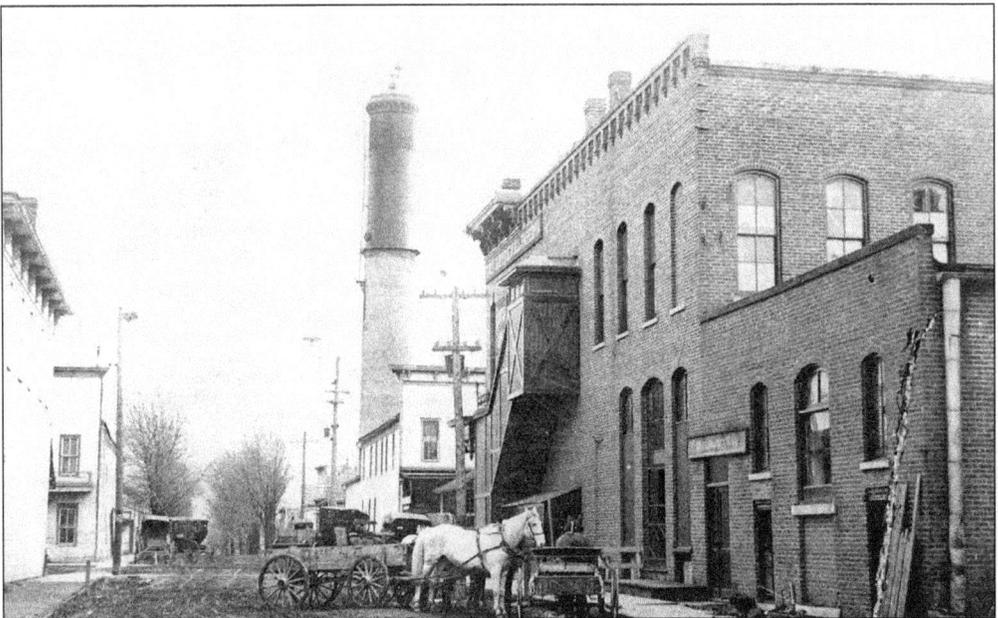

BREMEN WATER TOWER. The 100 block of N. Jackson Street looking south shows the Bremen Water Tower which held the original Bremen water supply. This photo was taken in 1912, and the structure still stands today. (Courtesy of Don Schneider, Don's Barber Shop.)

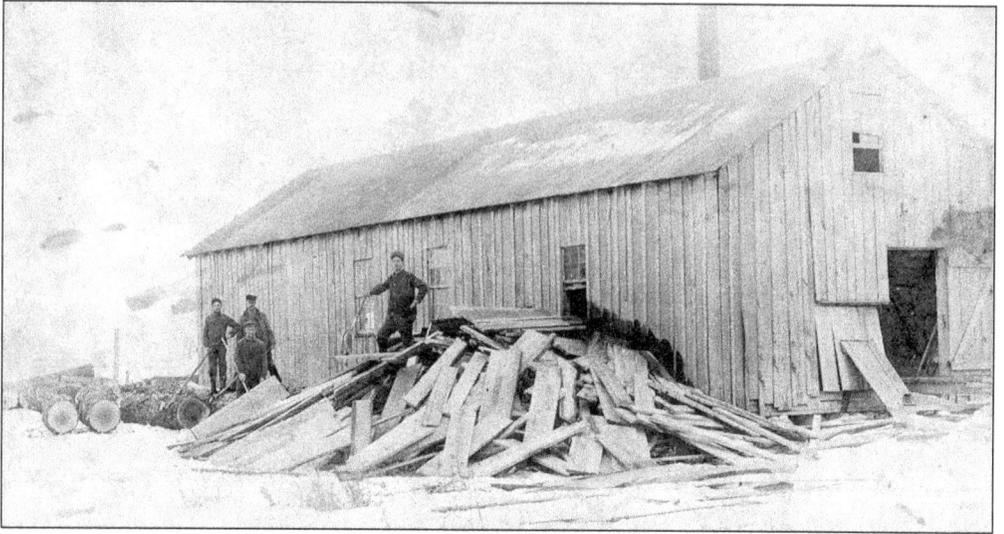

WRIGHT'S BENDING FACTORY BETWEEN 1900–1910. (Courtesy of Don Schneider, Don's Barber Shop.)

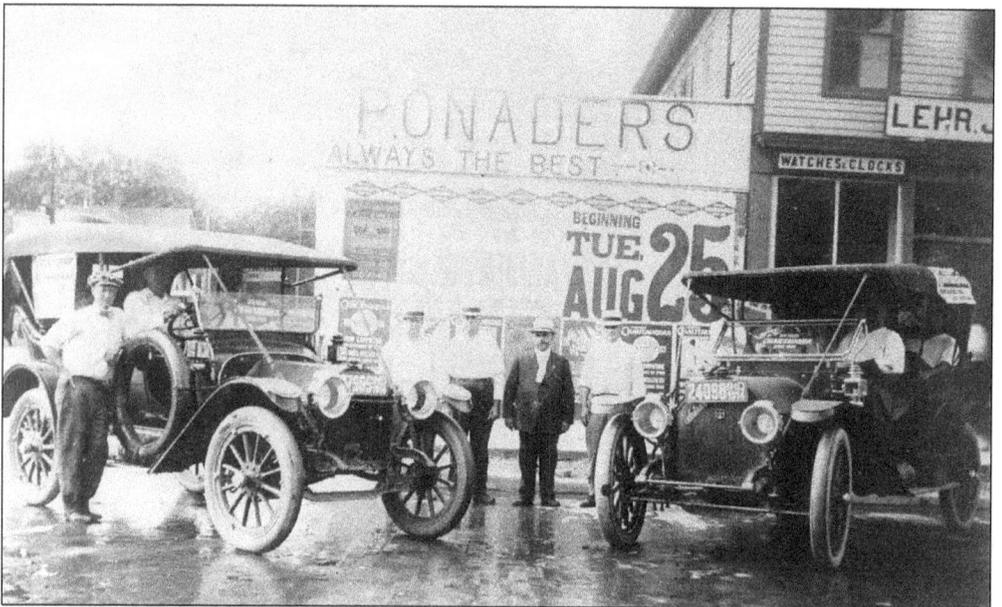

OUTSIDE PONADER'S BETWEEN 1910–1912. Ponader's stood on the 100 block of West Plymouth Street. This photo is looking south. They must have been getting ready for a sale seeing the sign in the background. (Courtesy of Don Schneider, Don's Barber Shop.)

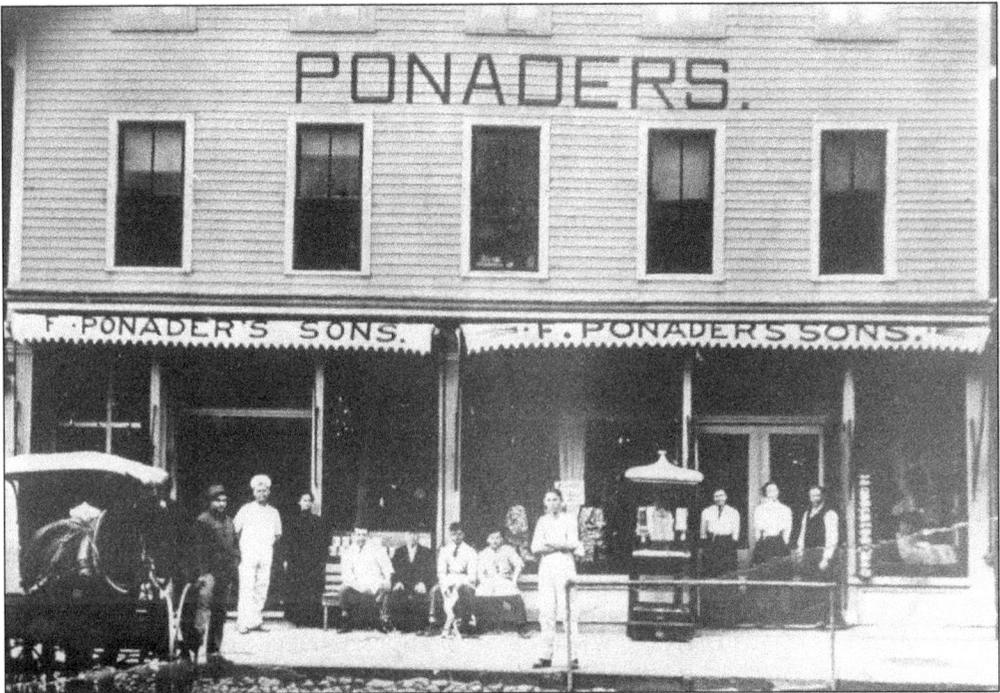

F. Ponader's and Sons Grocery and Millinery Sometime in the 1910–1919 Era. Looks as if the employees had come outside for a break to pose for a photograph. (Courtesy of Don Schneider, Don's Barber Shop.)

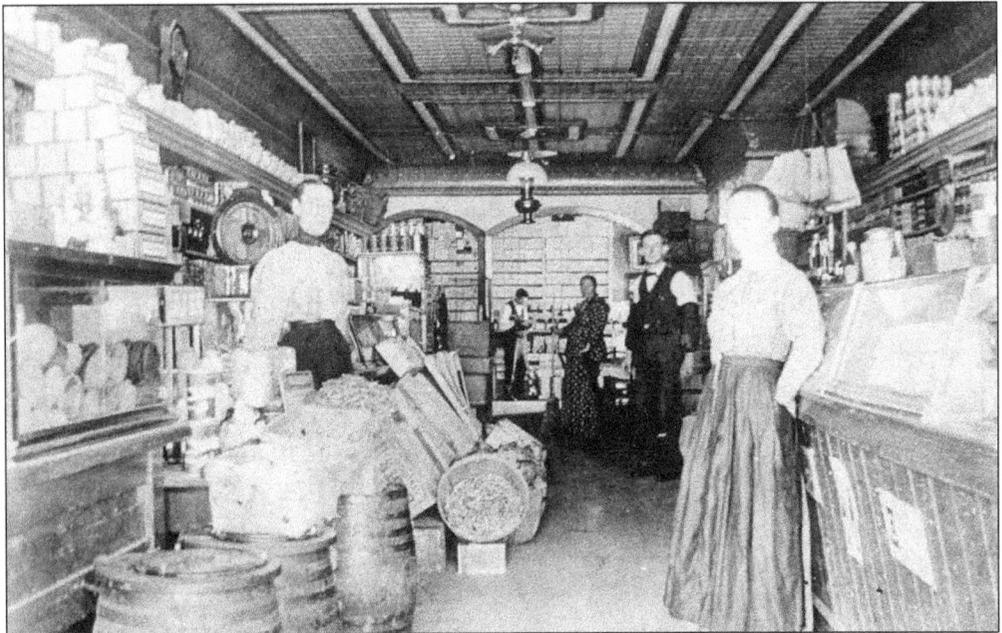

Inside Ponader's Variety Store Located on the 100 Block of East Plymouth Street. This photo was probably taken around 1911. This is a great look at the architecture of these buildings. (Courtesy of Don Schneider, Don's Barber Shop.)

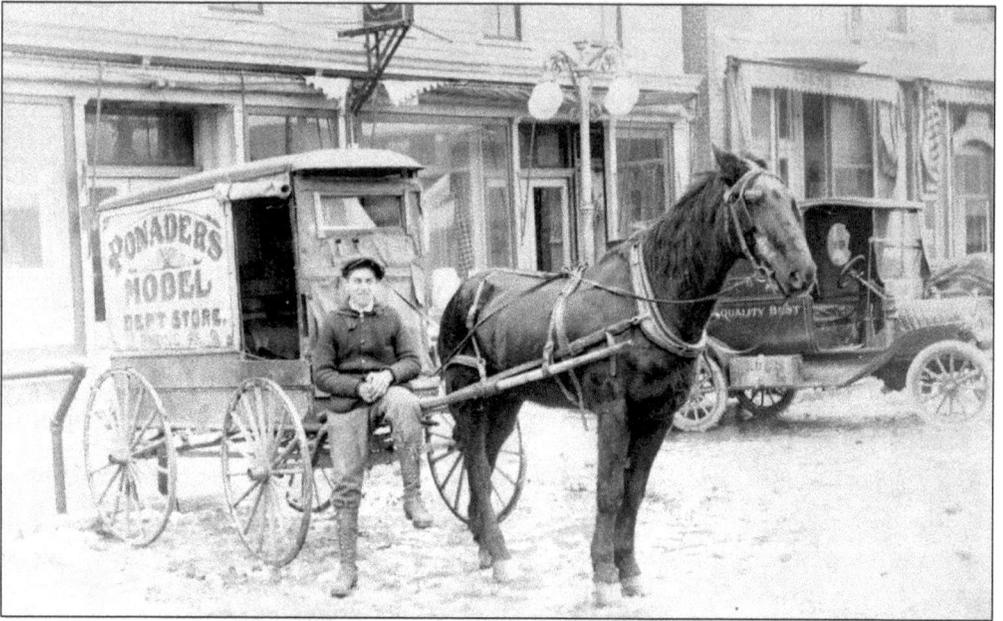

STOWE MATZ SITS ON HIS DELIVERY WAGON FOR PONADER'S VARIETY STORE. Look closely on the side of the wagon where it states their phone number as #8. (Courtesy of Don Schneider, Don's Barber Shop.)

CORNER OF CENTER AND MAPLE STREETS LOOKING SOUTH. The photo was probably taken around 1910. (Courtesy of Don Schneider, Don's Barber Shop.)

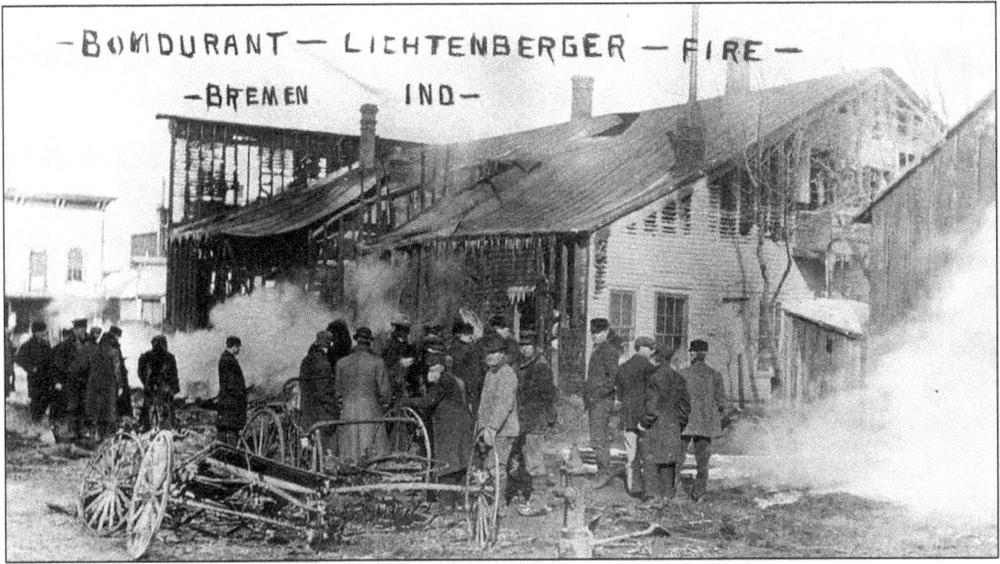

THE BONDURANT-LICHTENBERGER FIRE OF 1912. This set of photographs show the Bondurant-Lichtenberger fire in 1912. This building was located at the 100 block of South Jackson Street near the corner of Plymouth Street. The Bondurant-Lichtenberger Livery Stable provided horses and horse-drawn vehicle for residents as a means of general transportation. The picture shows a view looking northeast. (Courtesy of Don Schneider, Don's Barber Shop.)

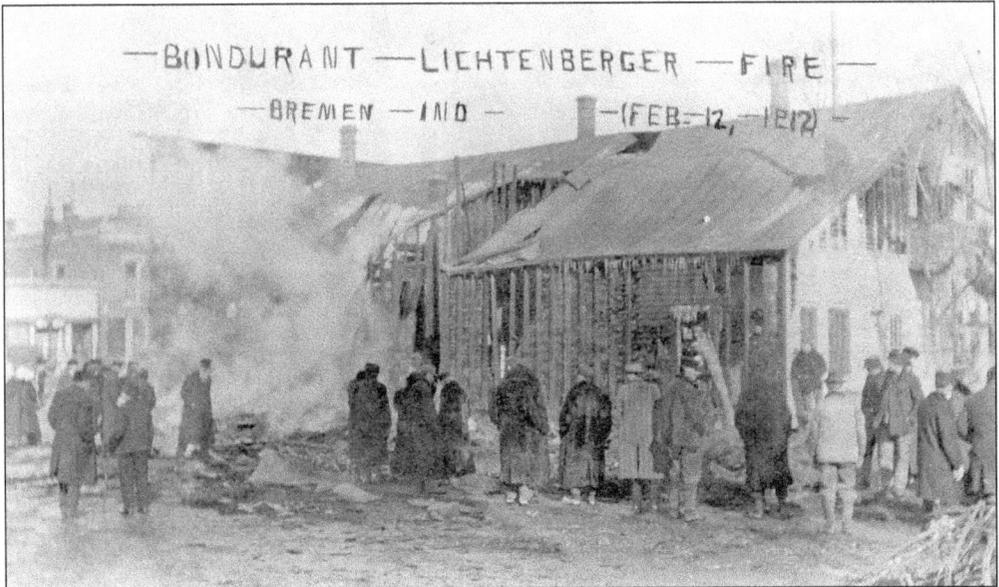

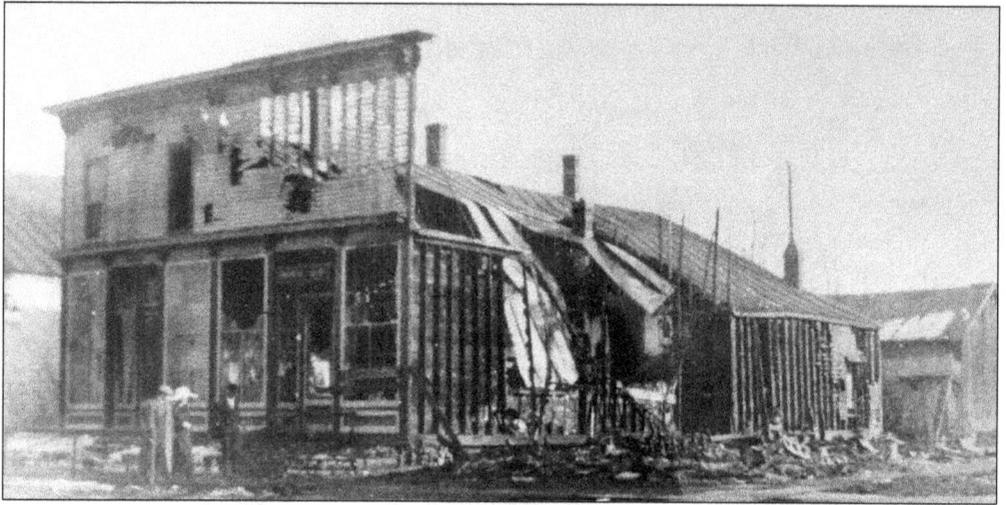

THE BONDURANT-LICHTENBERGER FIRE, 1913. This view is at the corner of Plymouth and Jackson Streets looking southeast. (Courtesy of Don Schneider, Don's Barber Shop.)

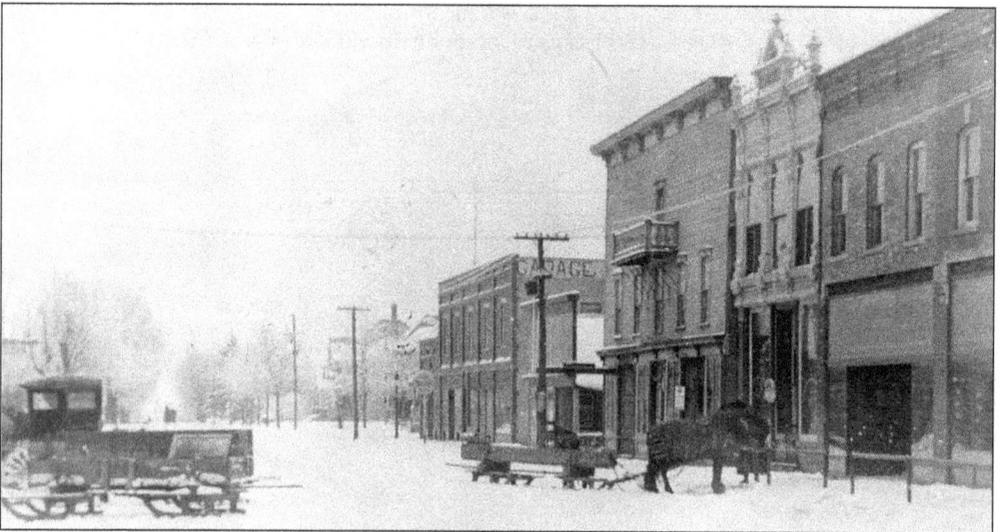

THE CORNER OF PLYMOUTH AND CENTER STREETS LOOKING EAST AROUND 1910. "Hoople's Bar" is seen on the right side near the horse which began in 1882 by Charles Hoople. This tavern was the oldest operating tavern in the State of Indiana that remained in one family. In the 1990s, it was sold to an outsider but still remains in the same operating condition. Mr. Charles Hoople, the tavern and his home became a part of a national syndicated cartoon strip written by a cartoonist, Mr. Aherne, who visited the Hoople home. The cartoon strip was called "Hoople's Boarding House." The present structure has virtually the same store front as it had in 1882. (Courtesy of Don Schneider, Don's Barber Shop.)

A VIEW OF PLYMOUTH STREET IN THE 1910S. (Courtesy of Don Schneider, Don's Barber Shop.)

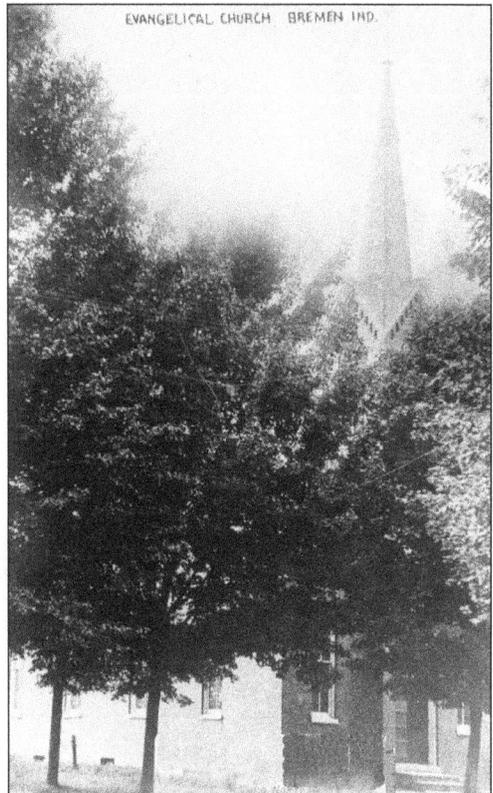

STEEPLE. The label on this picture said that this was the Evangelical Church in Bremen. After much studying, we found this photo to actually be two buildings. The steeple is actually in the distance and it belongs to St. Paul's Lutheran Church and the bottom building is on the other block nearby. (Courtesy of Don Schneider, Don's Barber Shop.)

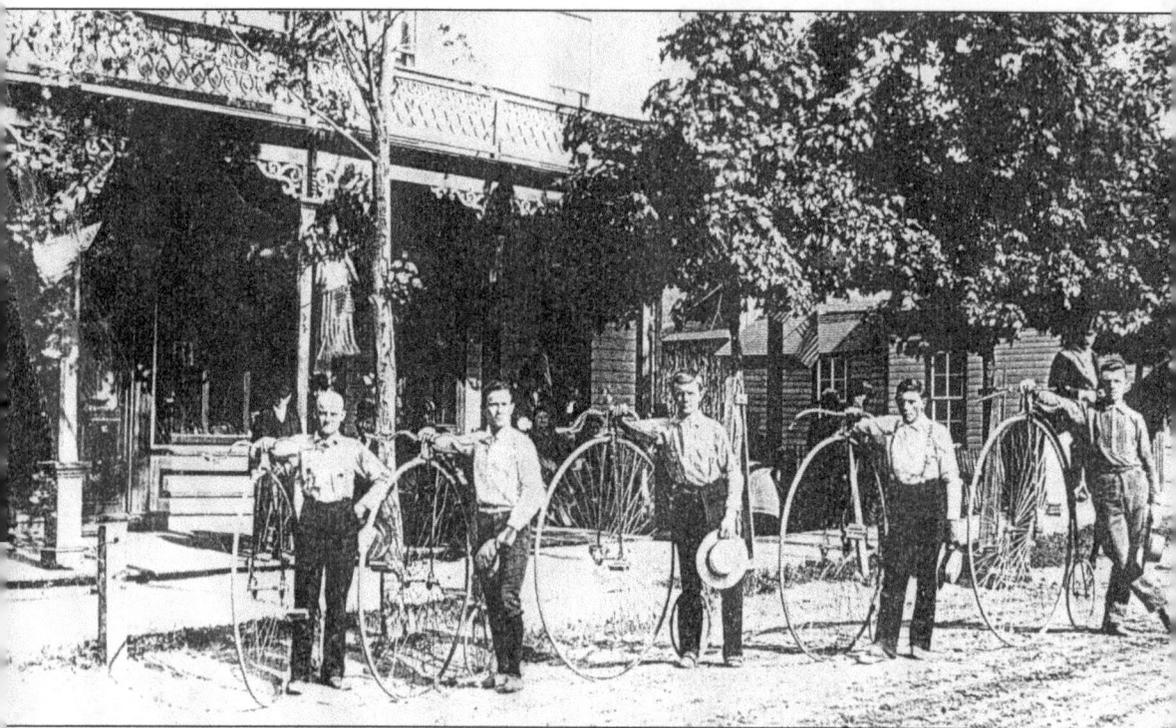

HIGH-WHEEL BIKES. These high-wheel bicycles were probably preparing for a parade. The photo was taken sometime around 1900. (Courtesy of Don Schneider, Don's Barber Shop.)

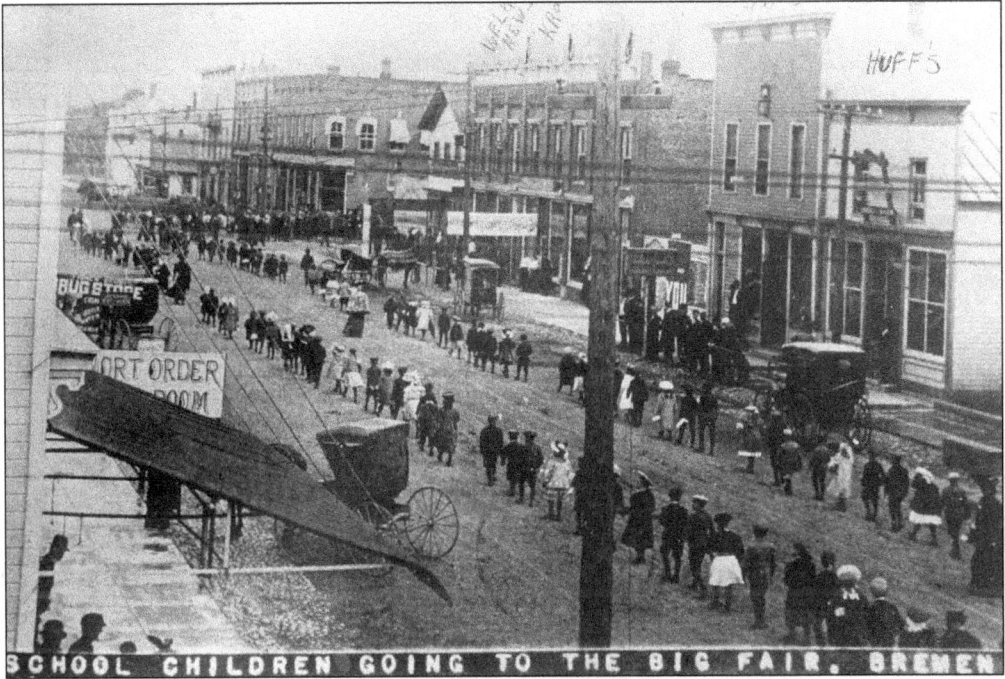

A Procession of School Children on Their Way to the Bremen Fair in 1913. (Courtesy of Don Schneider, Don's Barber Shop.)

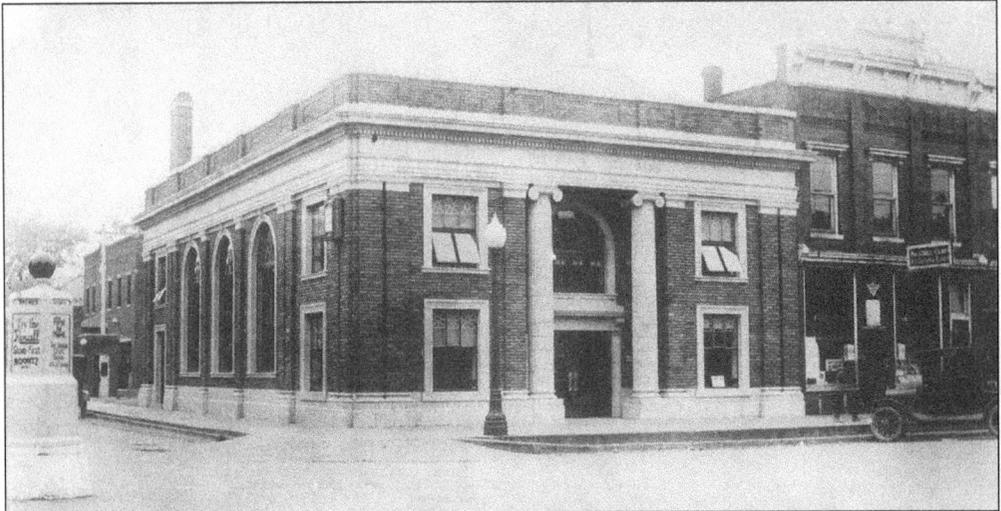

A Bank and Town Hall. The former Bremen State Bank was later turned into the Bremen Town Hall. In the 1990s the Town of Bremen renovated the building to make it look like the original building pictured here. This photo was probably around 1915. The building is still located at the corner of Plymouth and Center Streets. (Courtesy of Don Schneider, Don's Barber Shop.)

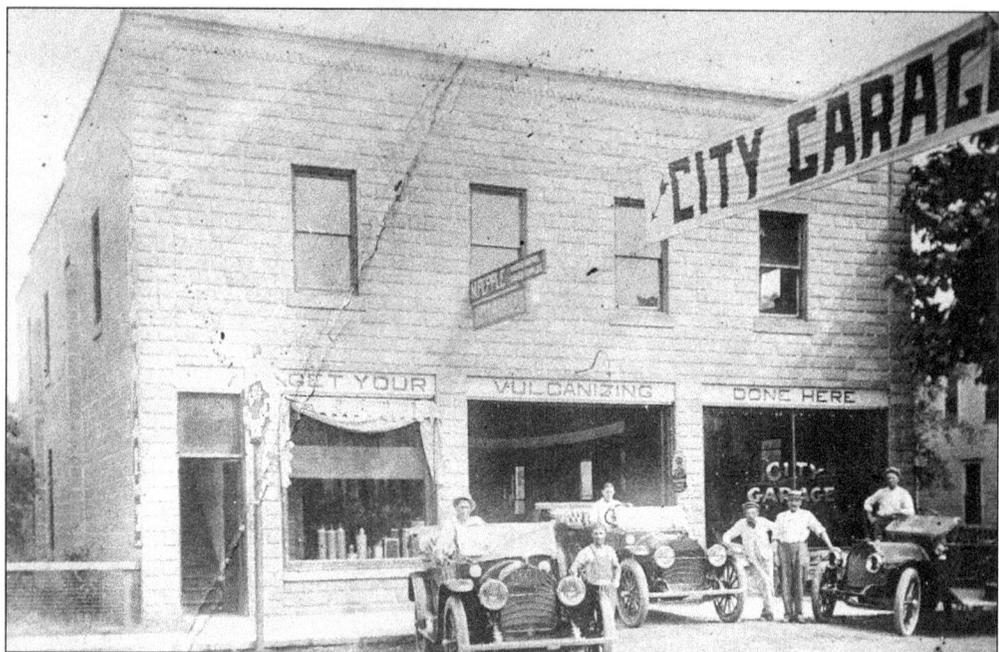

GARAGE. This photo of the city garage notes in the front of the building, "Get your vulcanizing done here." The garage was located on the north side of the 100 block of East Plymouth Street. The photo was probably taken around 1915. The building no longer exists. (Courtesy of Don Schneider, Don's Barber Shop.)

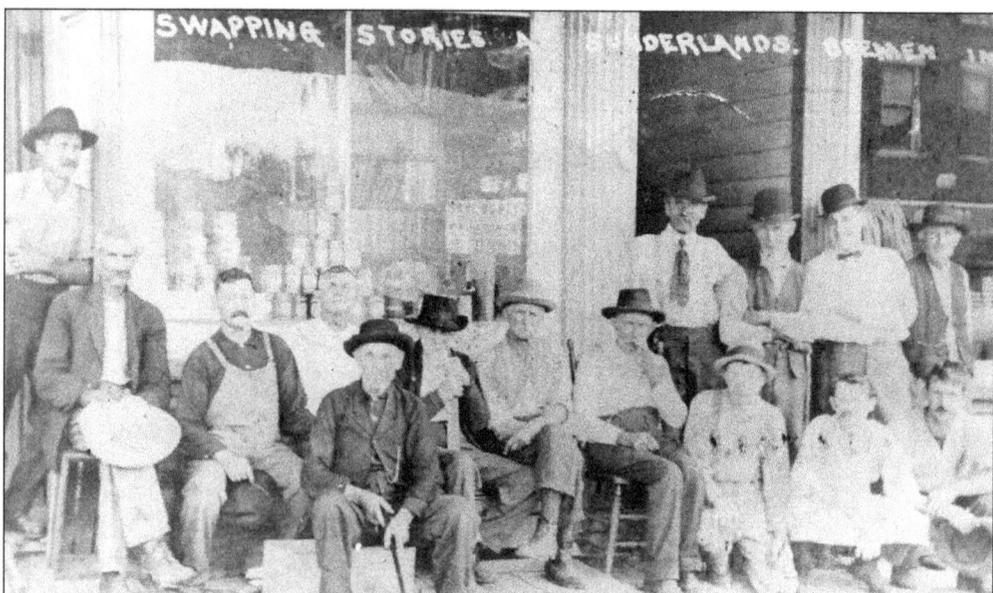

SUNDERLAND'S. This group was gathered at Sunderland's to swap stories. Sunderland's was located at the 100 block of W. Plymouth Street, on the north side. (Courtesy of Don Schneider, Don's Barber Shop.)

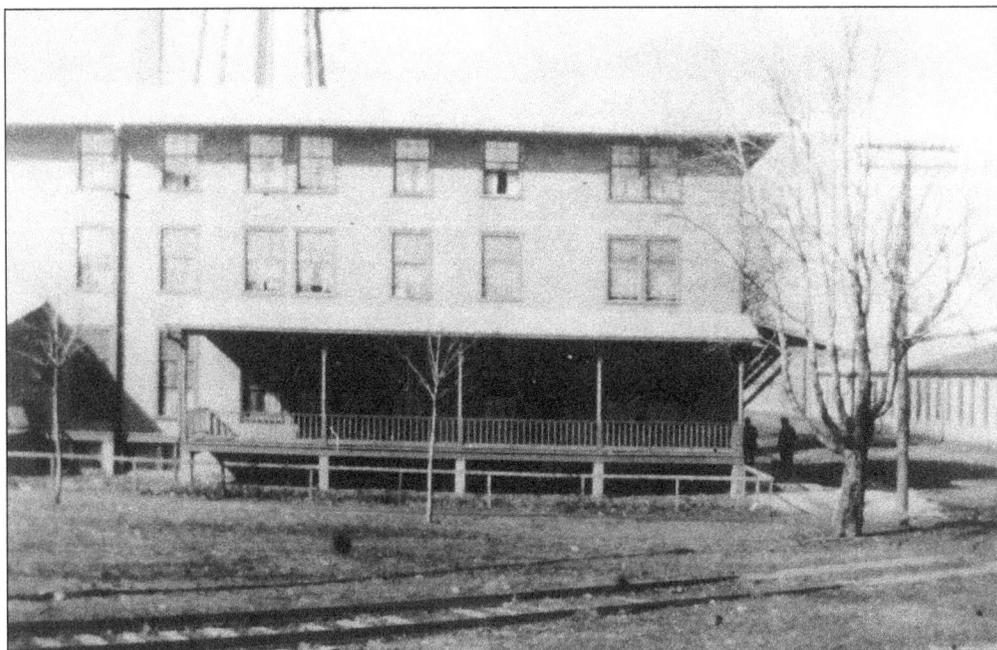

AMERICAN RADIATOR COMPANY HOTEL. The ARCO Hotel, which stood at N. Center Street just north of the old railroad depot, employed 400–600 people in the mid 1920s until the Depression. ARCO stood for the American Radiator Company Hotel. The original name of the hotel was the Holland Radiator Company. People working for the radiator company would bring the train into town and stay at their hotel. This hotel moved to Bremen in 1893. (Courtesy of Don Schneider, Don's Barber Shop.)

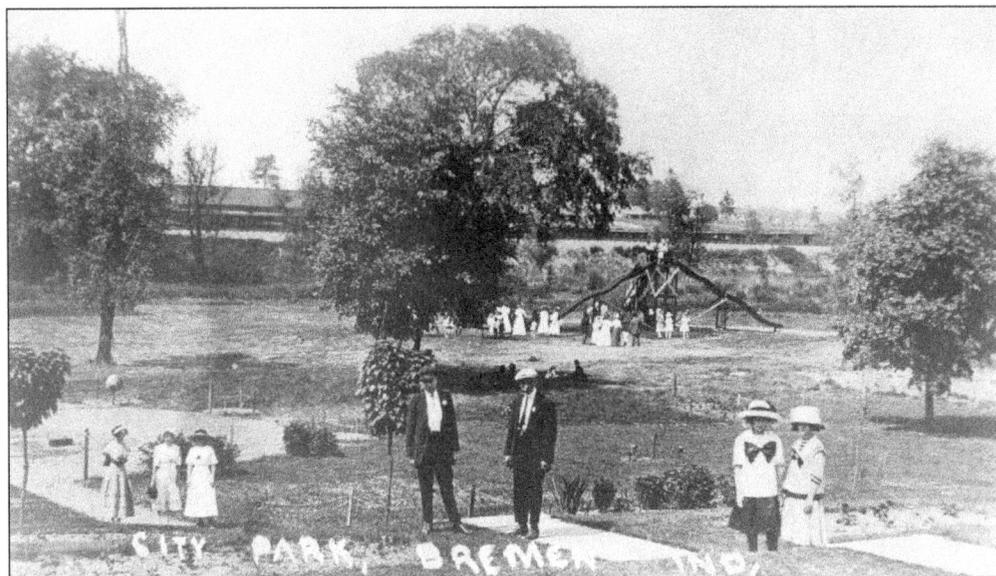

CITY PARK. What is now called Shadyside Park was just the city park back in the 1920s. The park is located on the 100 block of Dewey Street looking northeast. The park is next to the Yellow River and the B&O Railroad. This photo is before they built the pavilion that is currently there. (Courtesy of Don Schneider, Don's Barber Shop.)

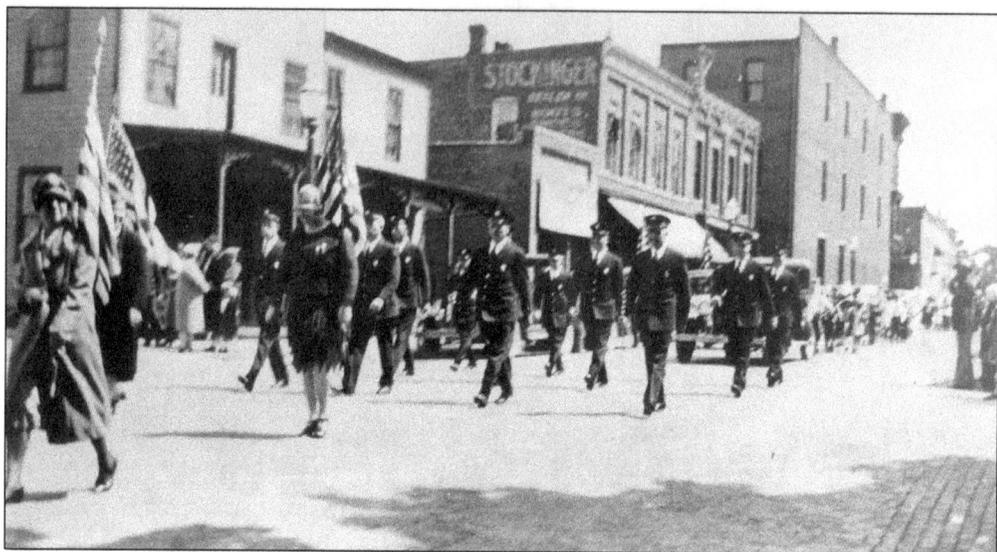

MEMORIAL DAY PARADE. Sometime in the 1920s, this Memorial Day parade took place at the 200 block of N. Center Street looking south. (Courtesy of Don Schneider, Don's Barber Shop.)

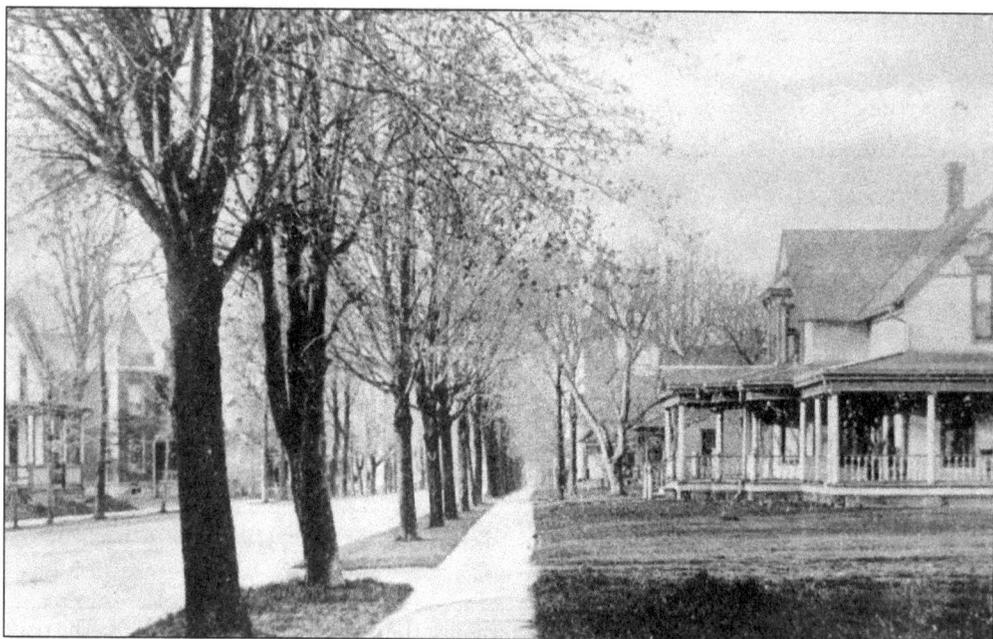

THE 200 BLOCK OF SOUTH CENTER STREET LOOKING SOUTH. This beautiful view of Bremen's tree-lined streets was photographed on April 24, 1921. (Courtesy of Don Schneider, Don's Barber Shop.)

56

THE BREMEN WATER TOWER, WHICH STILL STANDS ON SOUTH JACKSON STREET. This photo was taken between 1920–1922. This tower was used from 1892 to 1955. It was dedicated on August 10, 1975, and designated an American Water Landmark by the American Water Works Association. The plaque on the tower shows the Trustee's as J.P. Gass, J.J. Ringle, I.F. Wine, and William May. It shows the clerk as T.F. Knoblock, and the contractor as James Madden. (Courtesy of Don Schneider, Don's Barber Shop.)

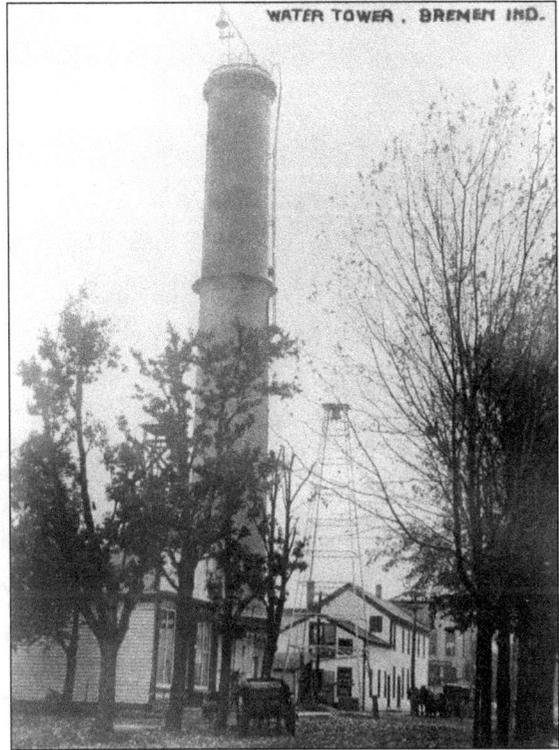

WATER TOWER, BREMEN IND.

WORK OF ART PAINTED BY MRS. BOWSER. It is a picture of the southwest corner of Dewey and Washington Streets. It is unknown when this was painted. (Courtesy of Don Schneider, Don's Barber Shop.)

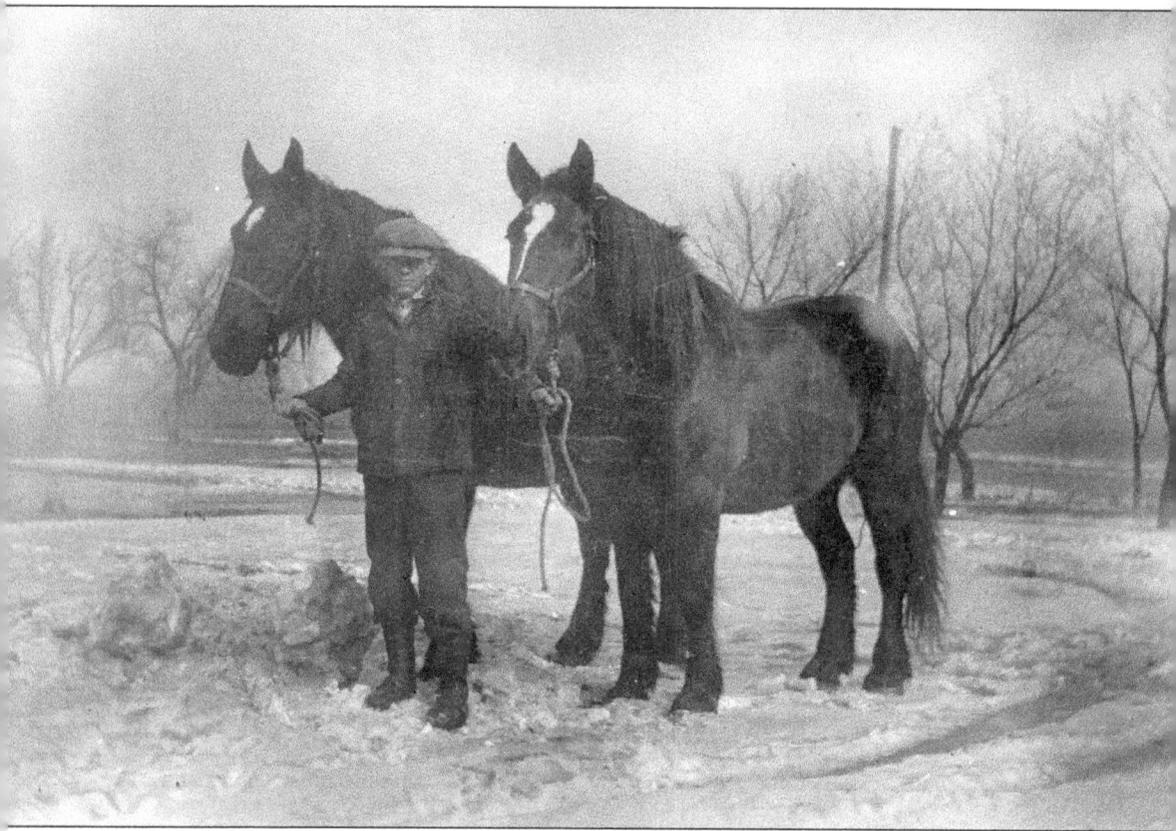

SOUTH OF BREMEN, 1924. Lester Kuhn gets ready to hitch up his father's work horses. His parents were Adam and Irena (Hepler) Kuhn. (Courtesy of Lester & Nellie Kuhn.)

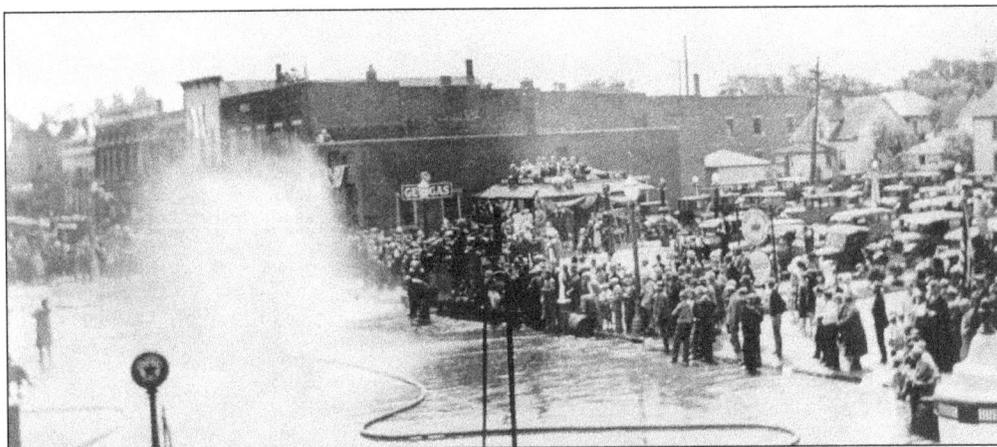

A WATERBALL COMPETITION, OR HOSE TOURNAMENT AS THEY CALLED IT BACK IN THE 1920s.
This competition took place on the 200 block of West Plymouth Street looking southeast.
(Courtesy of Don Schneider, Don's Barber Shop.)

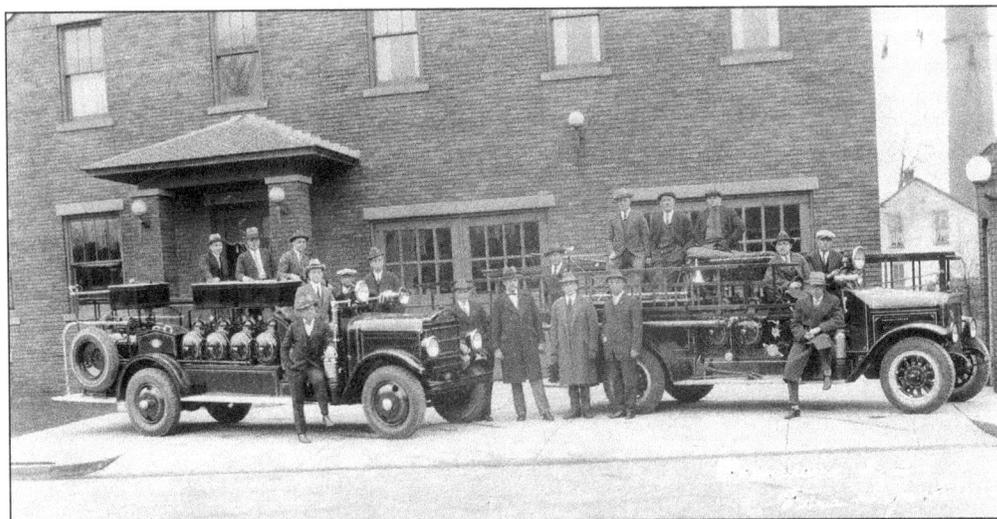

BREMEN FIRE DEPARTMENT STANDING IN FRONT OF WHAT USED TO BE BREMEN TOWN HALL.
The chemical truck is on the left and the ladder truck is on the right. This photo was taken
April 24, 1927. Pictured here are the following: (on chemical truck) F. Breunline, D. Walter, L.
Carothers, Chief E. Breunline, R. Molebash, E. Gass, and D. Ringle; (standing between trucks,
the Town Trustees) F. Annis—Clerk/Treasurer, members included: E. Foltz, E. Leeper, and J.
Brougher; (ladder truck) W. Wolfe, W. Edel, W. Kline, W. Edwards, H. Marburger, Assistant
Chief A. Knoepfle, and E. Redman. (Courtesy of Don Schneider, Don's Barber Shop.)

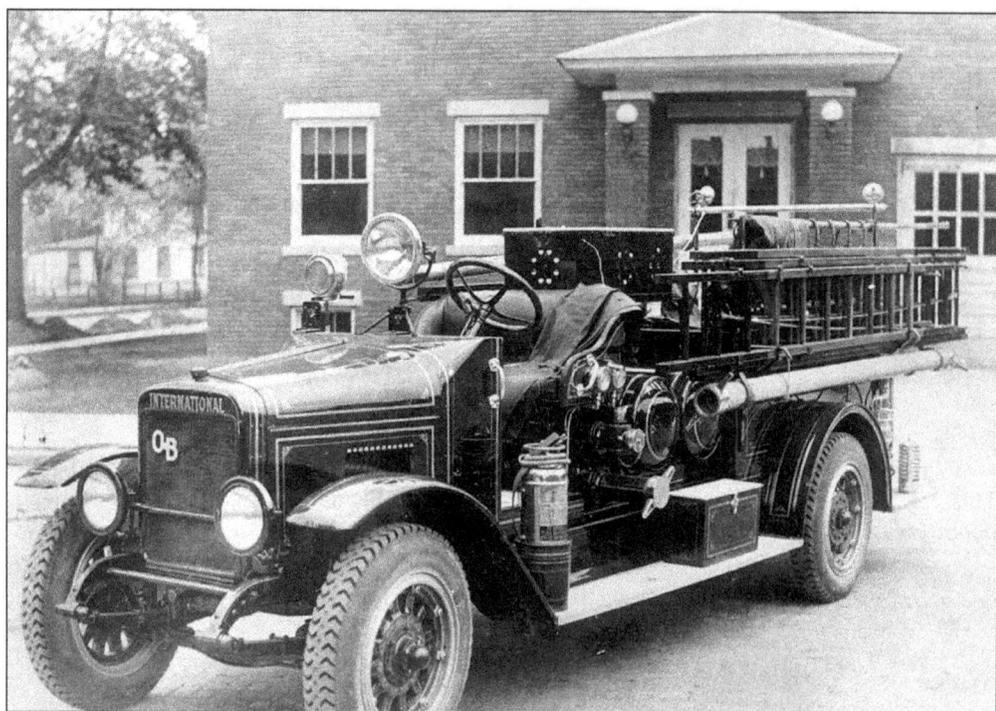

A New Fire Truck. Sometime between 1926 to 1928, this fire truck was brand new. In this photo it sits in front of the old town hall on the 100 block of South Center Street on the west side. (Courtesy of Don Schneider, Don's Barber Shop.)

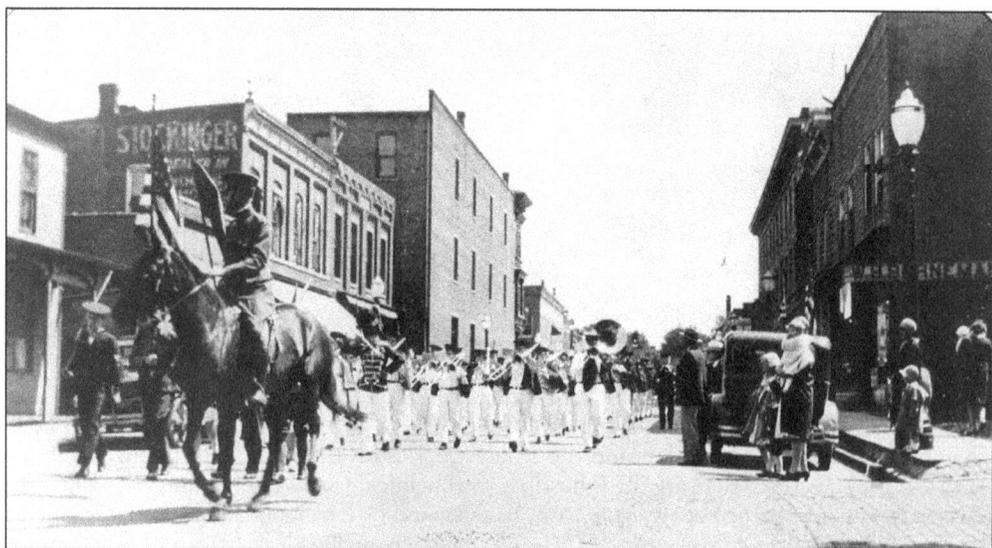

A Memorial Day Parade Sometime Between 1928–1932 on the 200 Block of North Center Street Looking South. (Courtesy of Don Schneider, Don's Barber Shop.)

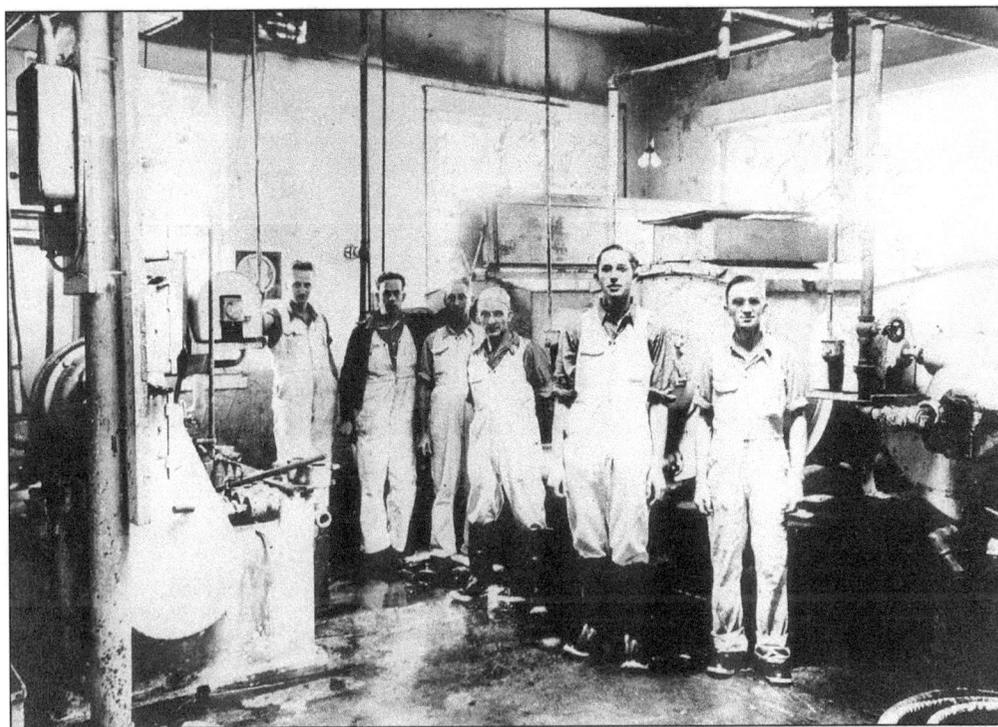

THE SCHLOSSER BROTHERS CREAMERY ON THE CORNER OF CENTER AND SOUTH STREETS SOMETIME IN THE LATE-'20S OR EARLY-'30S. The first four men pictured here are unknown, the two men on the right are (left to right) Dud Peterson's older brother, his actual name in unknown, and Roscow Penrod. (Courtesy of Don Schneider, Don's Barber Shop.)

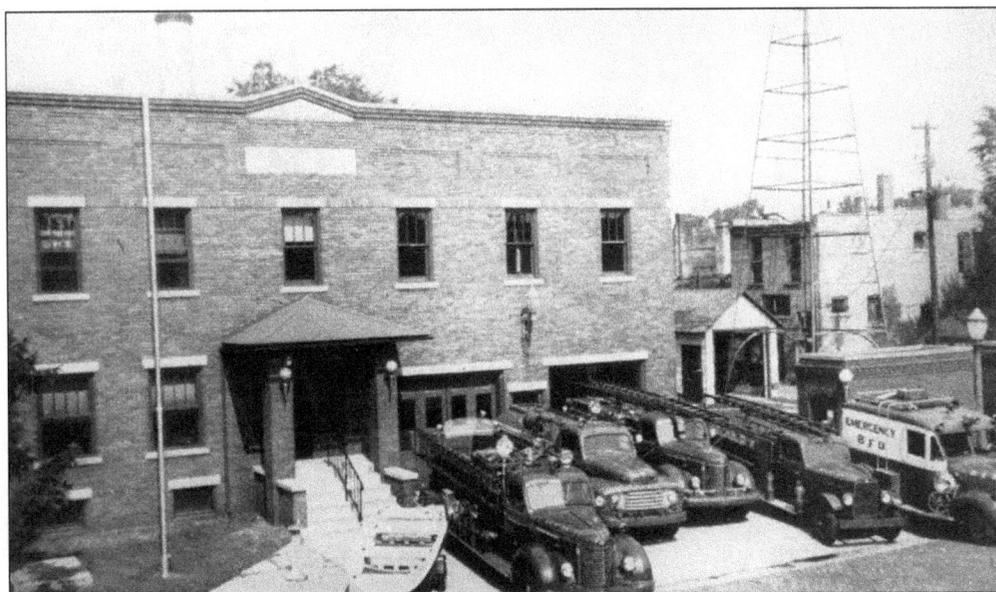

OLD TOWN HALL. The old town hall, which later became the Bremen Police Department in the late 1920s or early 1930s, is located at the 100 block of South Center Street on the west side. (Courtesy of Don Schneider, Don's Barber Shop.)

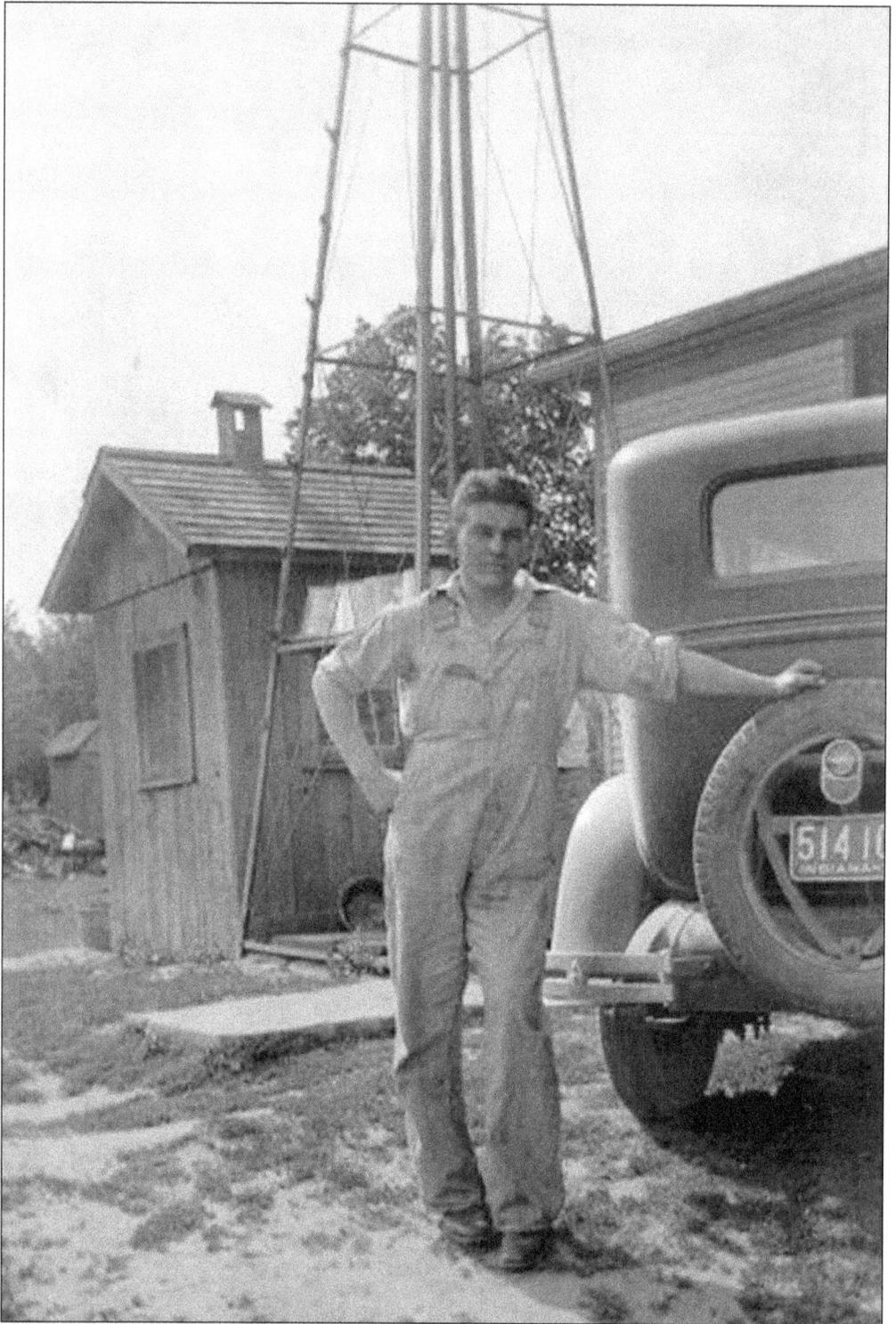

LESTER KUHN IN 1930 STANDING IN FRONT OF A MILKHOUSE AND WINDMILL. These were common sites on farms in those days. (Courtesy of Lester & Nellie Kuhn.)

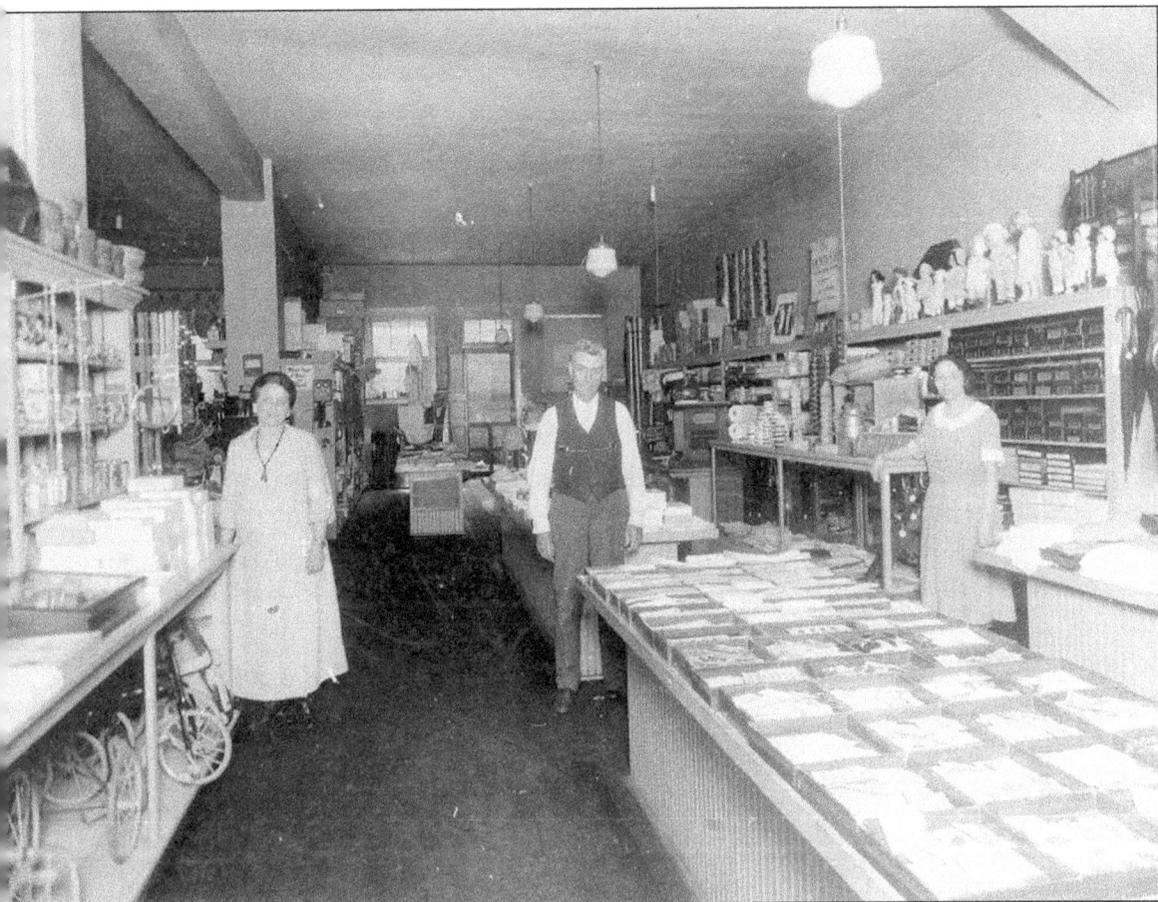

HEISTERS STORE. This photo taken in the 1930s at Heisters Store employed the author's great aunt, Laura Kuhn, before she married Milton Kern. Pictured here are: (left to right) Mrs. Ella Boss, Mr. C.M. Heister, and Laura Kuhn. (Courtesy of Lester & Nellie Kuhn.)

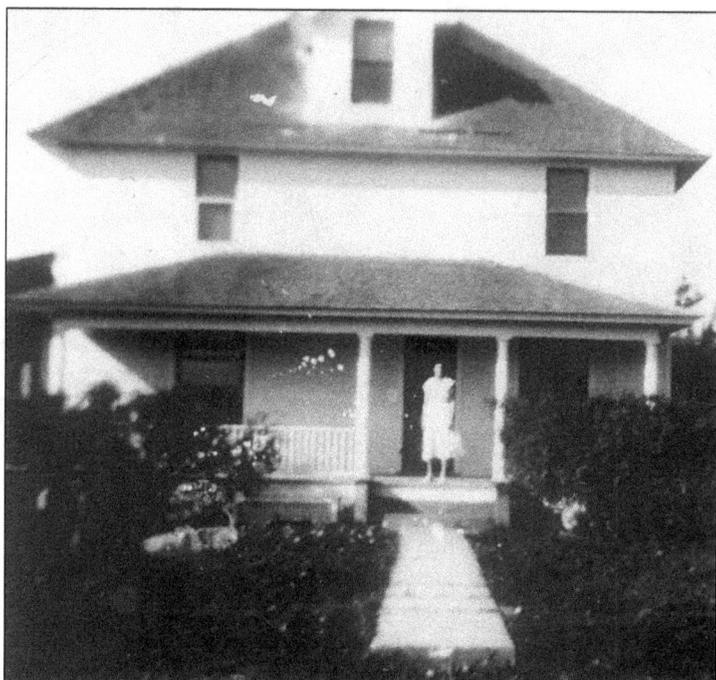

THE ELLIOTT FARM. Located 2 miles south of Bremen, the Elliott Farm was the home chosen by Clint and Mary Young, who moved from Circleville, Ohio. The house was not ready when they moved their family here so they lived in another house not far away for about three months until this one was ready. This photo was taken in 1932 and shows Nellie Young-Kuhn standing on the front porch. (Courtesy of Lester & Nellie Kuhn.)

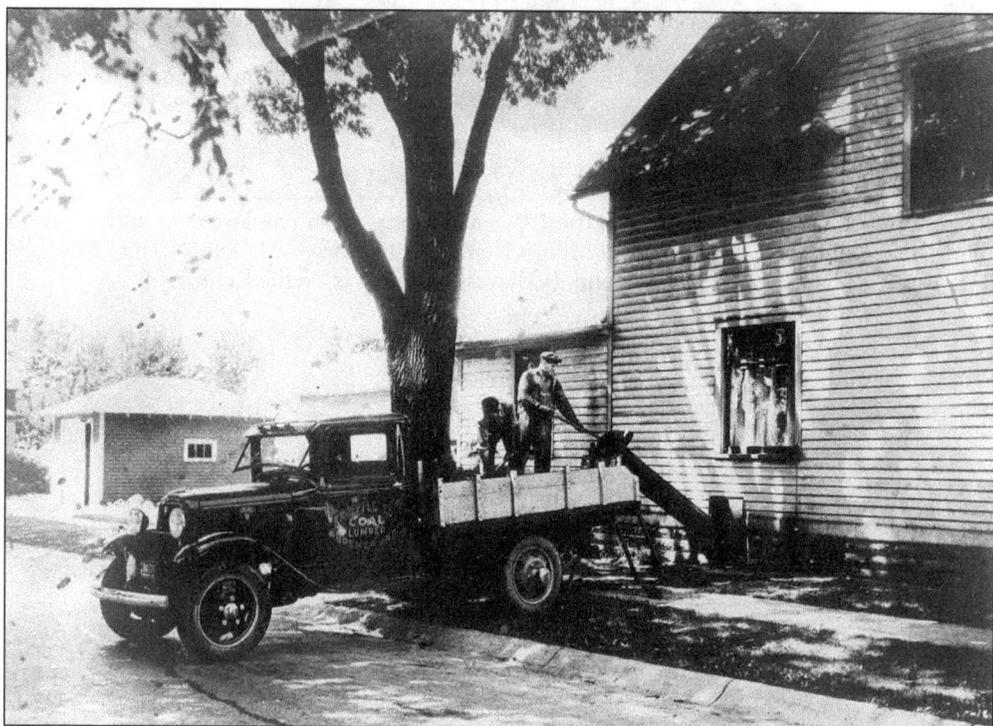

ST. PAUL'S LUTHERAN CHURCH OLD PARSONAGE. This photo was probably taken between 1932–1933. The house was located on the 200 block of South Washington and East South Streets looking southwest. Knoepple Coal and Lumber was delivering coal through the coal shoot on the house. (Courtesy of Don Schneider, Don's Barber Shop.)

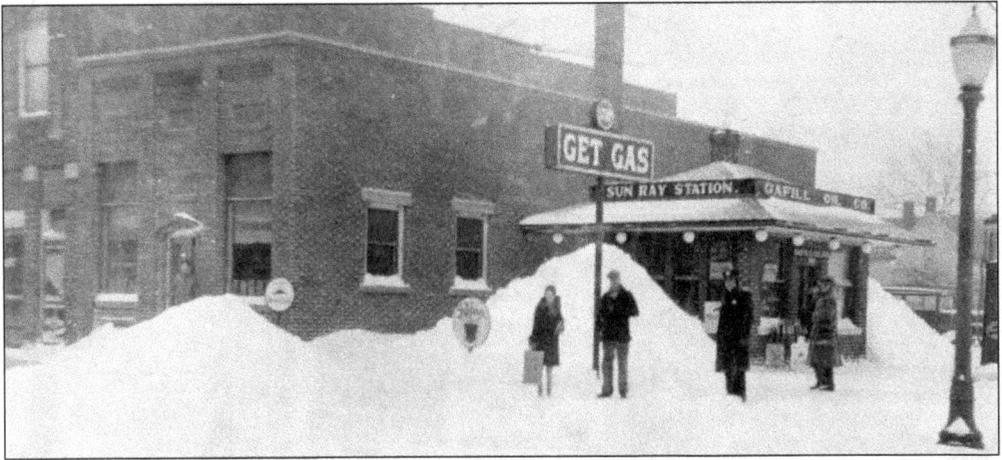

The Sun Ray Station located at W. Plymouth and S. Jackson Streets looking southeast. This photo was taken sometime in the 1930s. (Courtesy of Don Schneider, Don's Barber Shop.)

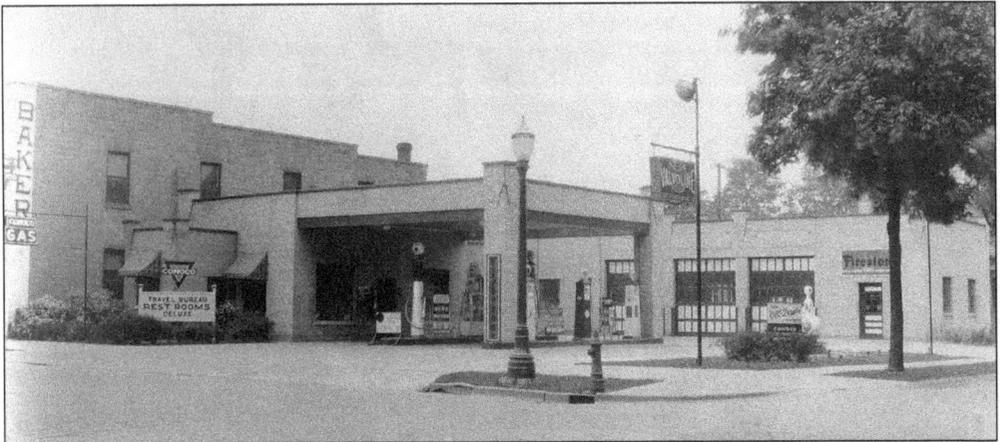

The Ideal Oil Company was owned by Oscar Moody. This photo was taken sometime between 1934–36. Bill Helmlinger worked here during 1935–39. He made extra money while going to High School at Bremen washing cars, filling gas tanks, and various other duties. The station was located on the northeast corner of Plymouth and Washington Streets. (Courtesy of Don Schneider, Don's Barber Shop.)

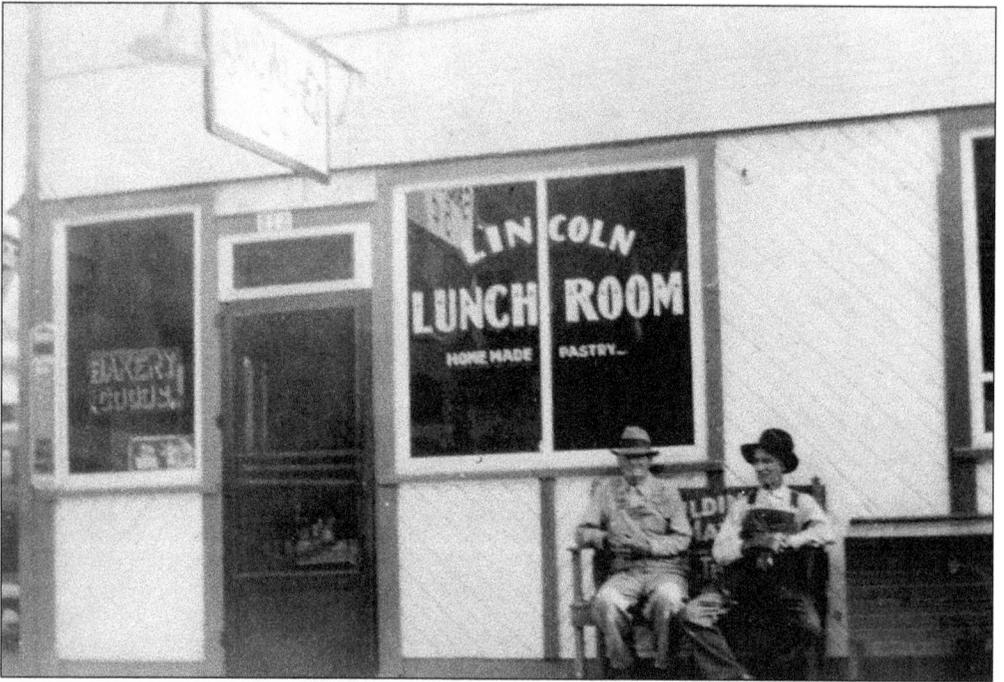

LINCOLN LUNCHROOM. The Lincoln Lunchroom was a popular place to meet for lunch in 1934. (Courtesy of Don Schneider, Don's Barber Shop.)

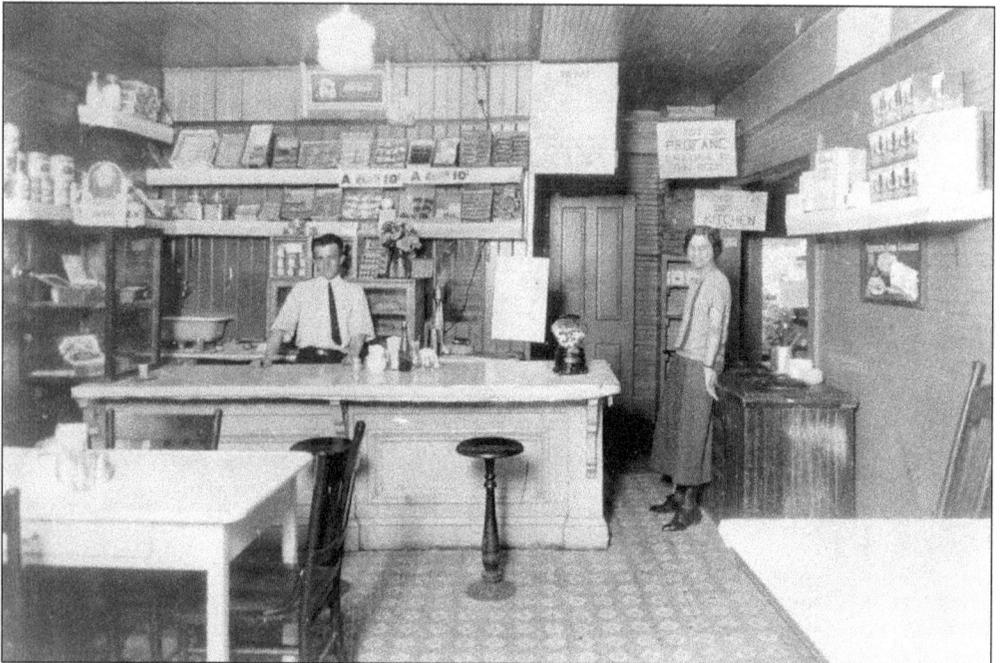

INSIDE THE LINCOLN LUNCHROOM 1934. The restaurant was located at the 200 block of West Plymouth Street (south side). (Courtesy of Don Schneider, Don's Barber Shop.)

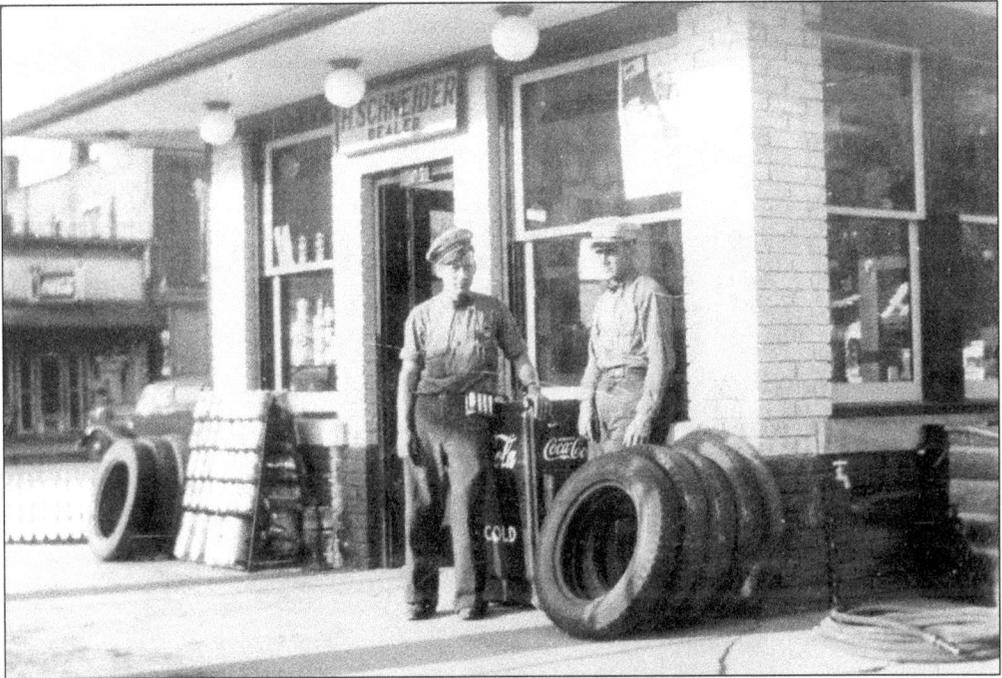

SCHNEIDER'S GAS STATION IN MAY OF 1937. Pictured here is Charles Neher on the left, and Harvey Schneider on the right. (Courtesy of Don Schneider, Don's Barber Shop.)

BILLY WALTER'S MEAT MARKET ON THE 100 BLOCK OF WEST PLYMOUTH STREET. This photo was taken sometime between 1937 to 1940. (Courtesy of Don Schneider, Don's Barber Shop.)

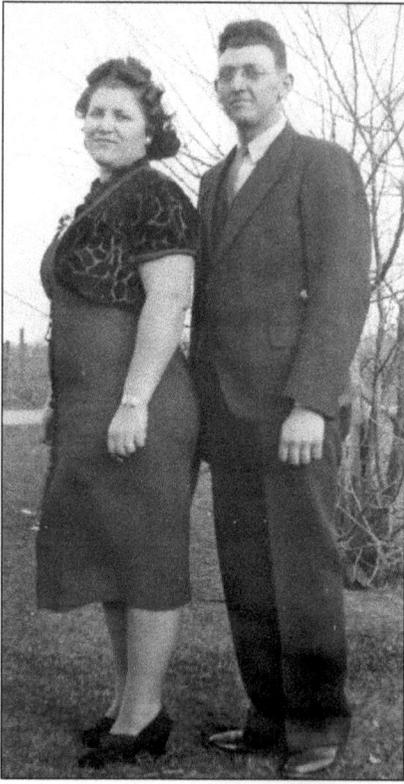

THEODORE AND LAVON YOUNG, C. 1938. The evening of their wedding day, they went to Theodore's sister's, Nellie Kuhn, house to do their chores while Lester and Nellie were out of town visiting family in Circleville, Ohio. While they were gone, the hogs got loose so Theodore got his grandparents to come over and help them put the animals back in their pens. Lavon fixed Theodore "fried taters and eggs" for their honeymoon supper that night. (Courtesy of Lester & Nellie Kuhn.)

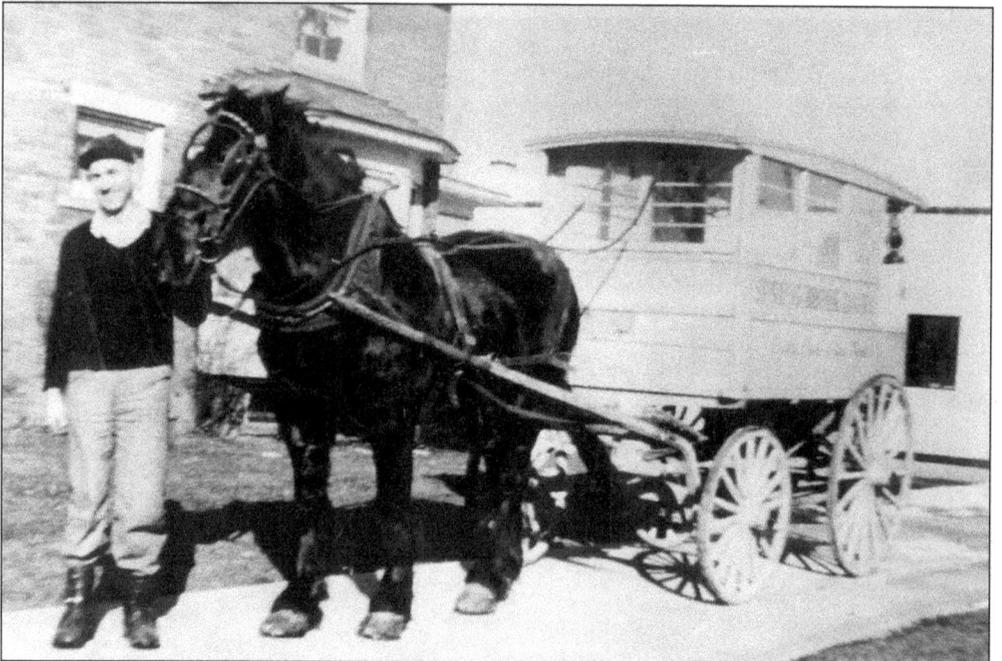

A 1939 PHOTOGRAPH OF RAY KIEFER WITH HIS SPRINGBROOK DAIRY MILK WAGON. The Springbrook Dairy was located on the 500 block of West Plymouth Street (north side). (Courtesy of Don Schneider, Don's Barber Shop.)

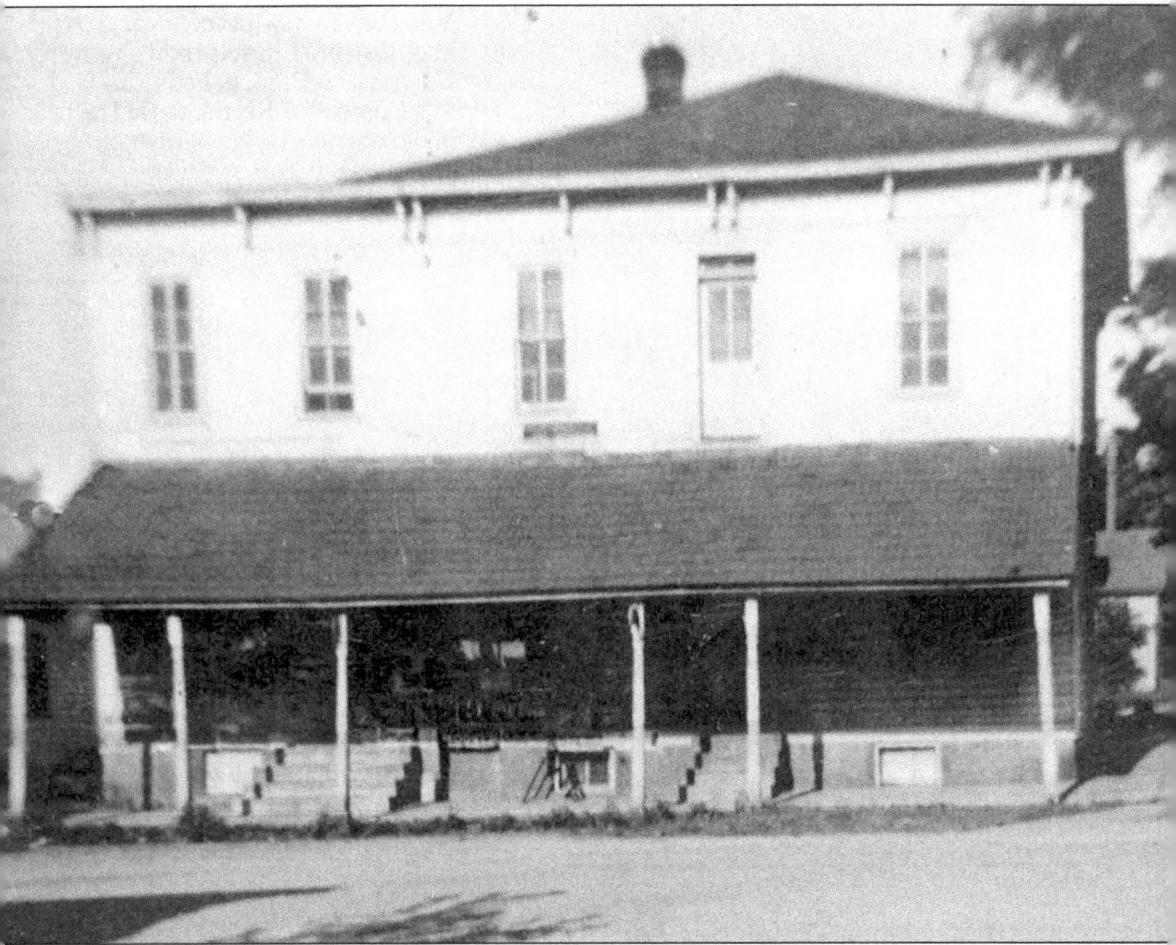

An Old Hotel. This building at 409 North Marshall Street was built as a hotel and stood on the northwest corner of Plymouth and North Center Streets. It was moved in 1909 to Marshall Street. It was used as a grocery store by John Beyler, and later by Bob Zentz. This photo was taken on July 16, 1939 by N. Bowser. (Courtesy of Don Schneider, Don's Barber Shop.)

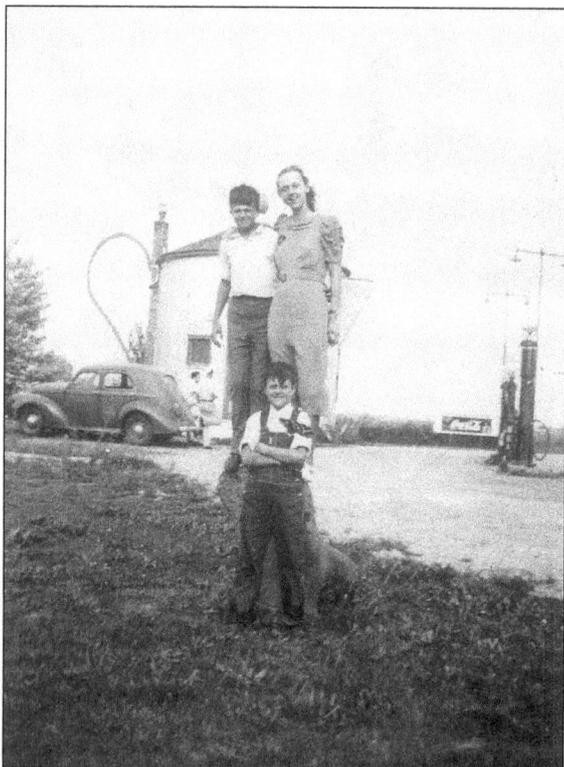

VIRGINIA YOUNG-JULIAN, AND HER VISITING COUSINS FROM CIRCLEVILLE, OHIO, IN FRONT OF THE COFFEE POT RESTAURANT. The photo was taken approximately 1935–1945. (Courtesy of Don Schneider, Don's Barber Shop.)

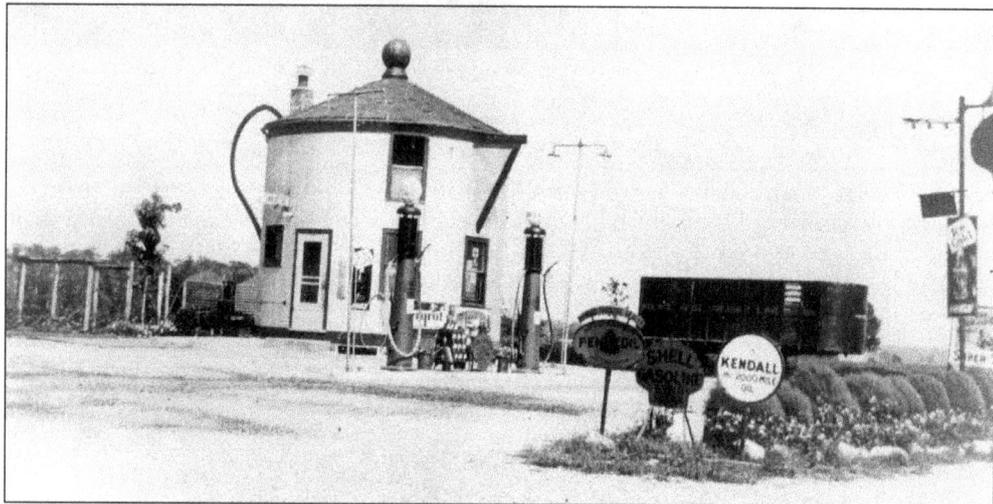

THE COFFEE POT RESTAURANT. The Coffee Pot Restaurant was a unique site located on U.S. 6 just east of Bremen. It was built in 1932 by Elmer Laudeman. It was originally an old wooden silo. Elmer modeled it after a smaller one pictured in *Popular Mechanics* magazine. The building was 18 feet in diameter, complete with a basement and upstairs. It featured a round counter in the center. Because it was located half way between Ohio and Illinois, it made it a popular stop for truckers passing through. In 1949 or 1950, an addition was built because of their need for additional seating. Later, it was no longer used and empty with many needed repairs so the state purchased it for land for the Bremen Bypass. The fence which borders the right of way on the bypass cuts through where the old coffee pot stood. (Courtesy of Don Schneider, Don's Barber Shop.)

Three

BREMEN
1940–2000

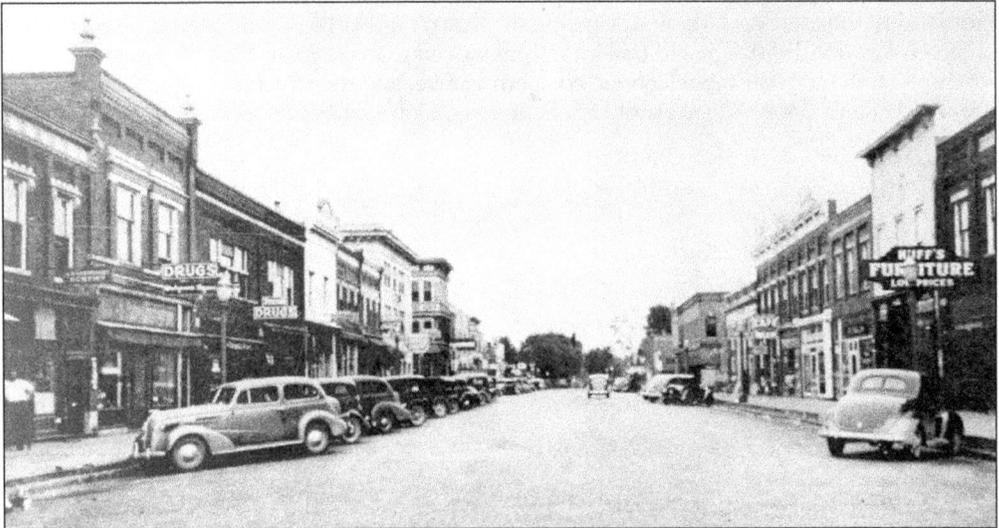

THE CORNER OF JACKSON AND PLYMOUTH STREETS LOOKING EAST BETWEEN 1937–1942.
(Courtesy of Don Schneider, Don's Barber Shop.)

NORTHEAST CORNER OF NORTH CENTER AND NORTH STREETS. Venus Bowser snapped this photo on April 9, 1940. The old buildings were moved to make room for a filling station. The structure on the left was the telephone company garage, and the structure on the right was the Lee Ringle Paint Shop. (Courtesy of Don Schneider, Don's Barber Shop.)

CONGREGATIONAL CHURCH LOCATED ON THE SOUTHEAST CORNER OF NORTH AND JACKSON STREETS. When photographed on April 9, 1940, it was a fundamental United Brethren Church. Venus Bowser believed this to be the oldest church in Bremen at that time. (Courtesy of Don Schneider, Don's Barber Shop.)

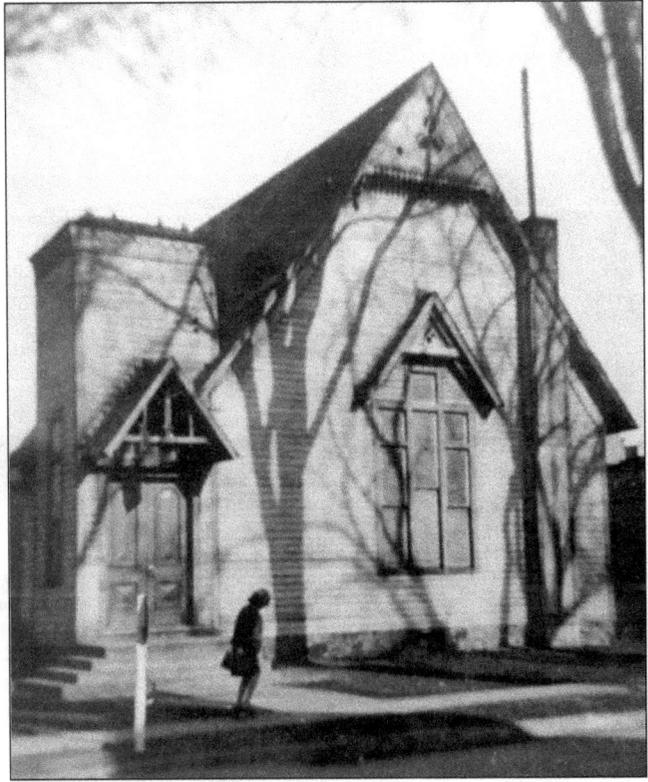

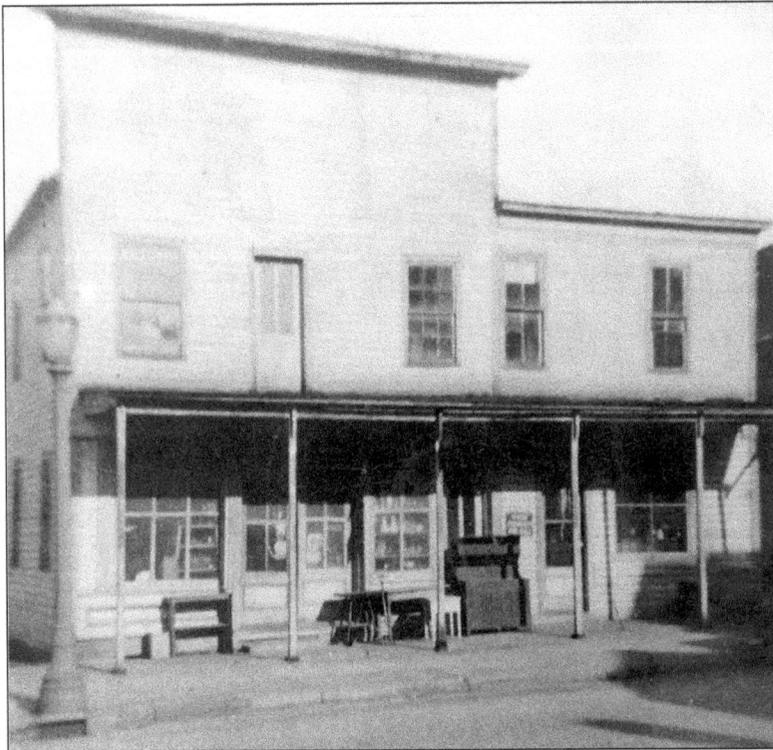

A SECOND-HAND STORE, 1940. Originally the establishment was the Garver Hotel located on the southeast corner of North Center Street and North Street. This photo was taken by Venus Bowser on April 9, 1940. (Courtesy of Don Schneider, Don's Barber Shop.)

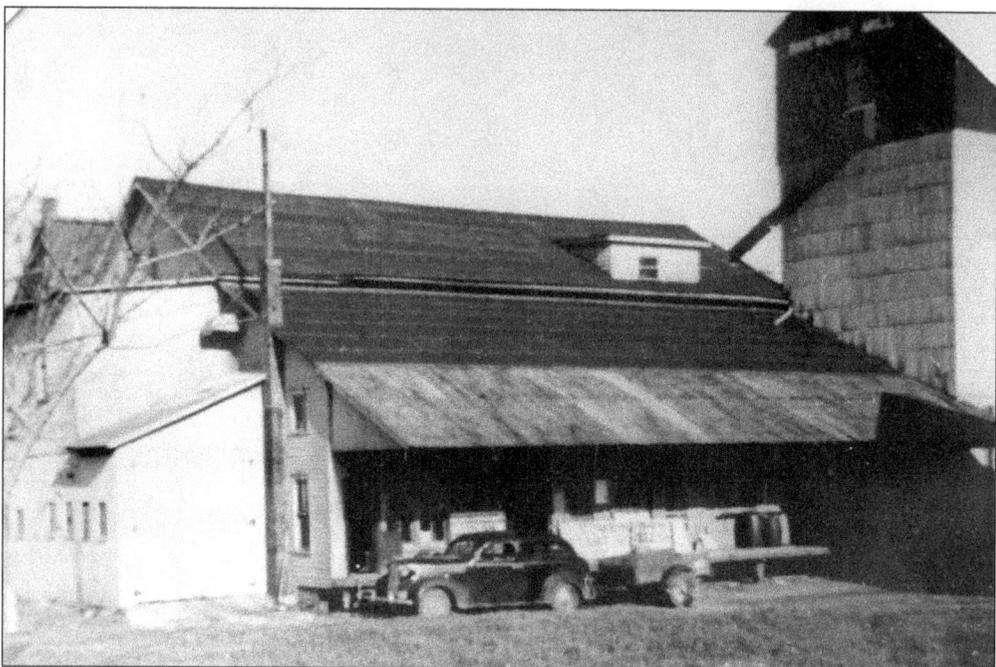

BREWER'S MILL. Located on the northeast corner of Dewey and Washington Streets, Brewer's Mill was photographed here in 1940. (Courtesy of Don Schneider, Don's Barber Shop.)

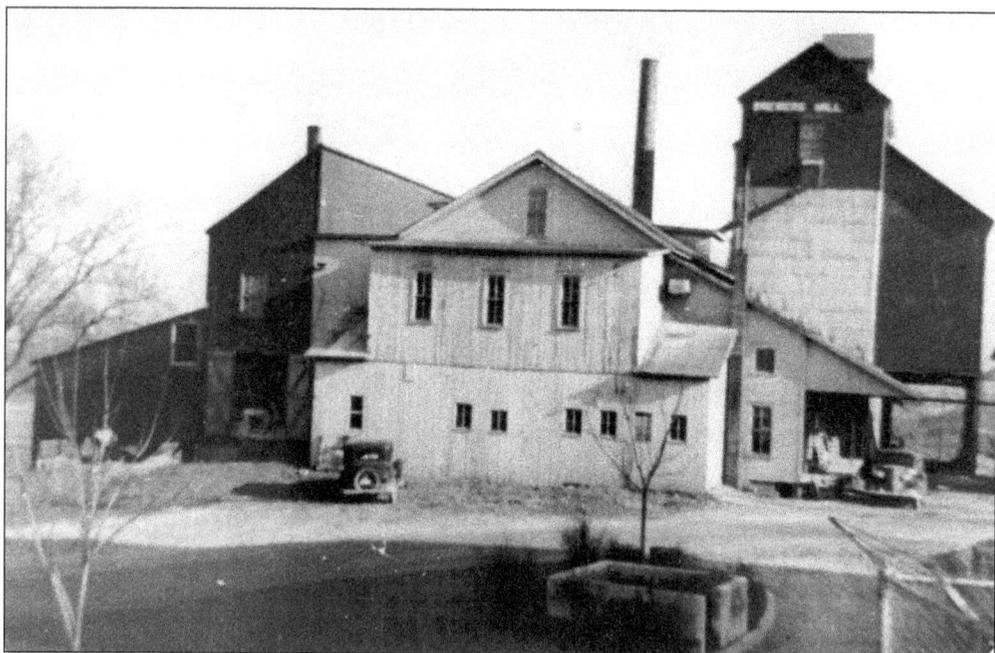

BREWER'S MILL IN 1940. This provides a different view of the structure. This flour mill was the first in Bremen. It was built in 1857 by Christian Schilt and Samuel Schmachtenberger. (Courtesy of Don Schneider, Don's Barber Shop.)

74

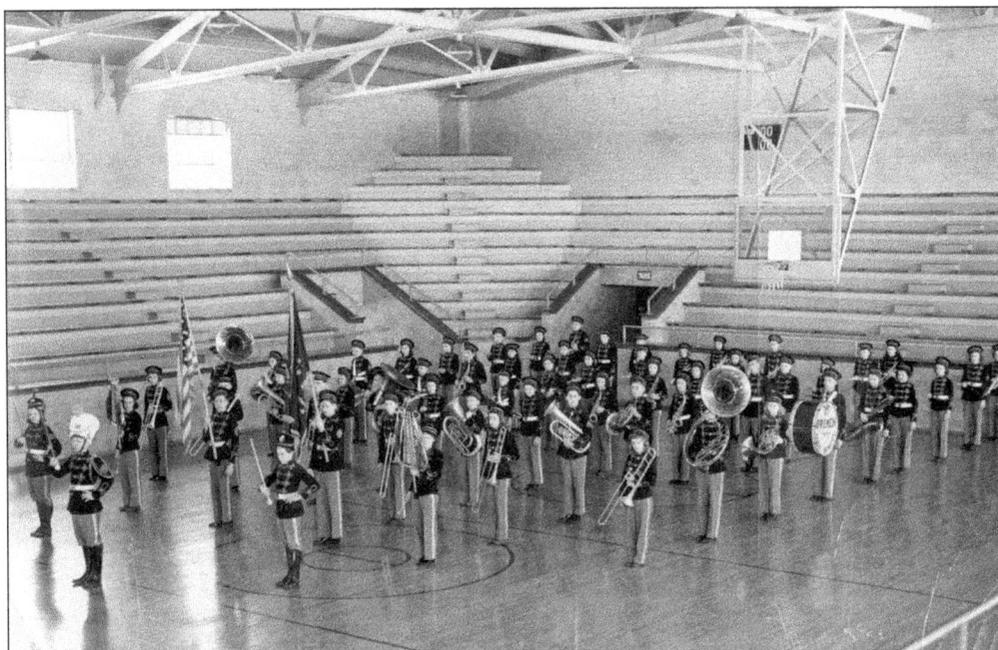

THE BREMEN BAND. This photo was taken in the early 1940s during a marching band dress rehearsal. (Courtesy of Don Schneider, Don's Barber Shop.)

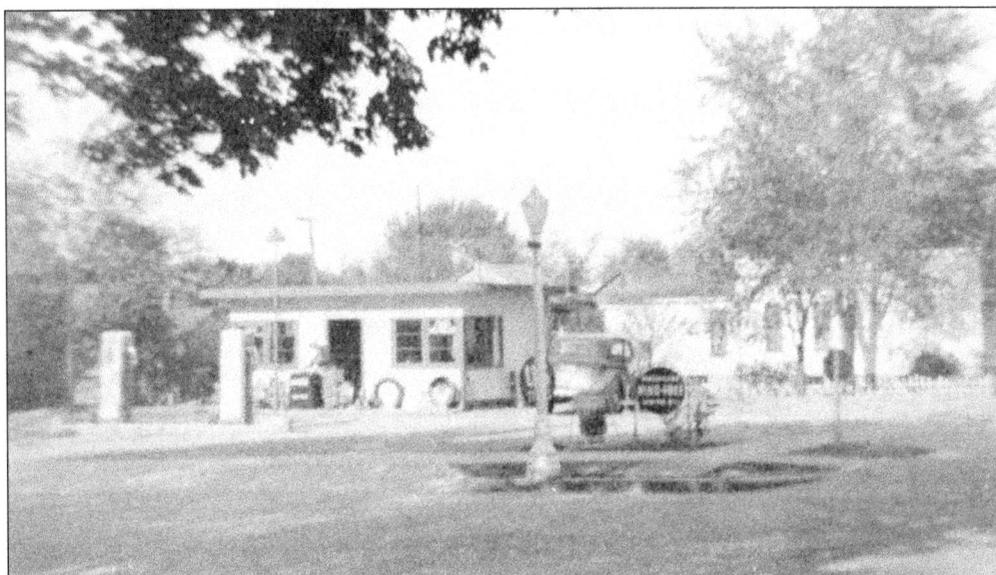

May 11, 1941, this photograph was shot by Venus Bowser of a gas station located on the northeast corner of Center and North Streets. The current location features the Legion Hall. (Courtesy of Don Schneider, Don's Barber Shop)

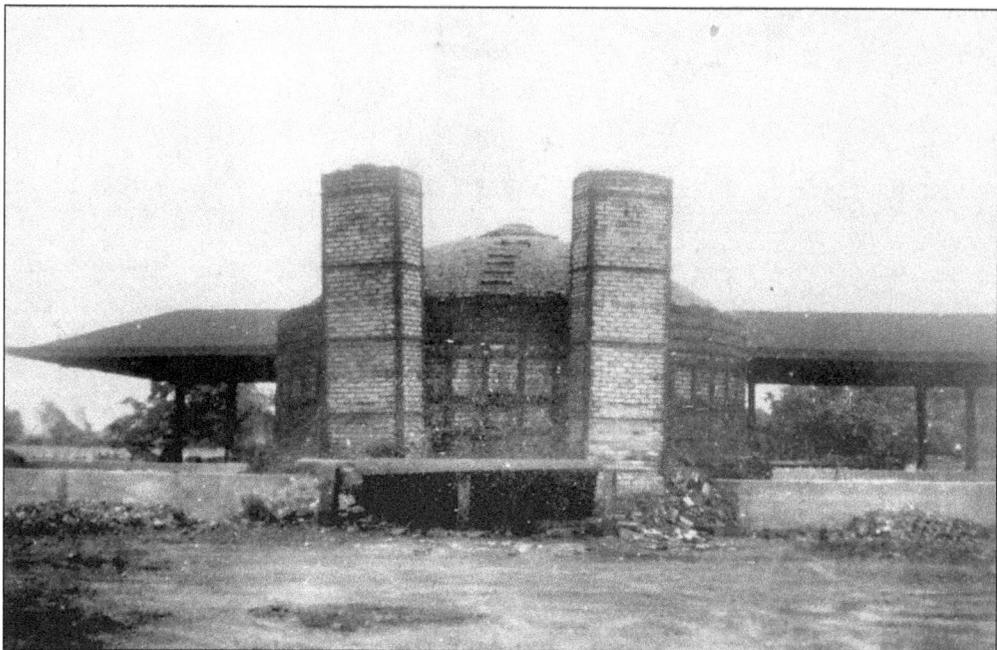

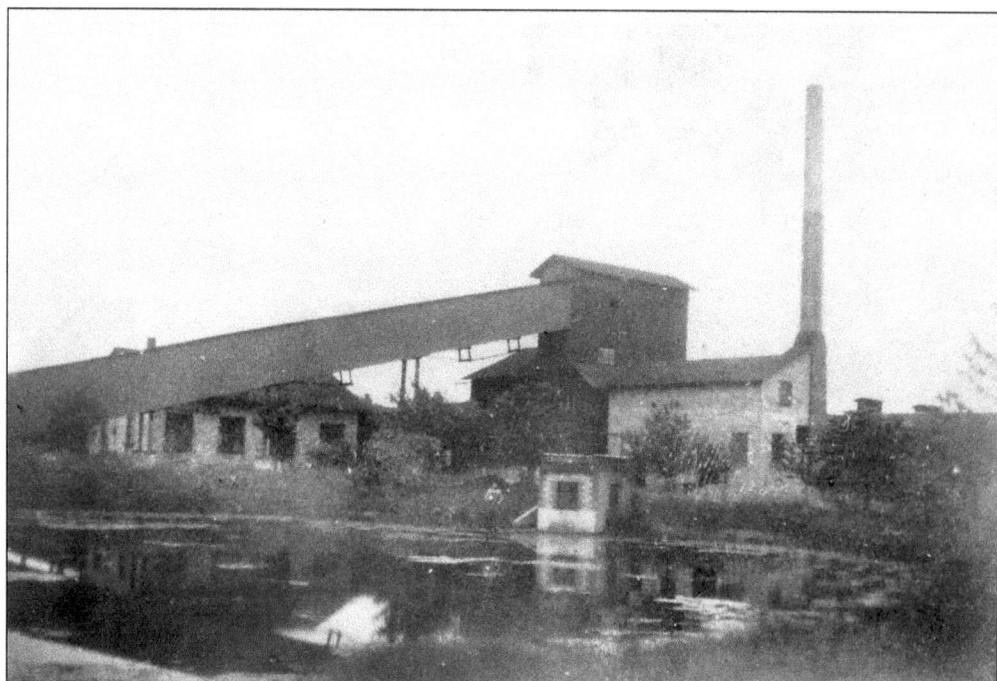

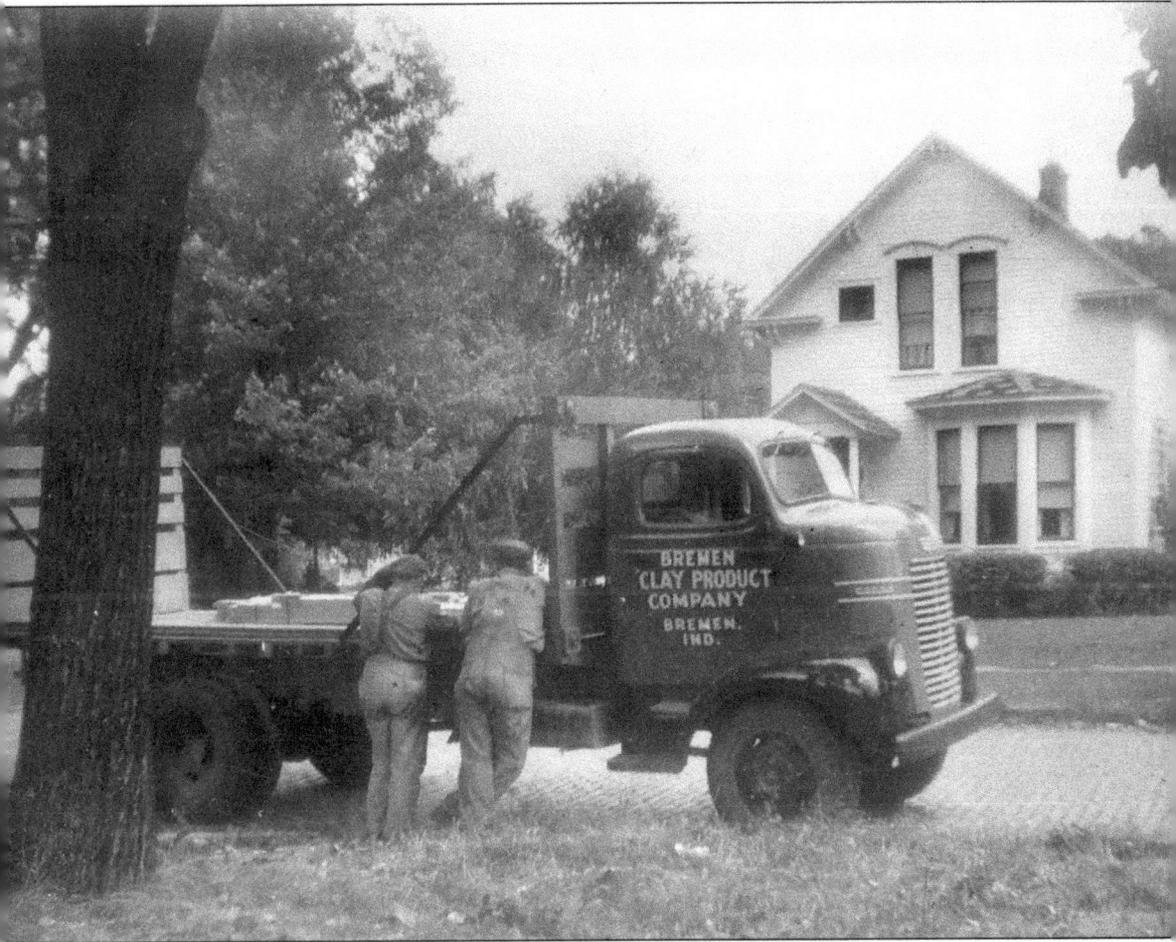

THE TILE MILL. The Bremen Clay Product Company was also known as the Tile Mill. Theodore Young worked for years at the Tile Mill loading and unloading tile. The top photo (previous page) shows Theodore and his father, Clinton Young, resting a bit after unloading some tile. The other two photos show the mill as it stood in 1944. (Courtesy of Lester & Nellie Kuhn.)

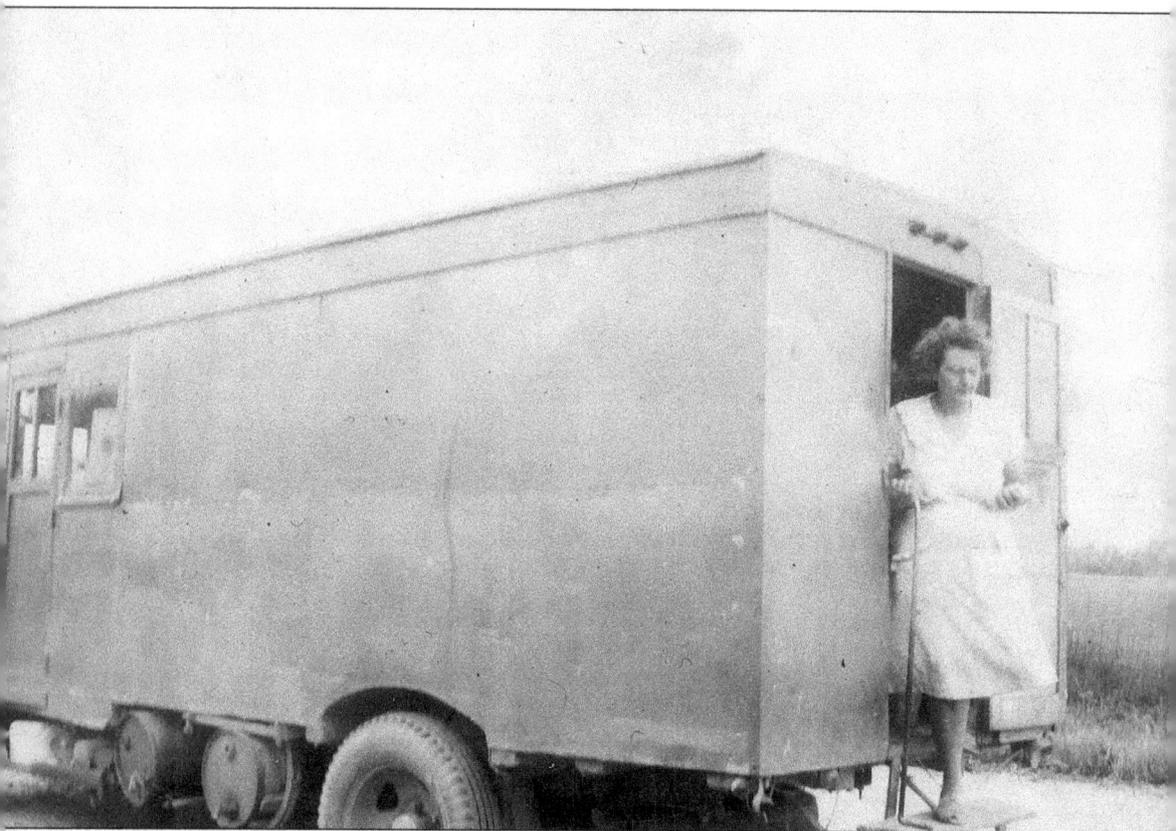

NELLIE KUHN LEAVING THE HUCKSTER. This was a mobile convenience store. The store would load up groceries and supplies in Linkville and deliver them to farmers every Friday. One week's worth of groceries and supplies usually cost the Kuhn's about $20 to $25 a week. The Huckster was owned by the Eckert Brothers Store. Elmer Eckert drove the truck and George Eckert waited on the customers. Every inch of space in the truck was utilized leaving only a small walkway for customers to view the items. The Eckerts carried bolts of yard goods, shoelaces, thread, and other sewing notions. There were staples in the grocery line, such as oatmeal, which was the standard breakfast item in those days. Flour, sugar, and other baking supplies could be purchased on this truck. Some items were secured on trays, hinged at the bottom and hooked at the ceiling, and drawers that could be opened to display the penny candy. This photo was taken in 1945. (Courtesy of Lester & Nellie Kuhn.)

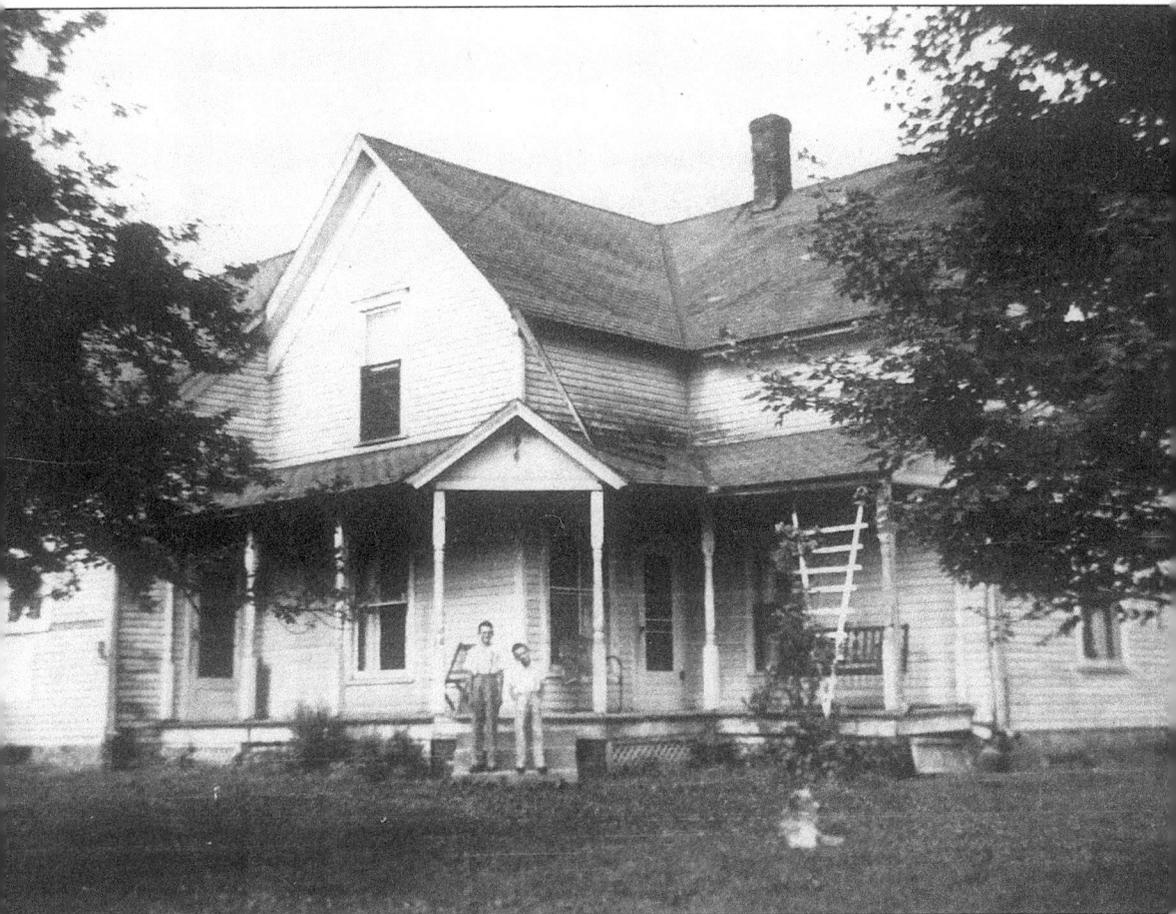

FAMILY FARM. The Lester and Nellie (Young) Kuhn farm was purchased in 1945. This photo was taken in 1946. Many improvements have been made to this home and it still stands in the same location on Shively Road in Bremen, Indiana. The author grew up in this house with her grandparents, Lester & Nellie Kuhn. (Courtesy of Lester & Nellie Kuhn.)

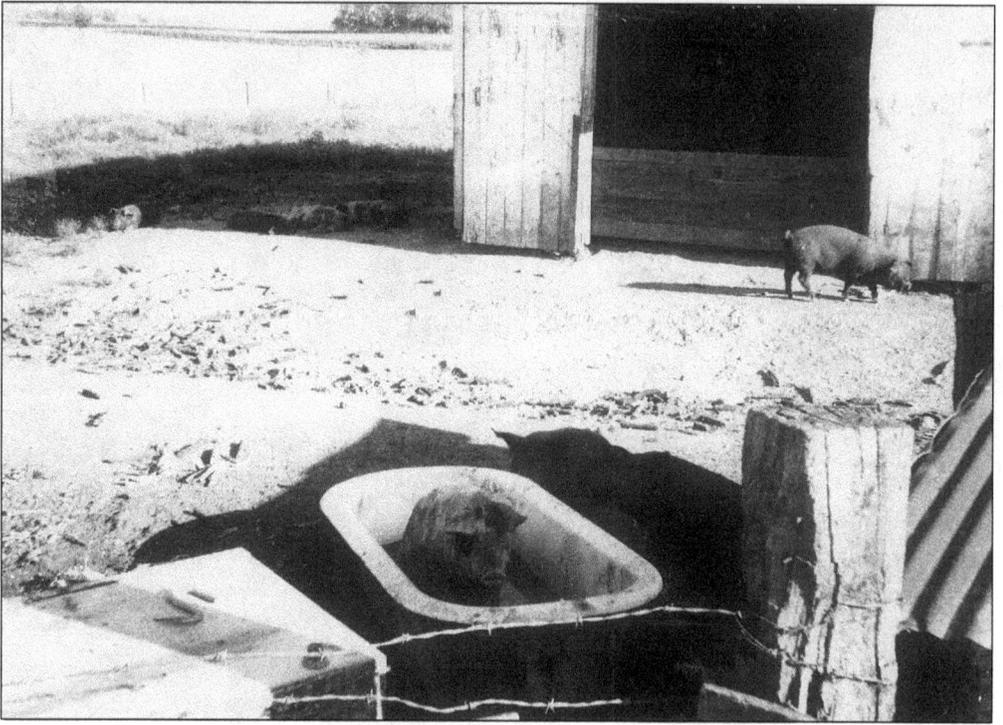

CLEAN SWINE. The hogs at the Lester and Nellie Kuhn farm always enjoyed bathing! These two photos from the 1950s show how they got into the tub and then soaked. Who said pigs were dirty animals? (Courtesy of Lester & Nellie Kuhn.)

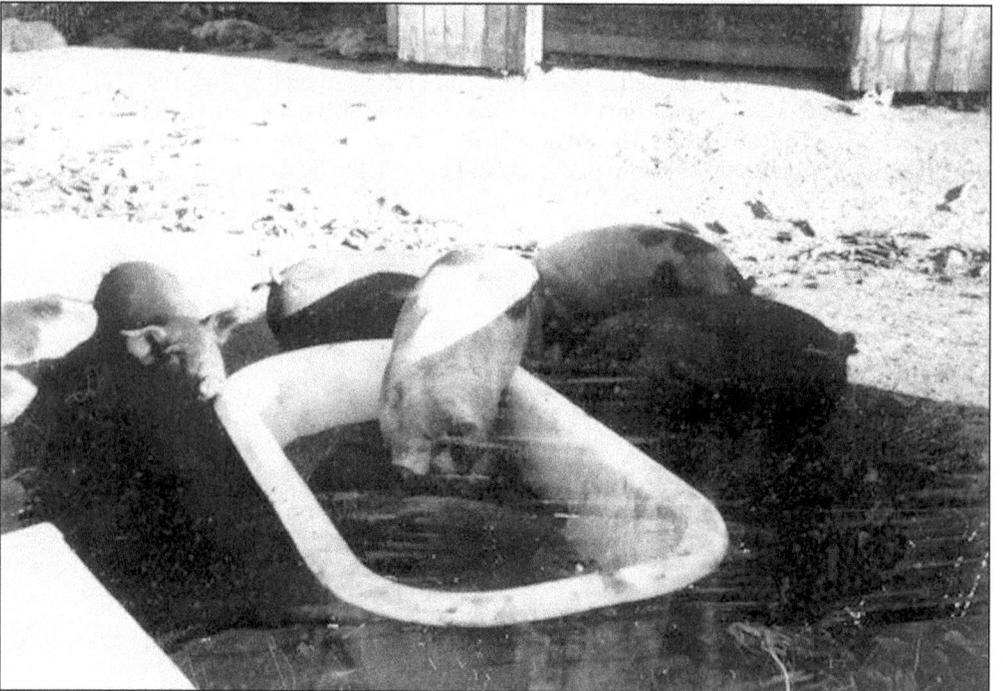

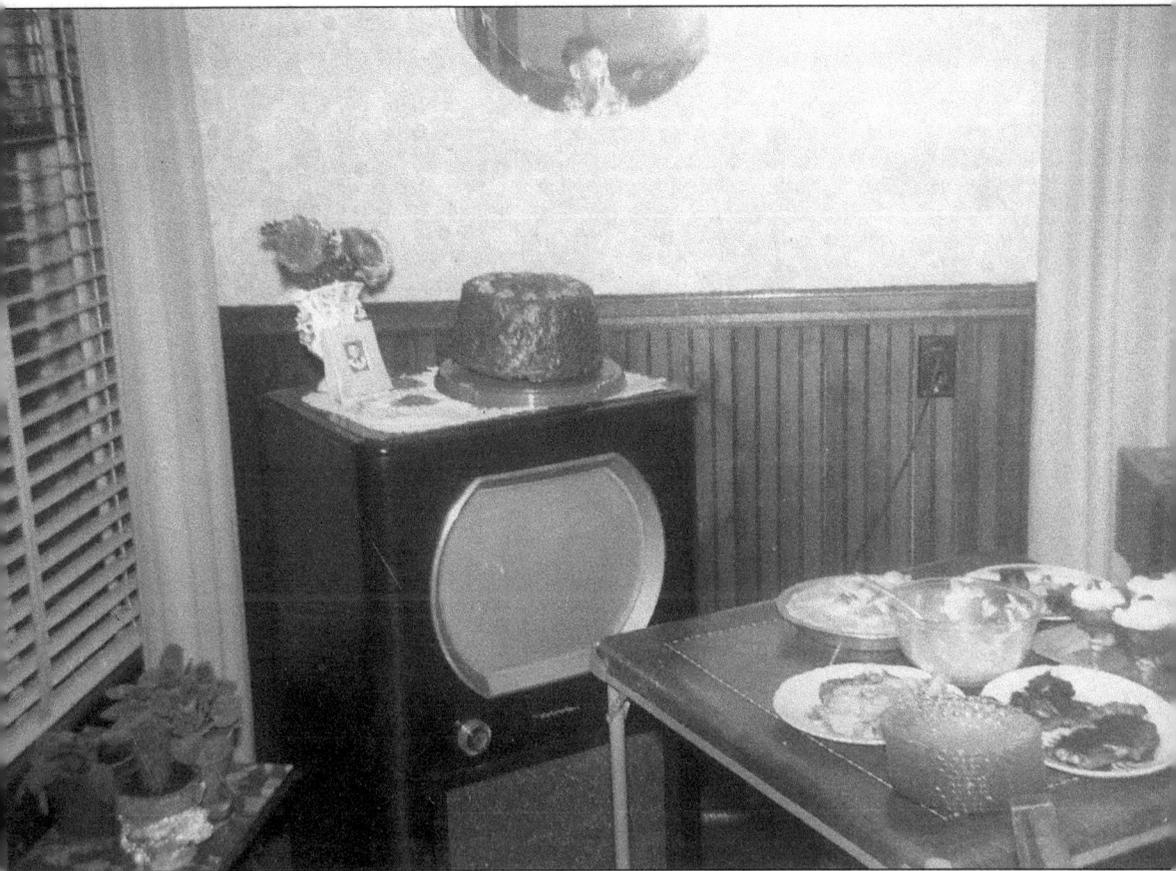

FIRST TV ON THE BLOCK. The Lester Kuhn family on Shively Road in Bremen was the first family to own a new 16-inch black and white television set in the neighborhood. People came from miles around to view this new amazing product. The only stations available then were Chicago stations that could only be seen by the use of an antenna. This was a very expensive form of entertainment at around $600 in 1950. (Courtesy of Lester & Nellie Kuhn.)

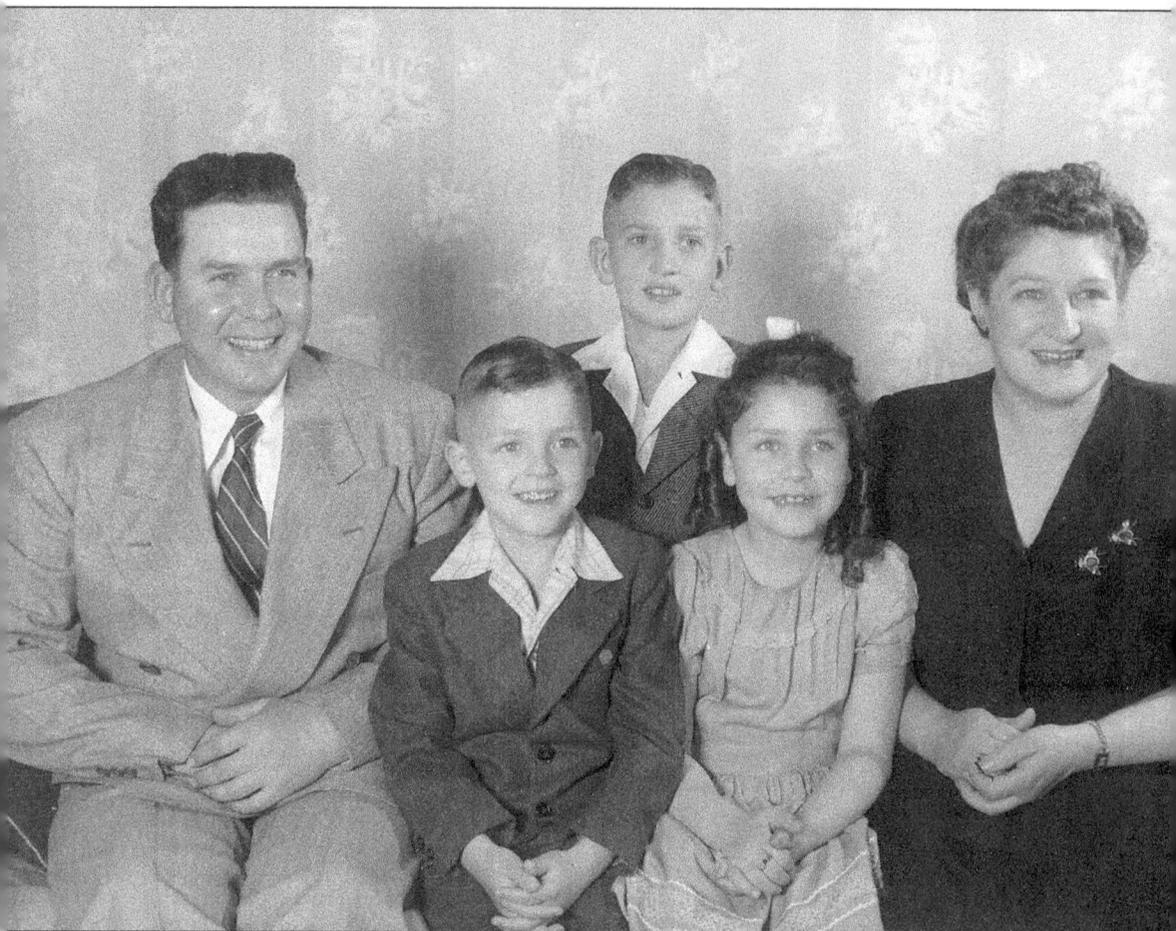

THE BEUFORD AND OLIVE ROWE FAMILY. The 1930s did not allow for a lot of choices in entertainment. The family enjoyed going to Bremen on Thursday nights for Band Concert Night. A performance was held on an outdoor platform where the current town hall stands, the former site of the Bremen State Bank. Another form of entertainment became available in the early 1930s, when the family was able to get their hands on a radio. They enjoyed shows like *Stella Dallas*, *Lulu*, and *Bell & Scotty* on WLS out of Chicago. During the winter, the family would, on occasion, have parties which usually included sleigh rides. In 1934, Olive married Beuford Rowe. They moved to Ann Arbor, Michigan, where Beuford was the manager of an A & P Store.

In 1937, Milt and Ethel Young persuaded Olive and Beuford Rowe to move from Ann Arbor to the farm in Bremen, Indiana. When Milt and Beuford first started farming together, the farm was in poor financial shape. The Great Depression had taken a heavy toll, there were lots of creditors. In order to supplement the family income, several important moves were made. First was acquiring an additional 44 acres on the Stein farm. Second was acquiring a semi tractor and then building a trailer to pull behind it. They were able to start a business hauling corn to Michigan and hauling fence posts back to Indiana. They also used the semi for a fertilizer business. Little by little the debts became smaller.

In the early 1940s, a basement was dug underneath the house using dynamite. Ethel didn't appreciate the use of dynamite, and just before each explosion she would pick up the cat and get away from the house. After the basement was complete, the old pot belly stove that sat in the living room was replaced with a coal furnace that could heat the whole house. (Courtesy of Lester & Nellie Kuhn. Historical recollection compiled by Curtis Rowe.)

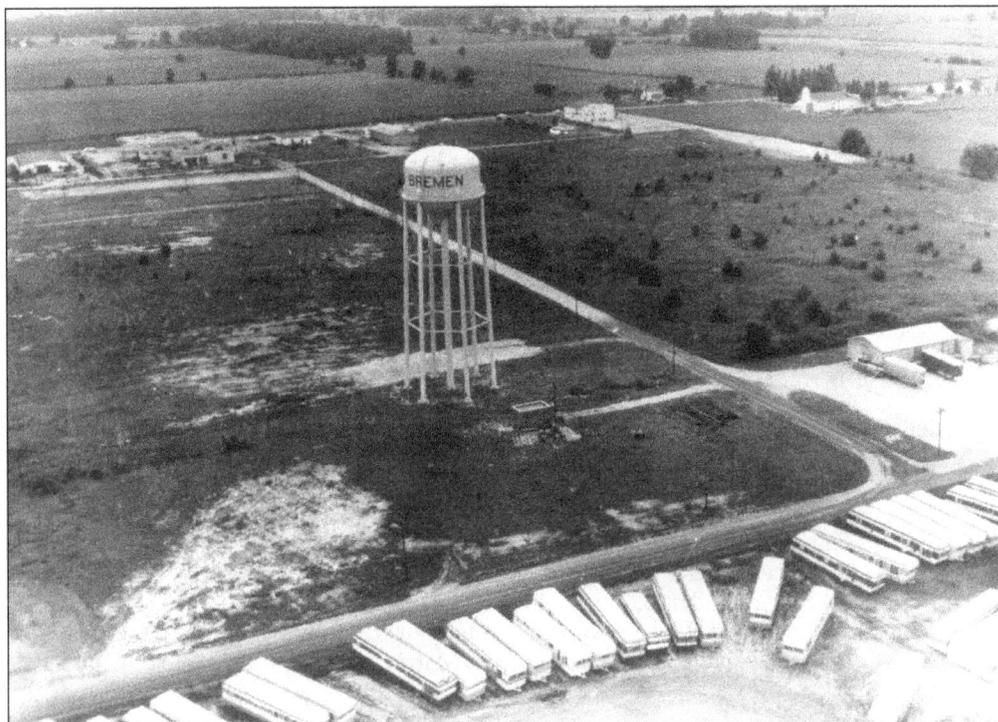

A 1950s View of the New Bremen Water Tower. The RVs at the bottom of the picture were part of the Liberty Coach manufacturing plant. The road at the bottom of the picture is Dewey Street. (Courtesy of Don Schneider, Don's Barber Shop.)

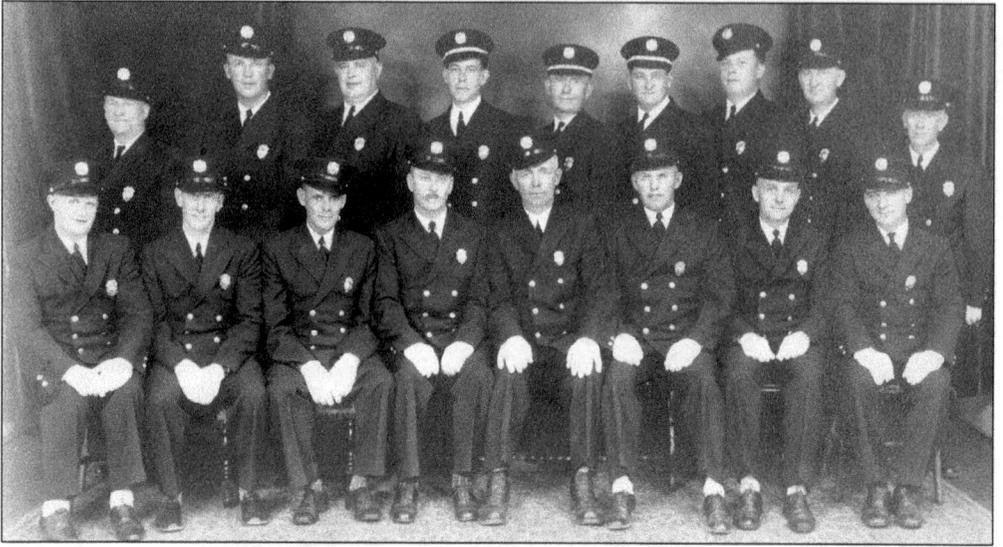

THE BREMEN FIRE DEPARTMENT AS SEEN IN THE EARLY 1950S. Pictured here in the front row are: (left to right) Robert Widmar, Doug Legner, C. Gunterman, D. Arch, O. Ringle, E. Brown, Leroy Carothers, and Robert Wahl; (back row, left to right) E. Gass, E. Ellis, D. Walter, Captain Edel, Chief H. "Jiggs" Marburger, Assistant Chief B. Martin, W. Edel, F. Stevens, and D. Neher. (Courtesy of Don Schneider, Don's Barber Shop.)

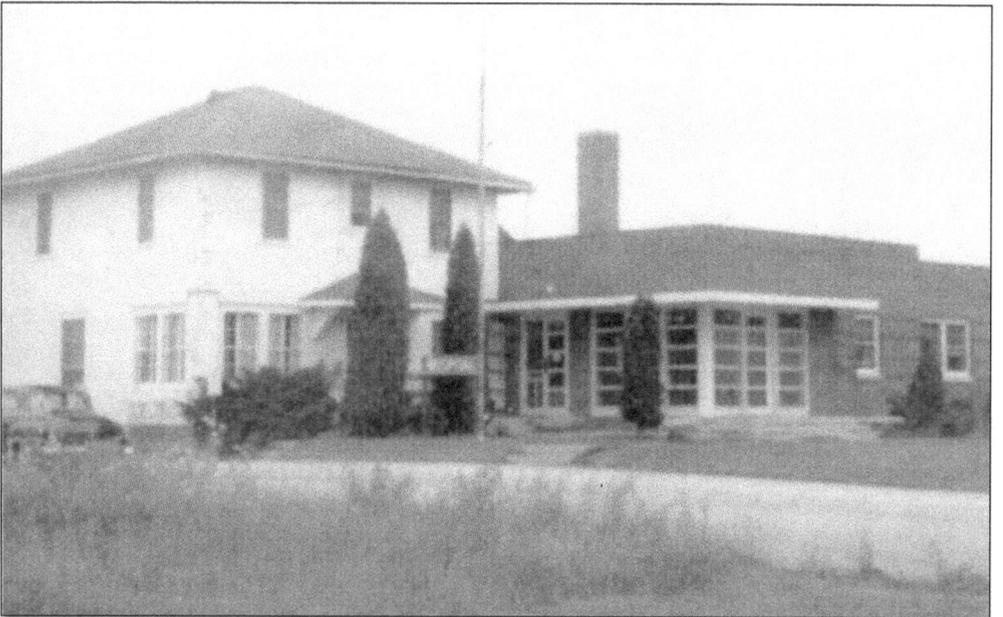

COMMUNITY HOSPITAL OF BREMEN. The Community Hospital of Bremen after the brick addition was added to the house in 1957 to provide basic hospital and maternity care. In 1946, the Church of the Brethren took over a nursing home run by Mrs. Myers, operated it a few years, until it was taken over by the community in 1948. (Courtesy of Community Hospital of Bremen.)

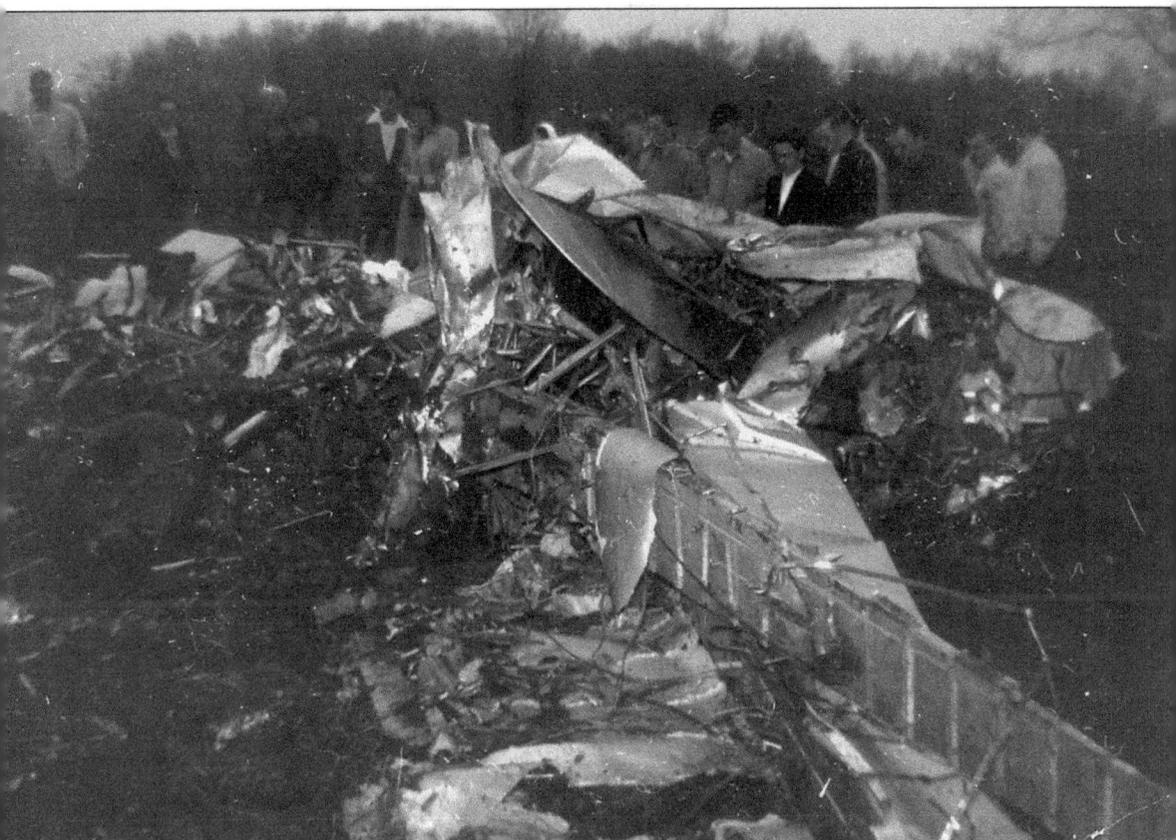

PLANE CRASH. This airplane crash killed both people on board. It occurred at the Maynard Feitz farm at Ironwood and Riley Roads on April 26, 1960s. (Courtesy of Lester and Nellie Kuhn.)

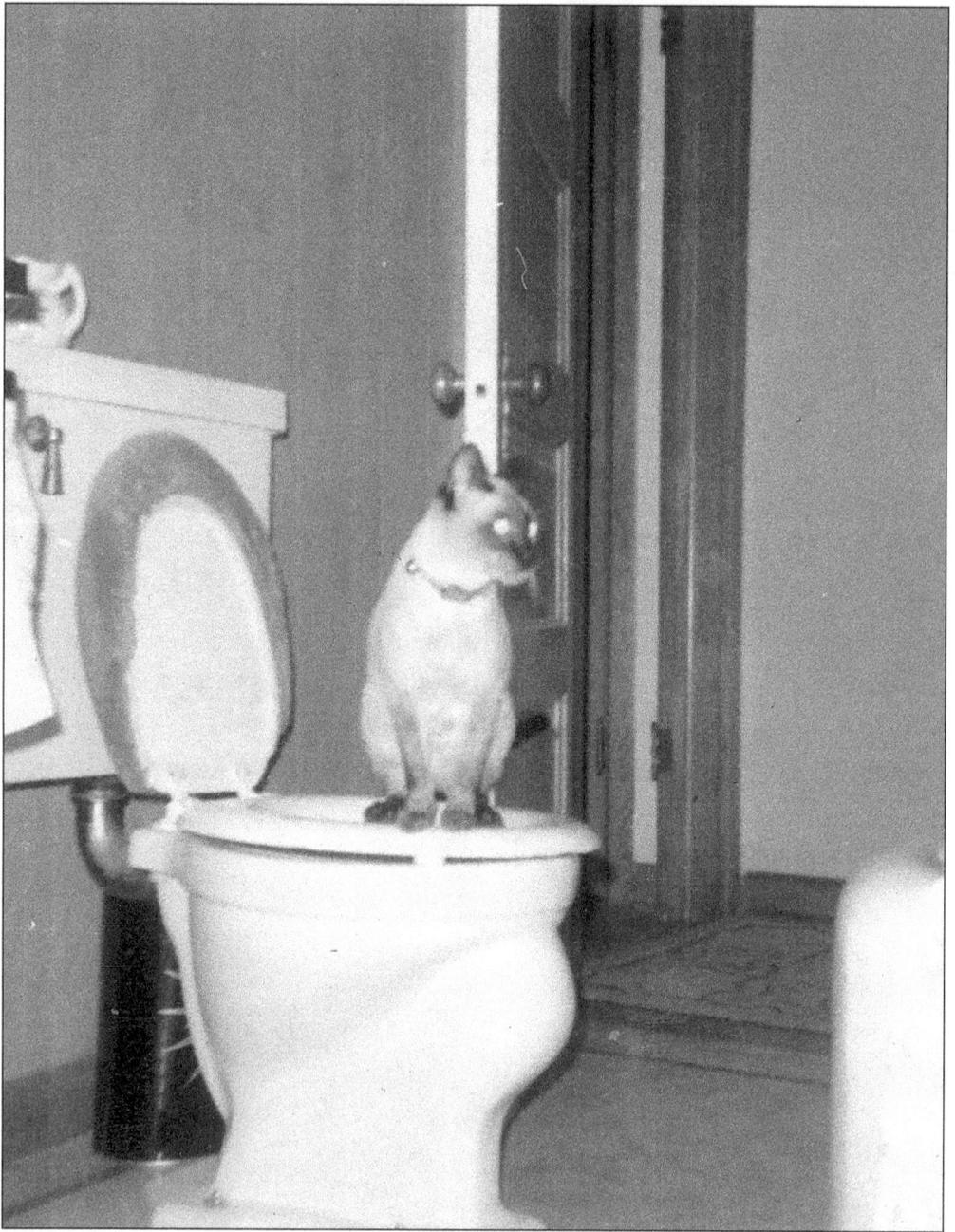

Proof That a Cat Can Be Part of the Family in More Ways Than One. In 1969, George (Pete) Eitel trained his cat to use the toilet just as a human would. It is unknown whether the cat flushed or not. (Courtesy of Lester and Nellie Kuhn.)

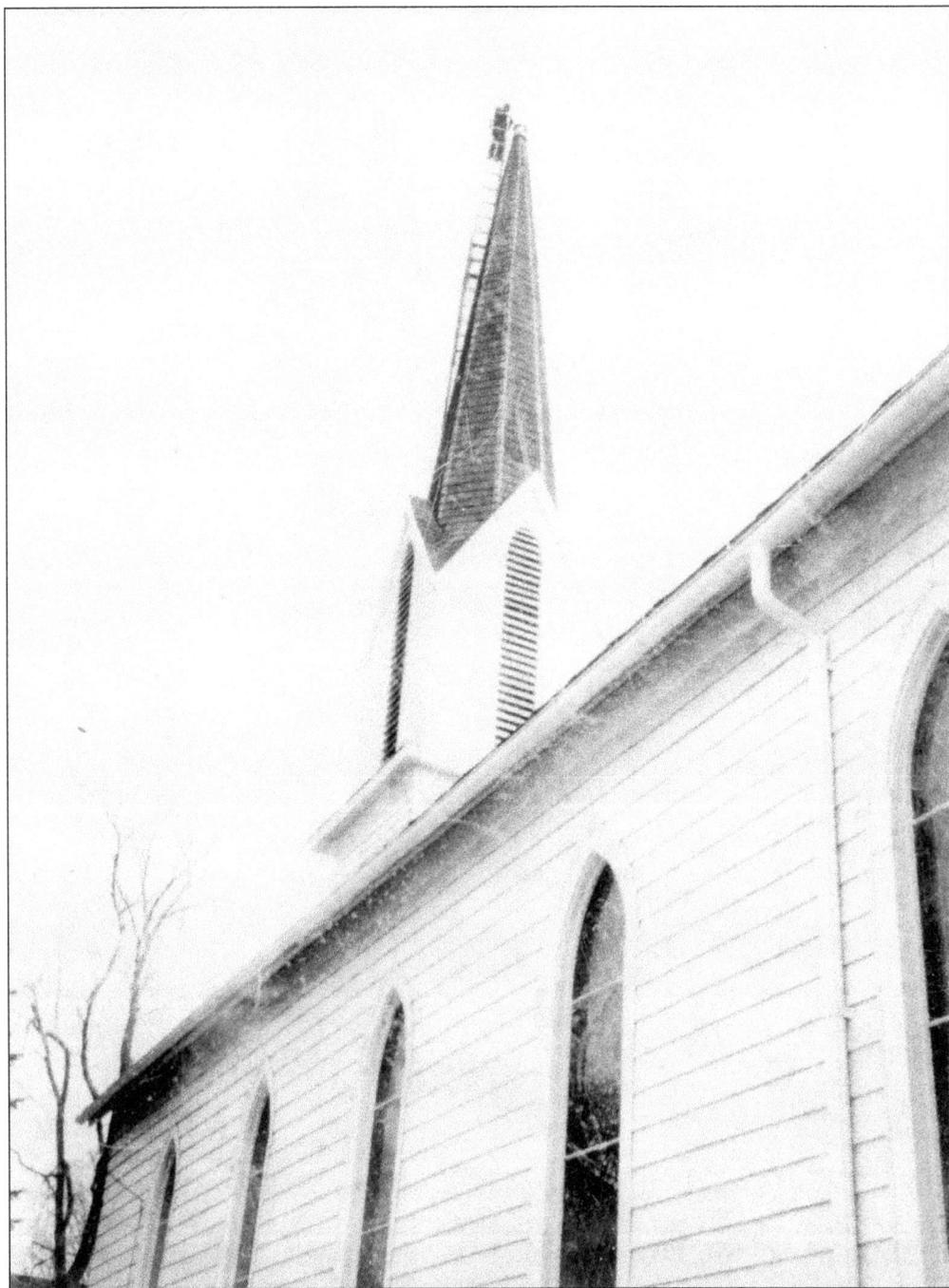

St. Paul's Lutheran Church in 1967. Dud Legner is at the top of the steeple in this photo. He was the only one brave enough to climb the tallest steeple in Bremen. He was attaching the cross on the top. (Courtesy of Lester and Nellie Kuhn.)

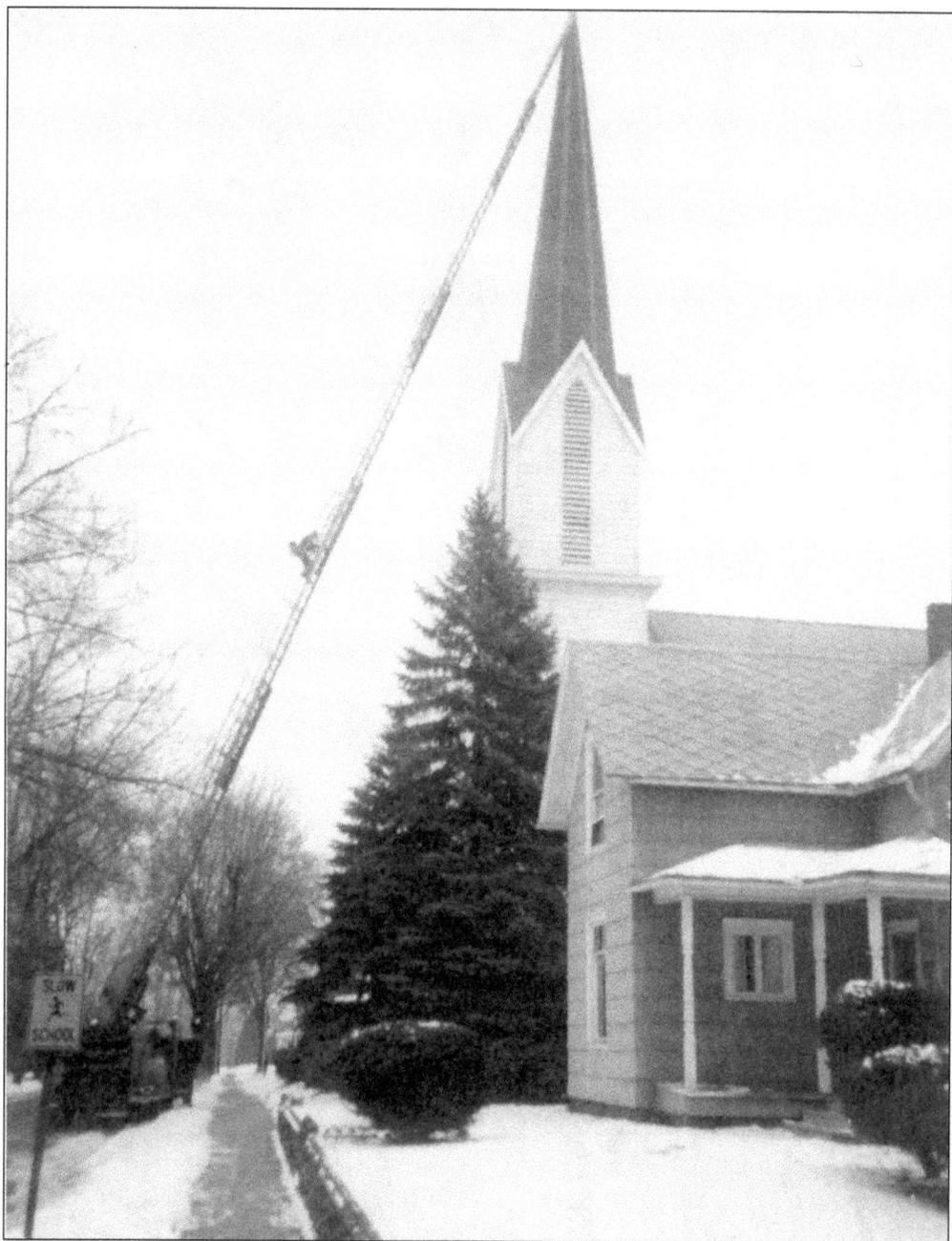

DUD LEGNER, JANUARY 1, 1971. Dud Legner is seen here halfway up the ladder to work on the steeple at St. Paul's Lutheran Church again. (Courtesy of Lester & Nellie Kuhn.)

CONFIRMATION. Mark Julian is seen here being confirmed at St. Paul's Lutheran Church. Reverend Raymond Mueller was the pastor at the time. (Courtesy of Lester & Nellie Kuhn.)

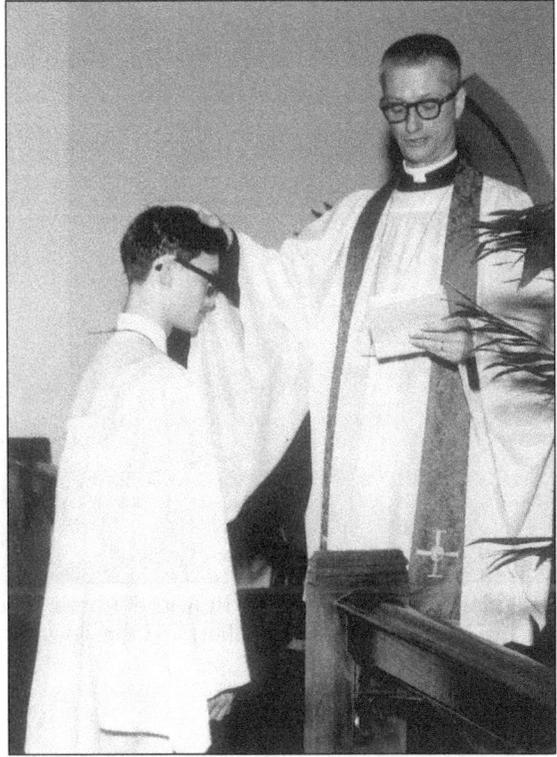

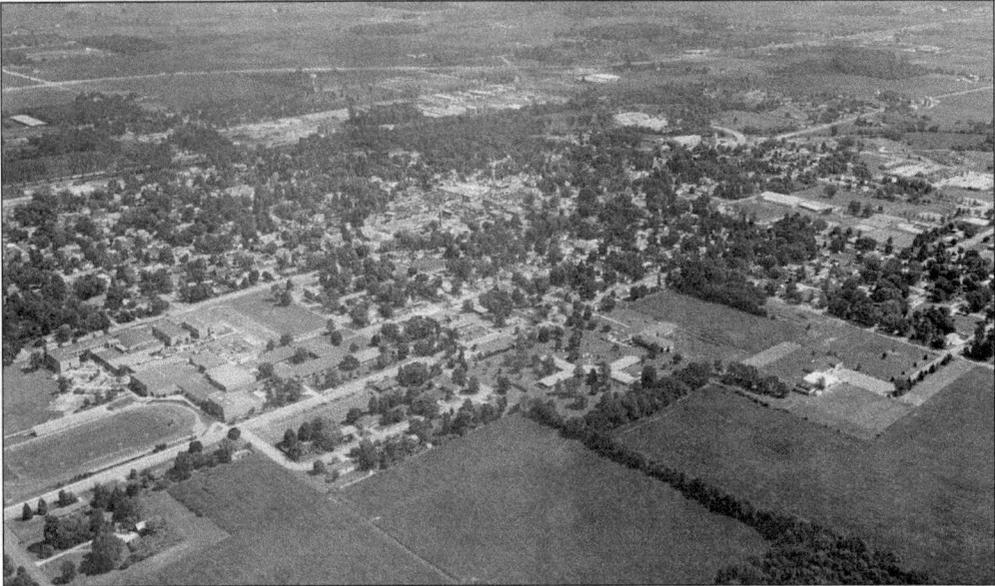

BREMEN 2000. A sky view of what Bremen looked like at the end of the millennium. (Courtesy of Duwaine Elliott & the Town of Bremen.)

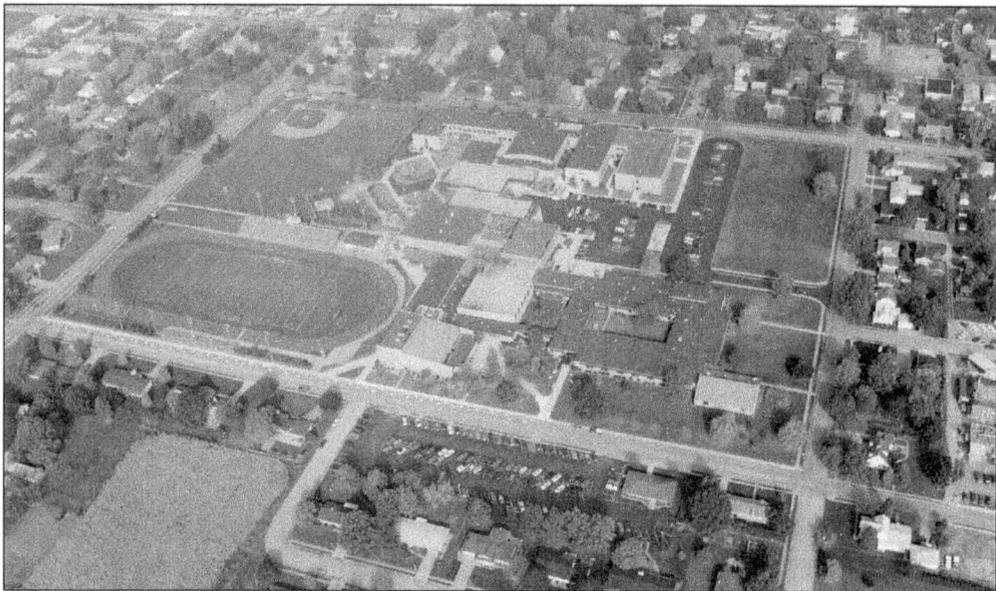

AN AERIAL VIEW OF BREMEN PUBLIC SCHOOLS. These photos were taken between 1999 and 2001. (Courtesy of Duwaine Elliott and the Town of Bremen.)

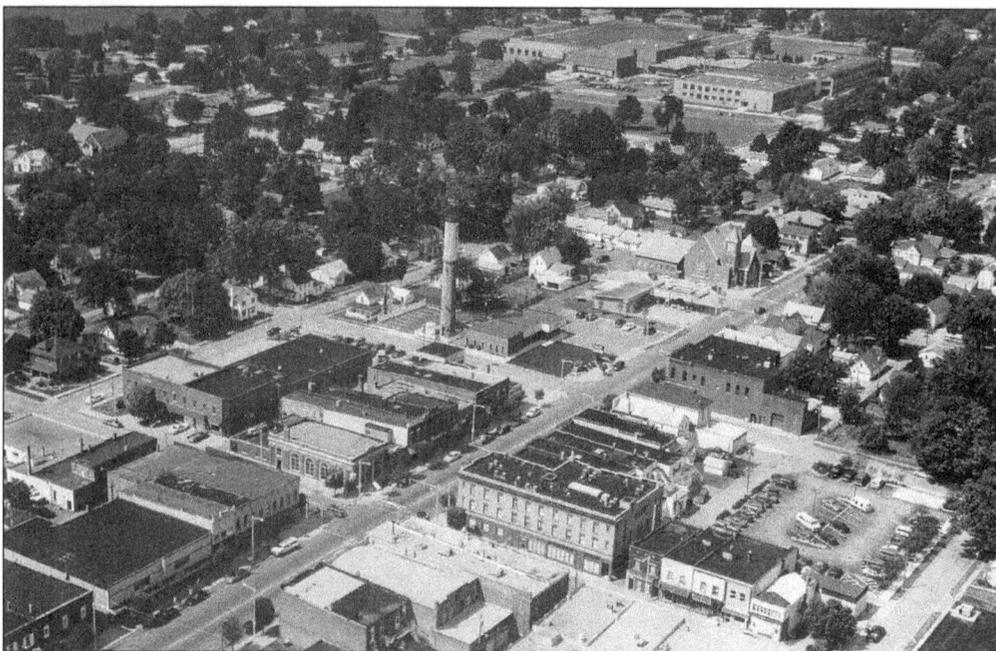

AN AERIAL VIEW OF DOWNTOWN BREMEN, BETWEEN 1999–2001. You can also see the Bremen Water Tower/Standpipe in the middle. (Courtesy of Duwaine Elliott and the Town of Bremen.)

Four

St. Joseph County

Indiana

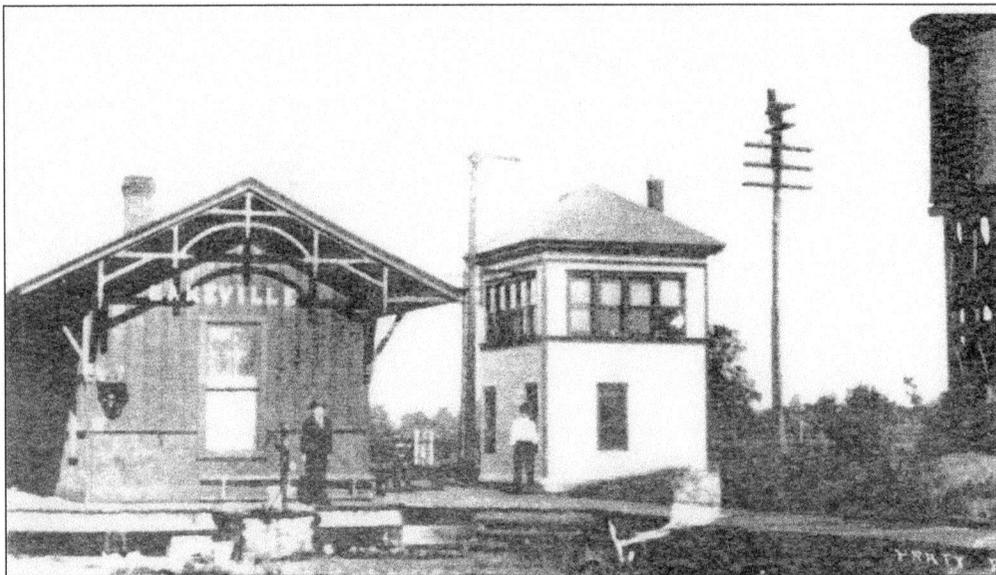

THE LAKEVILLE DEPOT AND WATER TOWER. Time period is unknown. The junction of the Wabash and Vandalia Railroads. Among the trains which passed through the depot was the doodlebug, which followed the South Bend-Logansport route. The property where the depot once stood was purchased by the town of Lakeville in 1986 to use as access for the industrial park. (Courtesy of Glenn Kuhn.)

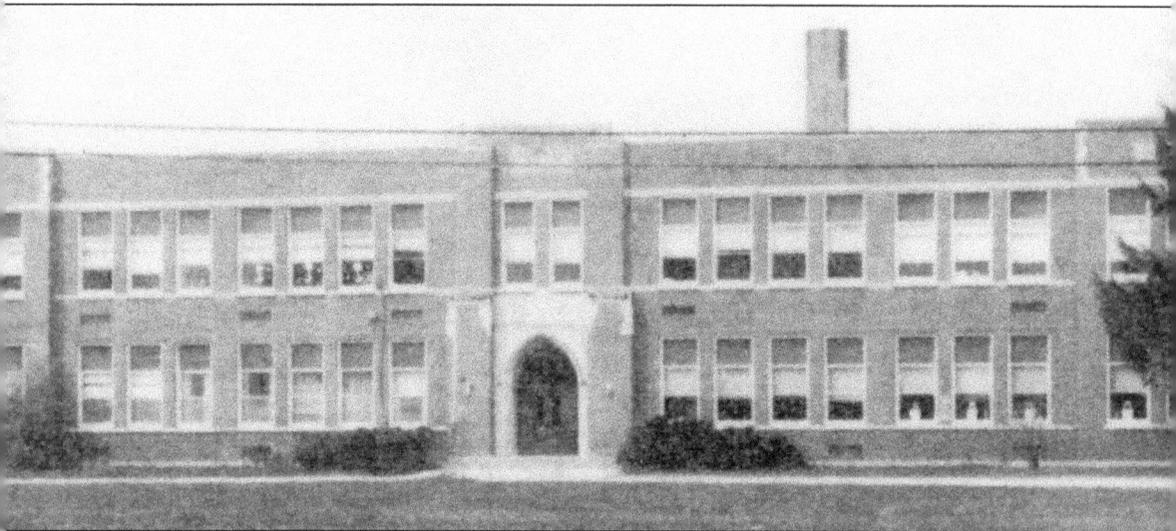

What is now the "Old Lakeville School Project" was used as Lakeville School from 1931–1972. It still stands on U.S. 31 North in Lakeville. Before the above structure was built, Lakeville School stood on the corner of Main and Harrison Streets from 1898 to 1921 (Courtesy of Glenn Kuhn).

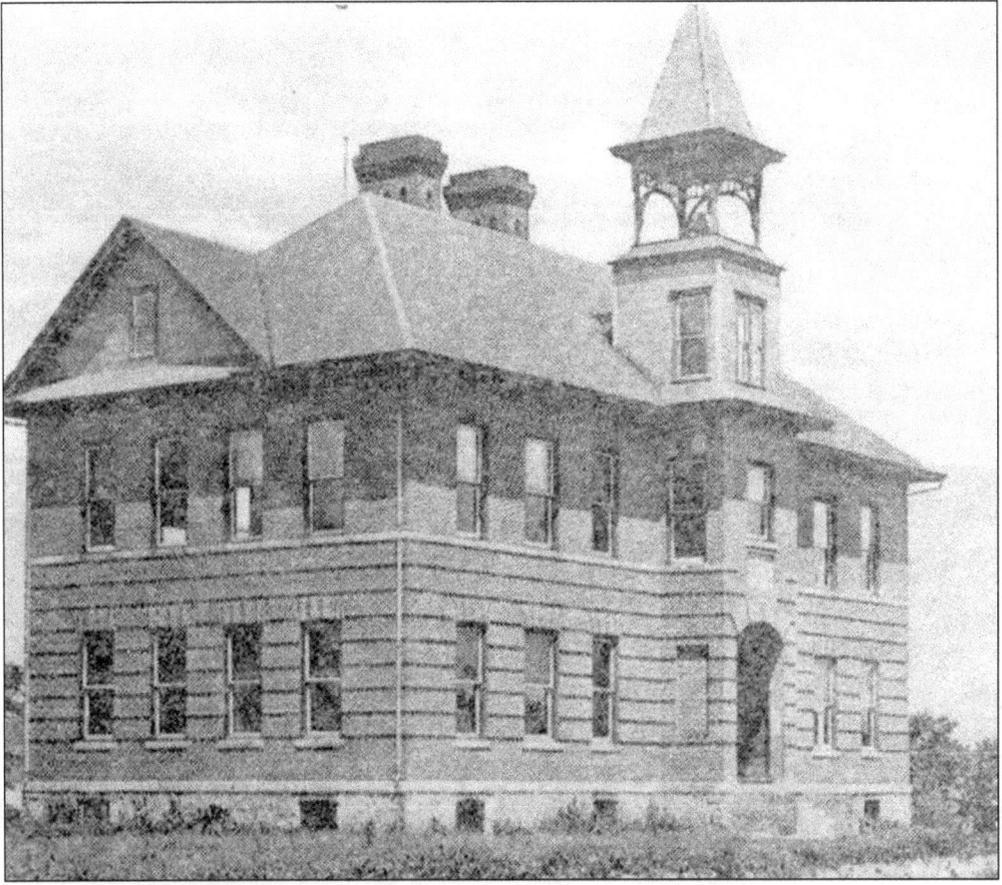

Around 1910, Schlosser Brothers Creamery had their business there until about 1927. The first schoolhouse was made of logs with split slabs laid together for a floor and was built on James Moon's farm in 1836. The farm was located one mile north of Lakeville. The first school was taught by James Roberson of South Bend in the winter of 1836–37. There were 20 pupils present. Oldean Barkley, the author's great grandmother, and wife of Mr. Charles Fuchs, remembered going to school in the one-room structure in Lakeville, called Shidler School in 1896–97. It stood at 205 E. Patterson St. It was replaced by a new two-story brick school at 211 South Main Street, which she attended from 1897–1898, the last year the old frame building was used. Charles and Oldean had 12 children, 5 of which were star basketball players at Lakeville School. In the summer of 1921, Mr. Barkley, the trustee, and another member of the author's family erected an addition to the High School building at Lakeville. This provided an auditorium, some class rooms, and a gymnasium. The first school annual, which was called *Ripples*, was produced in 1916. The first school social event given by the high school was a masquerade box social for the purpose of wiring the school building for electricity. It was held on Halloween with about 150 in attendance but only a few masked. The net proceeds amounted to $63. (Courtesy of Glenn Kuhn.)

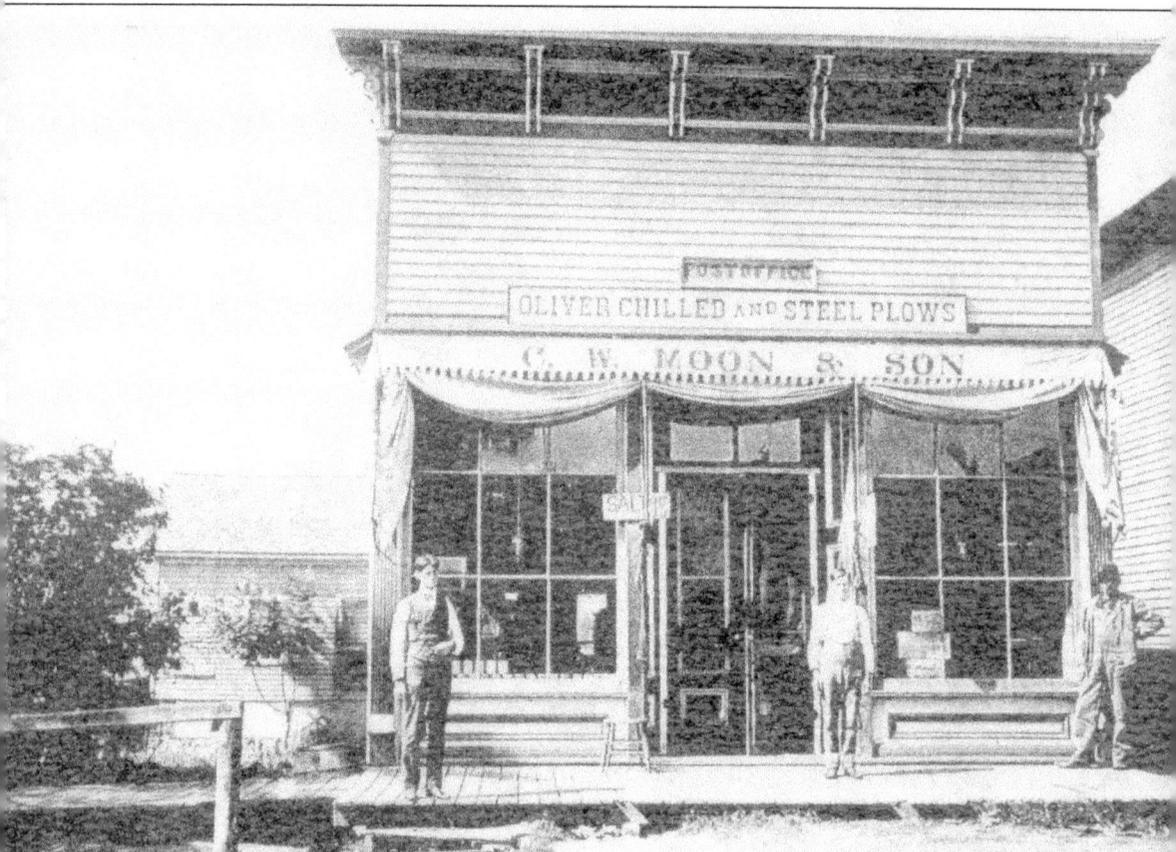

CALVIN MOON'S GENERAL STORE, 1897. The store carried farm implements for Oliver and also held the post office at one time. (Courtesy of Glenn Kuhn.)

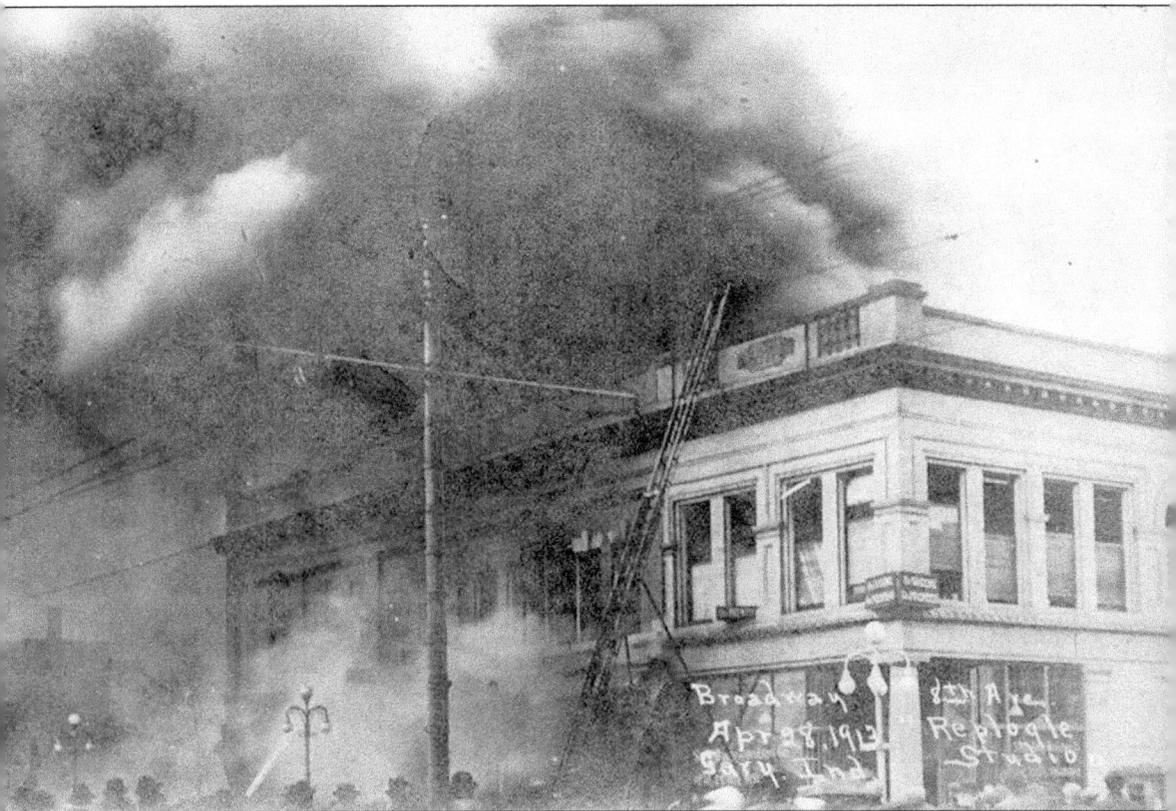

SENIOR ANNUAL. The senior class of 1924 dedicated their annual to "Mr. F.A. Replogle: Our Principal, whose name, is written on the scroll of fame. His good works and morals high, to appreciate we always try, A friend so good and true, as judge he is true blue. He's a jolly playmate full of mirth, a life of honor and of worth, LIVES ON FOR MANY A DAY. AMEN!" This photograph shows the Replogle Studio at the corner of Broadway and Eigth Avenue in Gary, Indiana. The photo was taken on April 28, 1913. There must be a connection to the studio and the principal since the photo was found in the possession of a lifelong Lakeville resident. (Courtesy of Dee Fuchs-Weaver.)

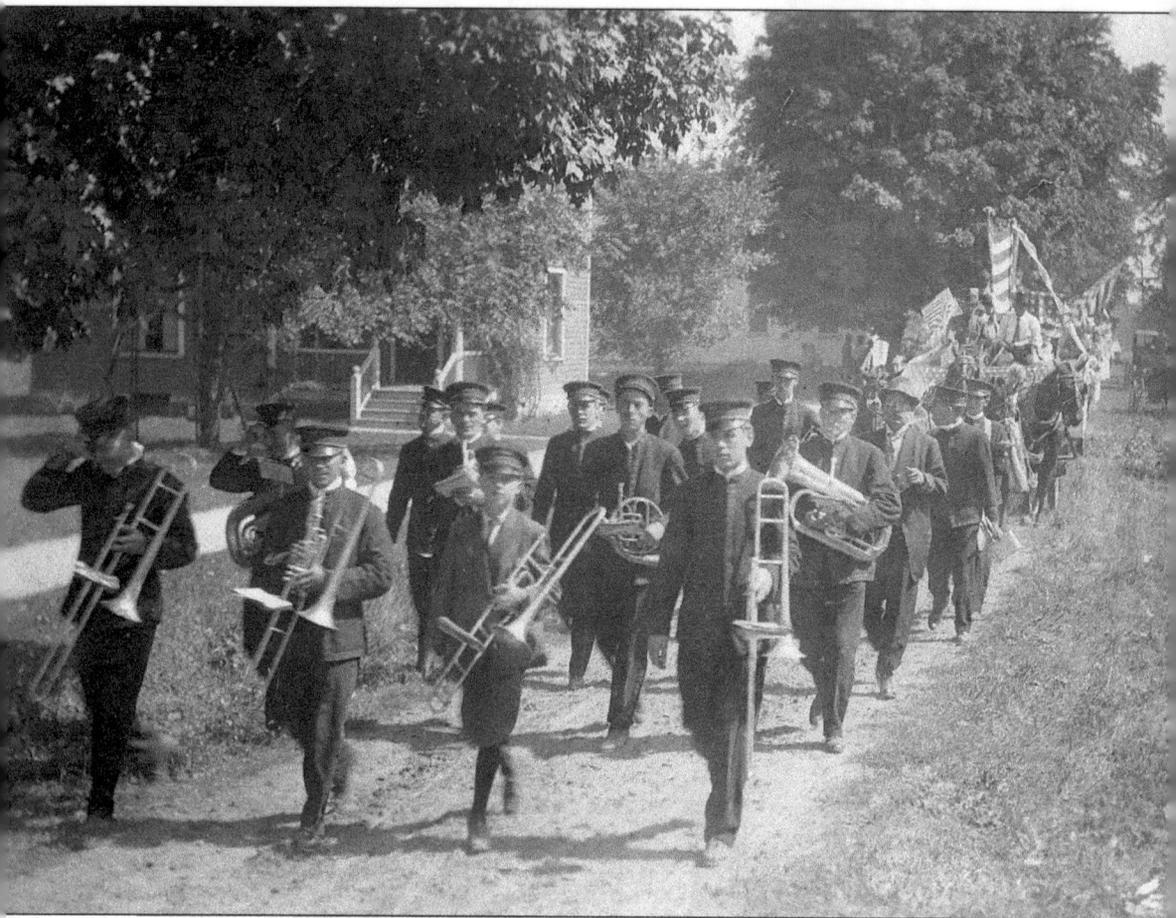

THE LAKEVILLE BAND MARCHING DOWN THE STREET C. 1910. The orchestra was organized in 1924 and the High School Band was organized about 1935, after a county school band had been organized about 1932. About 1936, a Band Boosters Club was organized of parents of band members with its general purpose to encourage participation and to provide the first band uniforms. This was done by community fund-raising projects to purchase the first uniforms. By 1956, the band was composed of 35 members who participated in district contests where three of the members received first honors and went on to the state contest. The first band director was Wayne VanSickle from 1936–1940. (Courtesy of Dee Fuchs-Weaver.)

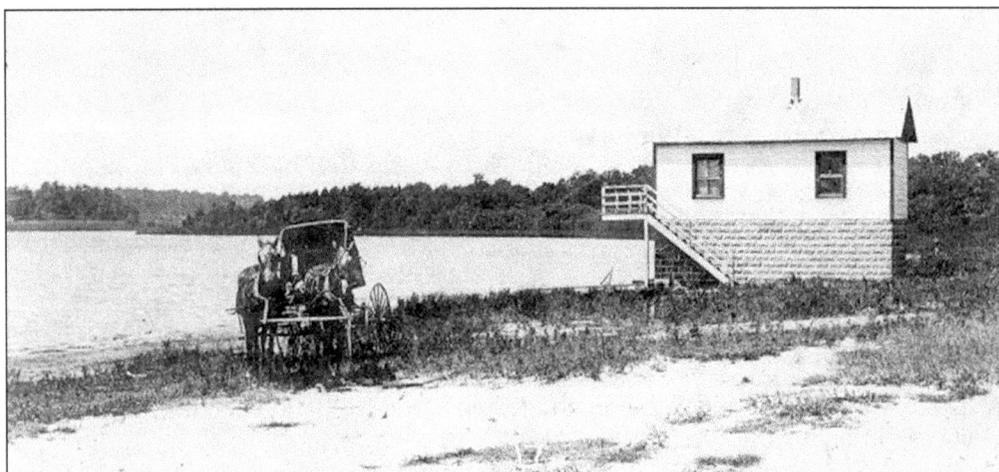

RIDDLE'S LAKE IN LAKEVILLE, INDIANA, C. 1910. (Courtesy of Dee Fuchs-Weaver.)

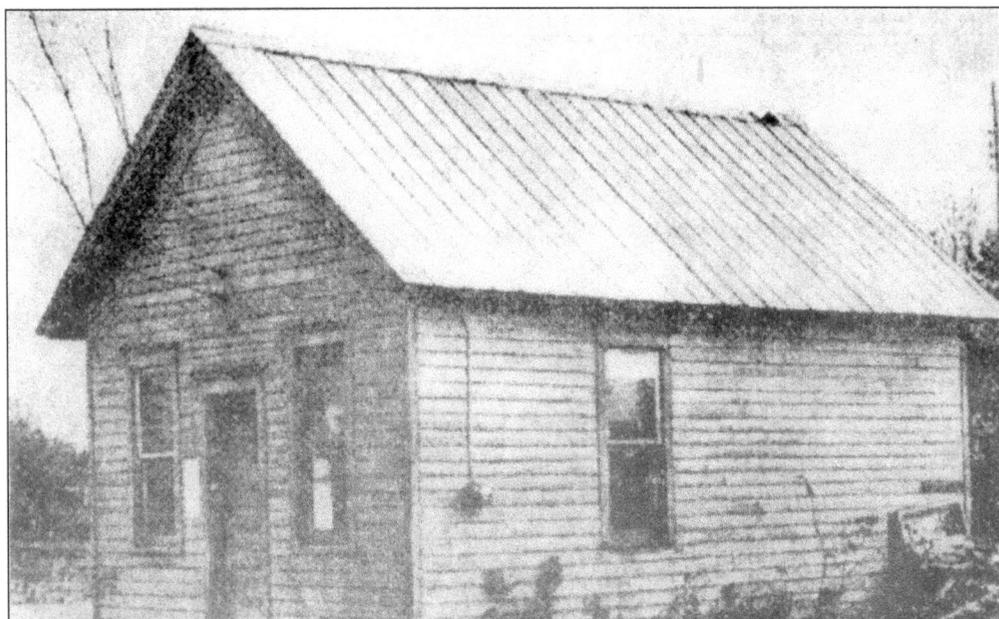

THE LAKEVILLE TOWN HALL, 1938. St. Joseph County was organized on August 27, 1830. The first election in Union Township was in 1836 with only 30 votes polled. The Lakeville town census showed a population of 1,733 persons in 1900. (Courtesy of Glenn Kuhn.)

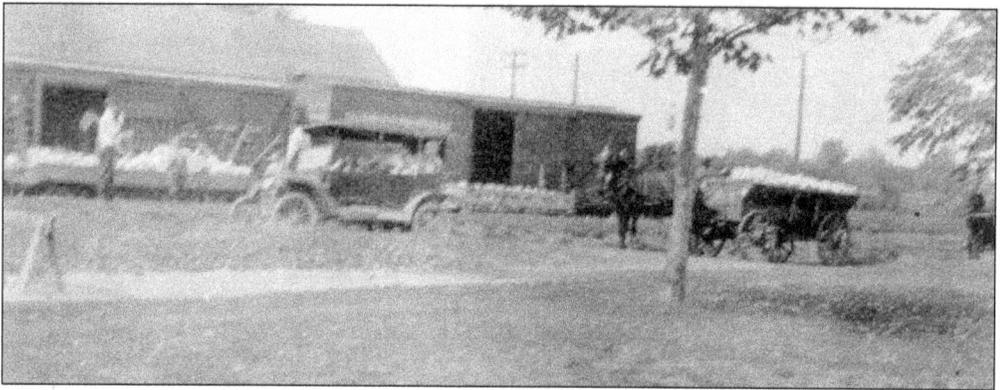

A Truck Crop-Marketing Scene in St. Joseph County, 1915. (Courtesy of St. Joseph County 4-H Fair, Inc.)

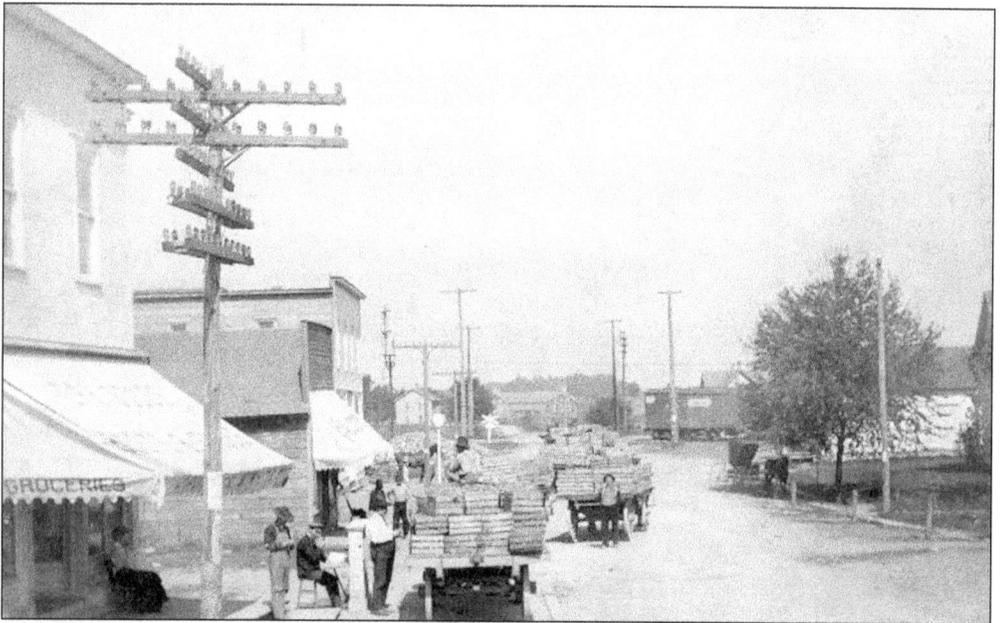

Another Truck Crop-Marketing Scene in St. Joseph County in 1915. (Courtesy of St. Joseph County 4-H Fair, Inc.)

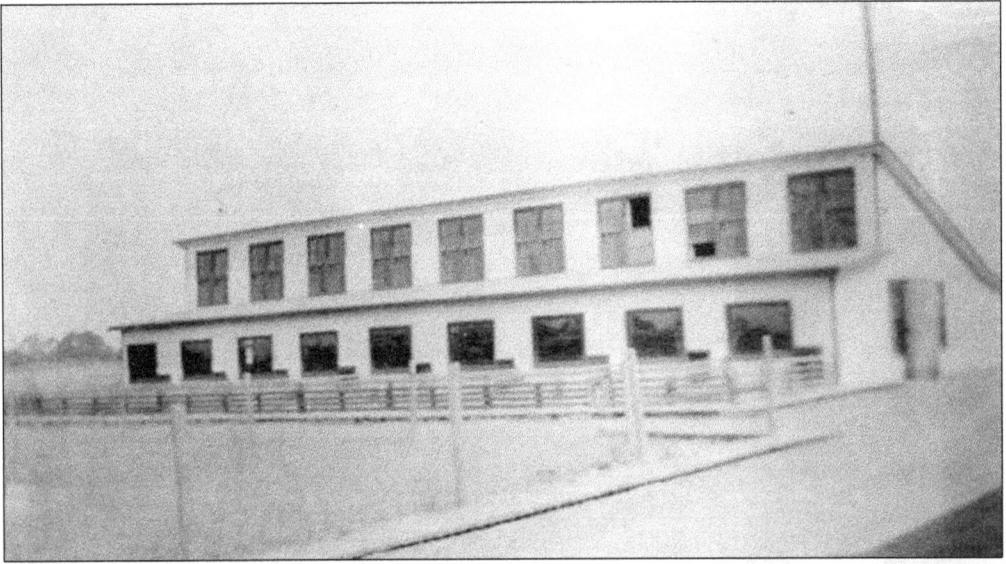

HOG HOME. This type of hog house was quite popular throughout St. Joseph County in 1915. A house of this type was planned and built on the County Farm by the County Agricultural Agent in 1915 as a demonstration of how to combine all the comforts of a practical hog shelter with the greatest convenience. (Courtesy of St. Joseph County 4-H Fair, Inc.)

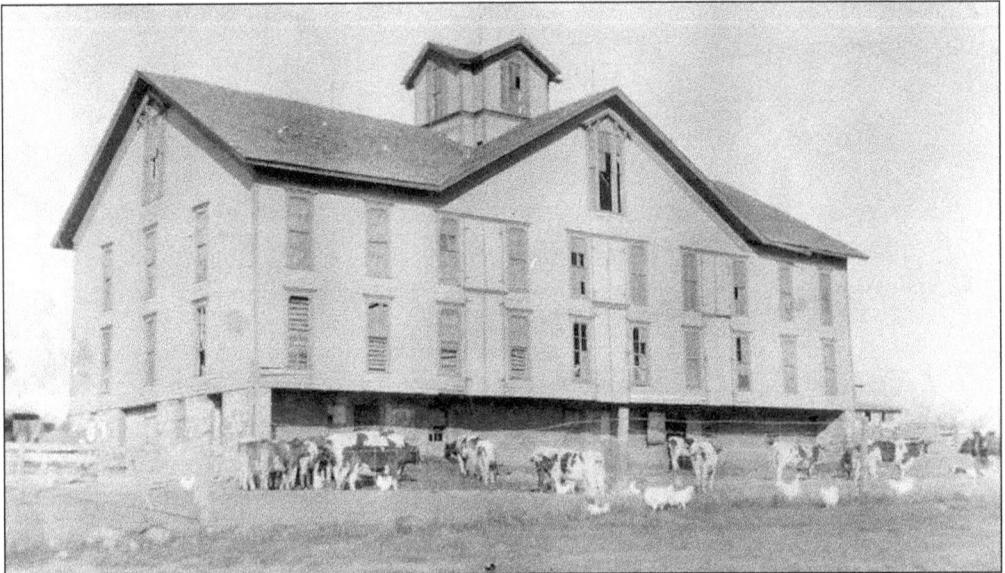

BANK BARN. In 1916, this Bank Barn was considered old-fashioned. It was made sanitary by the use of Whitewash, a cement floor and a few additional windows. By keeping the manure removed from near the building, and practicing horse sense in handling his herd of tubercular tested cows, he was able to produce milk with less than 3000 bacteria per CC which sold in South Bend for 15¢ per quart. (Courtesy of St. Joseph County 4-H Fair, Inc.)

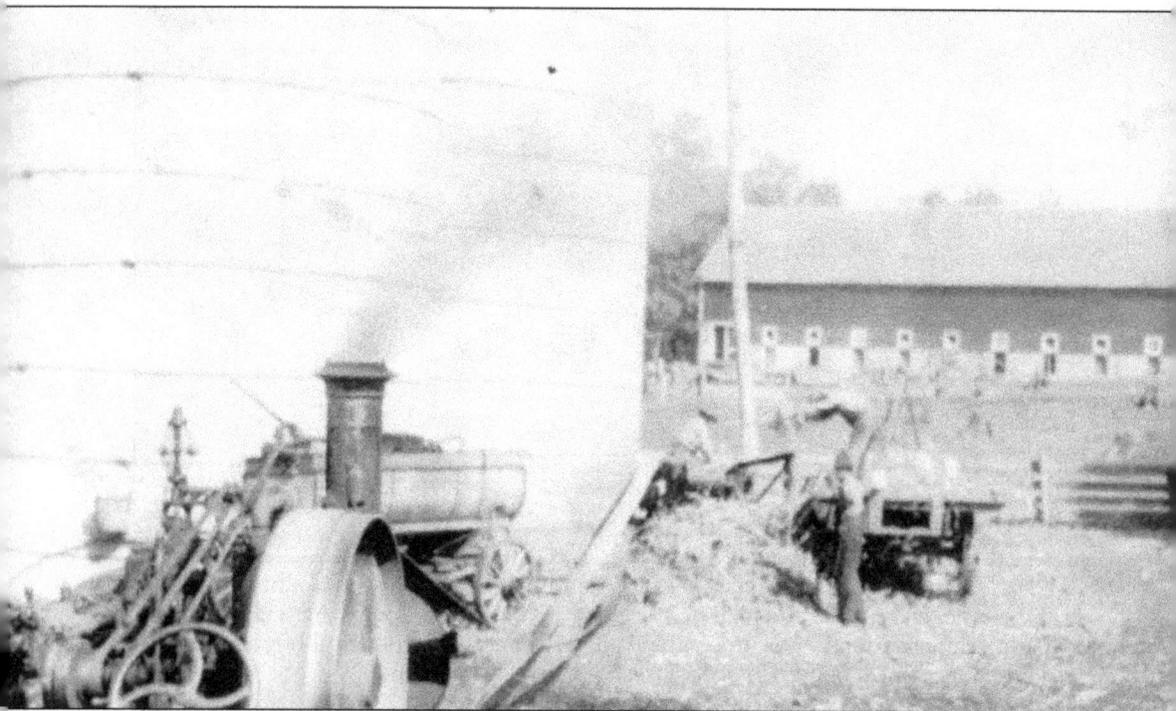

COUNTY GROWTH. In 1916, farms averaged one silo to every four farms with five or more acres. The number of silos in the county grew from 161 in 1913, to 650 in 1916. (Courtesy of St. Joseph County 4-H Fair, Inc.)

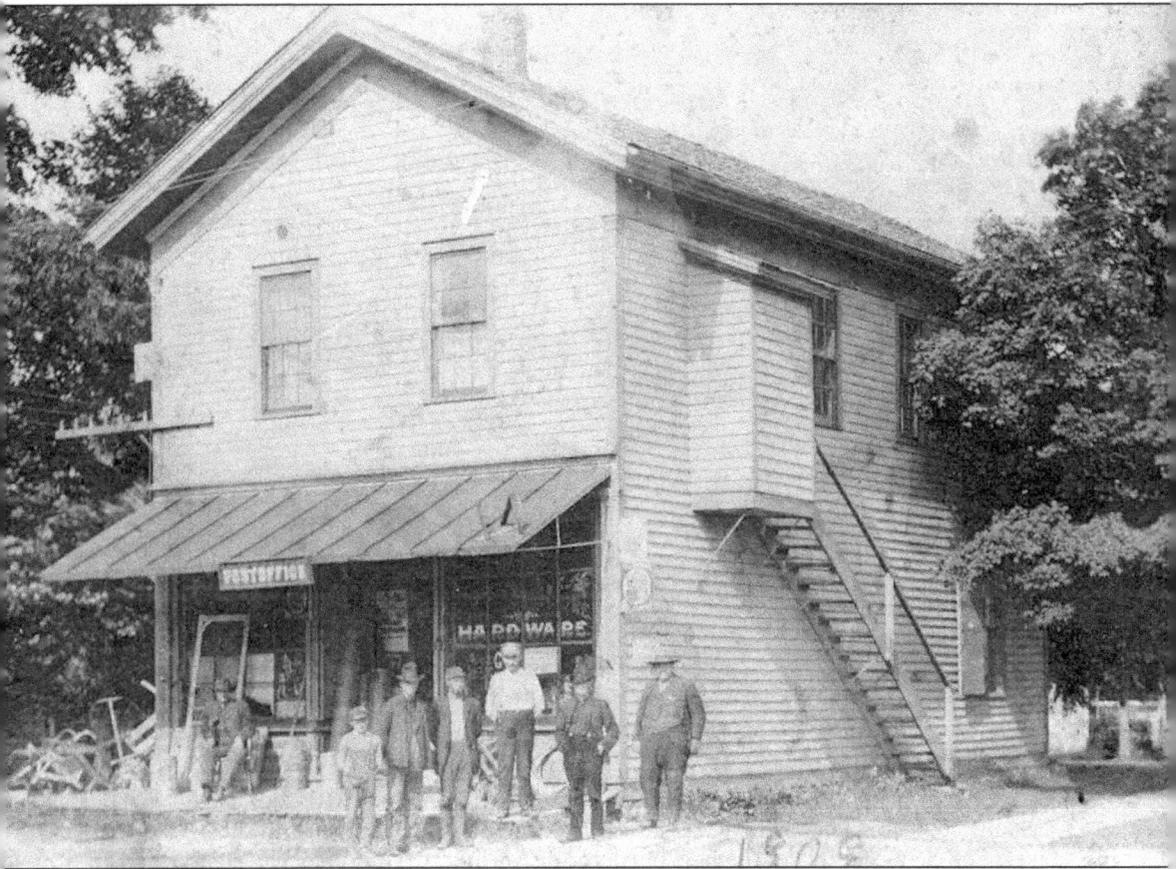

BARKLEY'S AND JACK'S. This building, located on Michigan Street in Lakeville, Indiana, in 1909, housed the post office, hardware store, and spirits. The Barkley family were the owners of the building at that time. Today you'll find this same building known as Jack's Bar and Grill. (Courtesy of Dee Fuchs-Weaver.)

A GATHERING OF THE ARDMORE HOME ECONOMICS CLUB IN 1916. Notice the extremely modern country school which was rare in those days. The Purdue University Cooperative Extension Service provides the base of education for the Extension Homemakers Association. The earliest recollection of the Extension Service shows John S. Bordner becoming the first county agriculture agent on April 1, 1913. This made St. Joseph County the fourth county in the State of Indiana to employ a county agriculture agent. January 1, 1915, Grace King became the first supervisor of Domestic Science in St. Joseph County. After a short time, she was promoted to state work and she was followed by Bernice Yoder, who organized classes in Union Township and other townships. At that time, 4-H was not yet known by that name, but rather called Purdue Boys Club and Purdue Girls Club. Indiana was not the first state to initiate 4-H Clubs. (Courtesy of St. Joseph County 4-H Fair, Inc.)

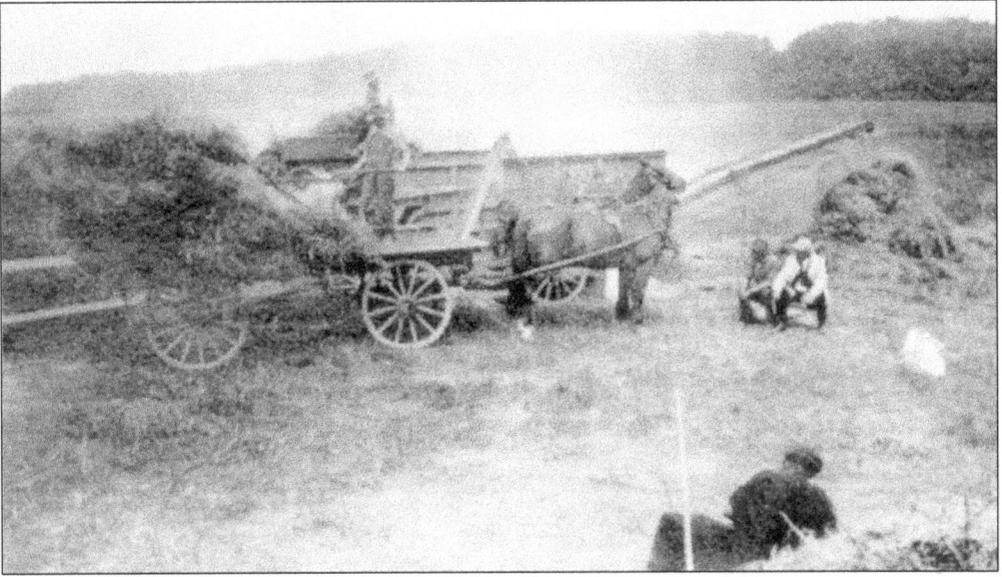

SWEET CLOVER. The first field of sweet clover ever harvested in St. Joseph County was grown by Elroy Kime of Greene Township in 1916. The soil was a sandy loam that had been treated with two tons of limestone and 1000 pounds of rock phosphate. The field was pastured until August 1st, then cut with a binder and hulled. It yielded five bushels of clean seed per acre. (Courtesy of St. Joseph County 4-H Fair, Inc.)

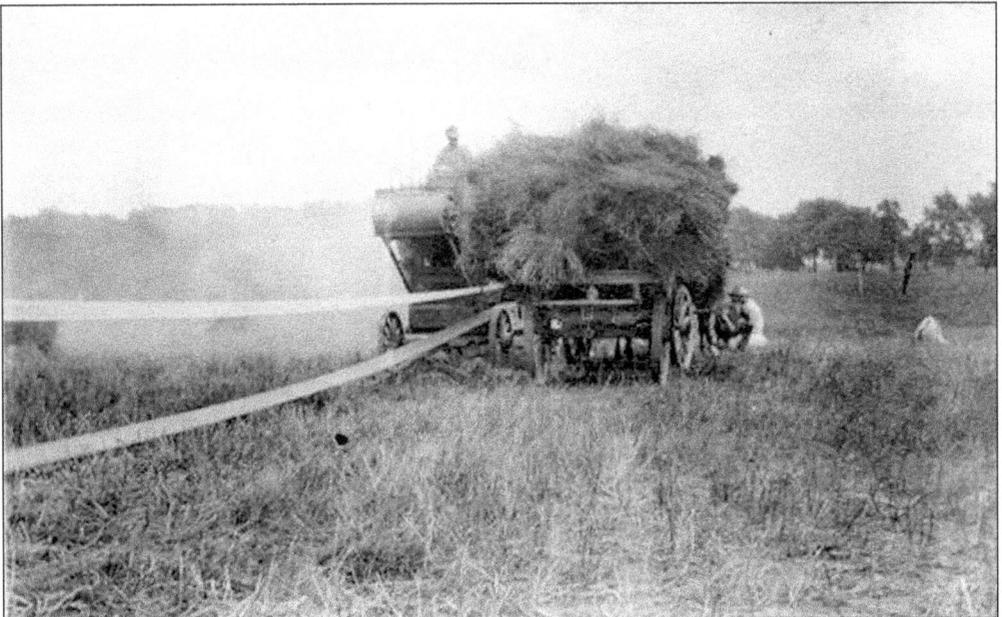

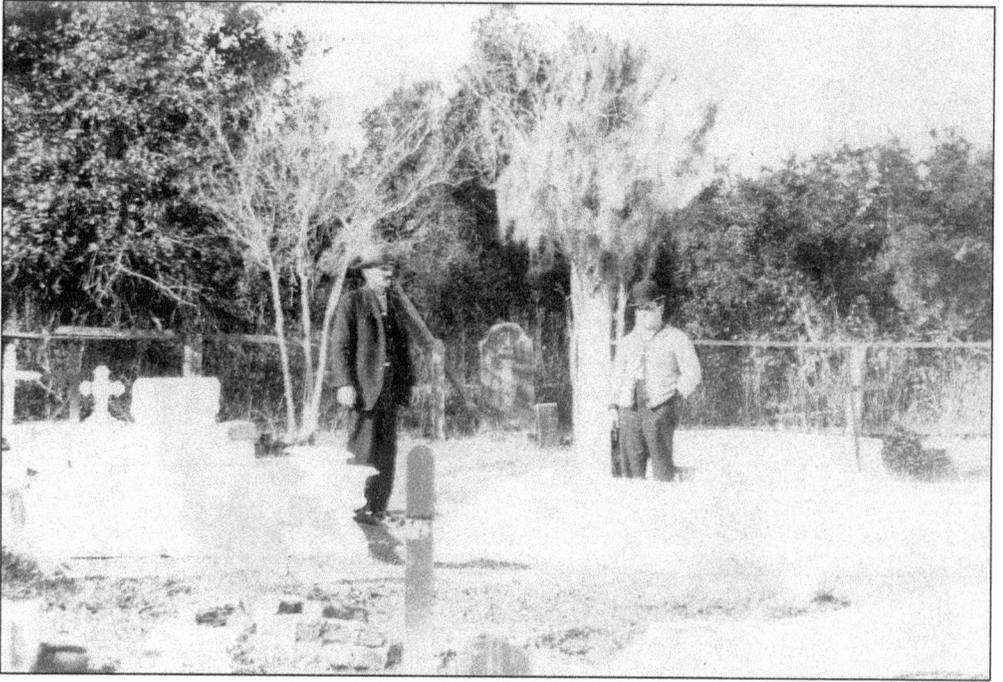

THE LAKEVILLE CEMETERY PREPARES FOR ANOTHER BURIAL. It looks as though it may have been a mass burial or an entire family. Time period is unknown. (Courtesy of Dee Fuchs-Weaver.)

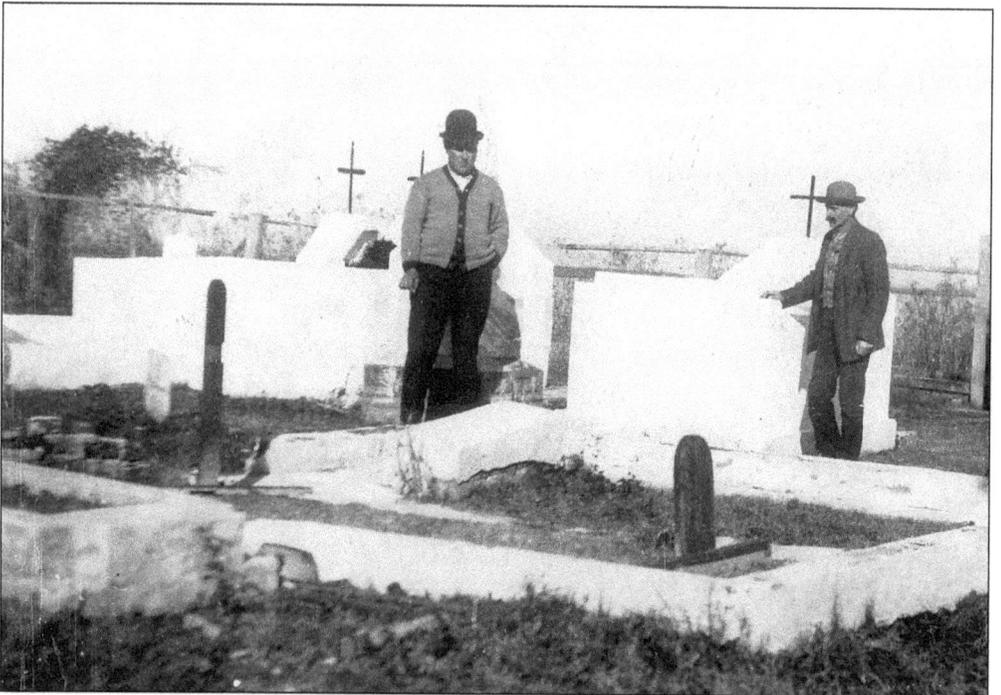

STATE REP. RICHARD W. MANGUS. The state representative is shown here in 1946, working with his 4-H Livestock projects.

STATE REP. RICHARD W. MANGUS. Mangus started his 4-H work in 1940. Since his 4-H years, Richard has been highly involved with the St. Joseph County 4-H Fair by becoming a 4-H Leader and 4-H Livestock Auction supporter. (Courtesy of Richard W. Mangus.)

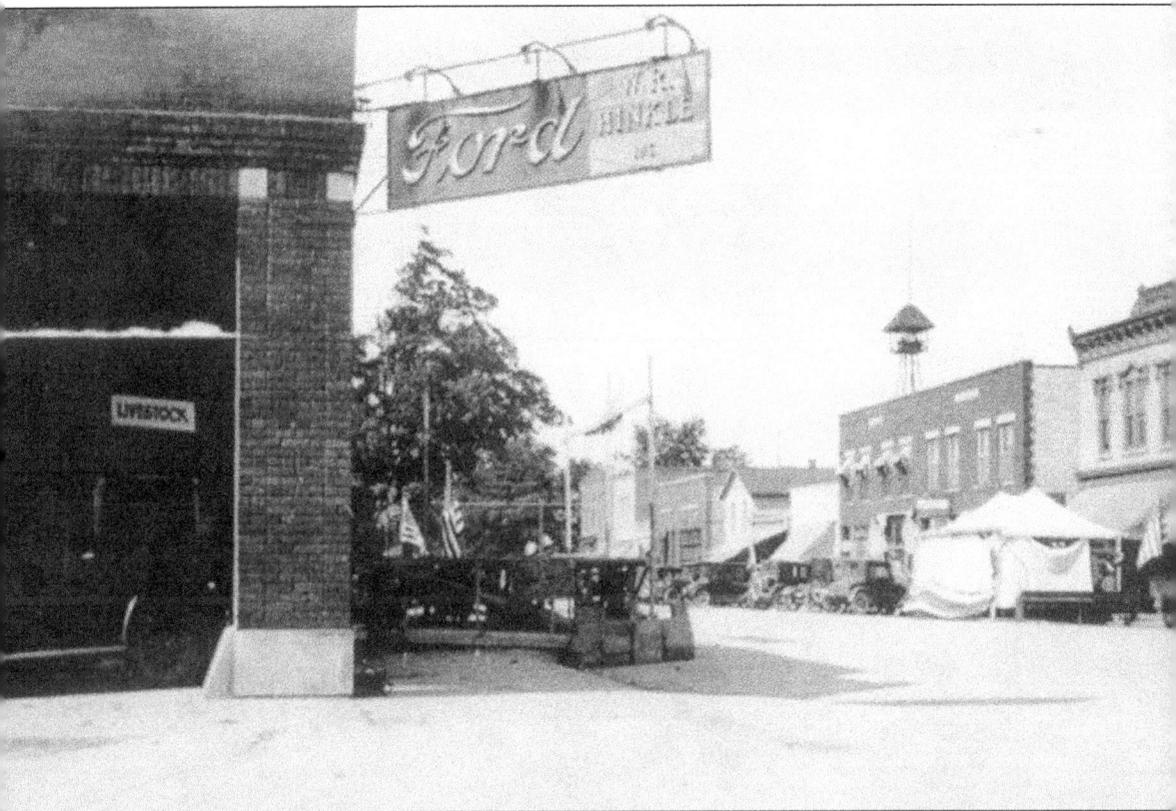

FAIRS AND FAIRS. The county fairs began at Springbrook Park, later called Playland Park, at Lincoln Way and Ironwood Roads in South Bend around 1926. In 1927, there were 426 county 4-H members enrolled. However, in 1928, the first real 4-H Fair was held at North Liberty (shown in the picture), pulling away from the county fair because the gambling and lottery concessions which seemed to dominate the county fair. Five hundred and fifty-five members enrolled that year. This purely 4-H Fair was sponsored by the North Liberty businessmen, vocational teachers, and the Extension Service. The fair was held in North Liberty until 1934. (Courtesy of the St. Joseph County 4-H Fair, Inc.)

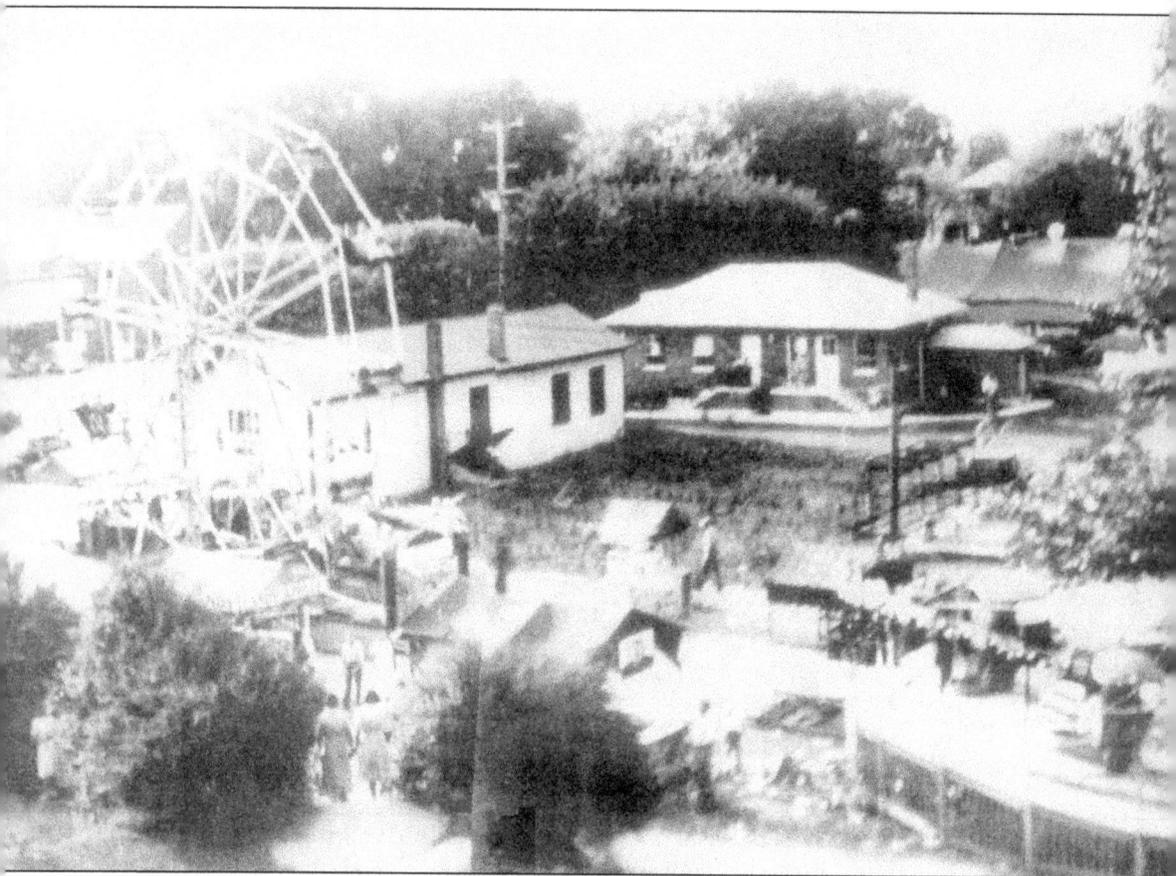

4-H FAIR. When Lakeville began holding the 4-H Fair in 1935, the events would draw people from St. Joseph and Marshall Counties. Cattle tents were set up where Annis Finer Foods once stood. The Lakeville Merchants sponsored the fair at that time. Generous prizes were donated by merchants for the exhibits. Some of the events for the fair included: draft horse show with team judging, colt show, upland farm crops exhibit, county muck crops show including a peppermint exhibit, 4-H corn and potato show, baked goods, and quilts. The program included a parade, a horse pulling contest, hog-calling contest, husband-calling contest, soap box derby for boys, and many others. The oldest "settler" registered at a specified location from Union Township and adjoining townships received 100 pounds of sugar as a prize. The first "successful" fair in St. Joseph County was held in Lakeville, August 11–13, 1936. This was the 10th annual 4-H Fair in St. Joseph County. The event also held the first 4-H Steer Auction. Forty-three steers were sold by 4-H'ers that year. Fred Reppert, internationally known Hoosier auctioneer, donated his time and was assisted by local auctioneers. Auctioneers still volunteer their time at the 4-H Fair today. Bleachers were built for the first time. In 1937, a public address system was installed. On August 12–14, 1941, 12,000 people attended the fair with fences around the perimeter. Admission of 10¢ was charged for adults, and children under 12 were admitted free. In 1944–1945, the admission price was raised to 25¢. (Courtesy of St. Joseph County 4-H Fair, Inc.)

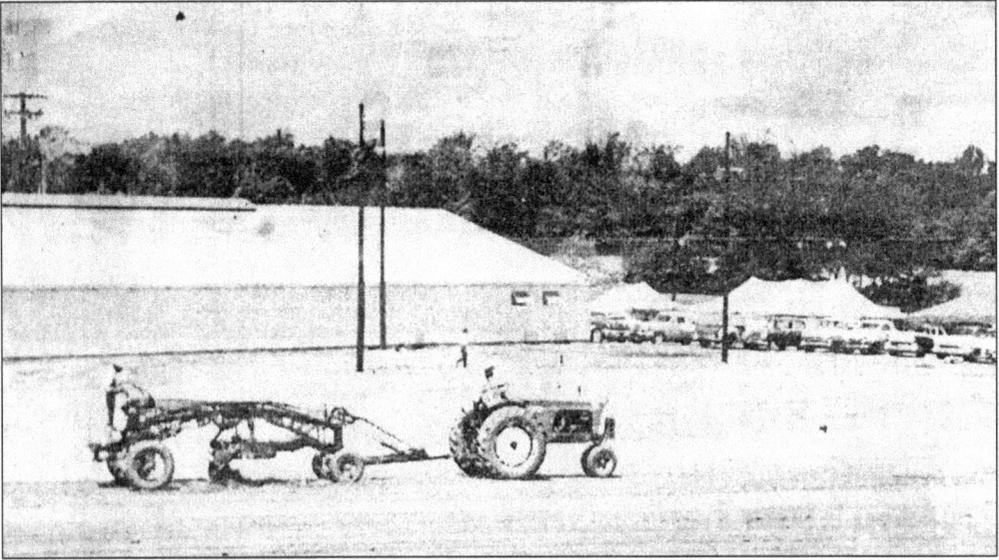

4-H Fair. From 1946–1958, the 4-H Fair was again held at Playland Park in South Bend. Plans were underway to purchase the acreage for the present 4-H Fairgrounds on Jackson & Ironwood Roads in South Bend. In 1959, the plans were finished and fair had their own property. The photo shows the 1959 Fair in South Bend. (Courtesy of the St. Joseph County 4-H Fair, Inc.)

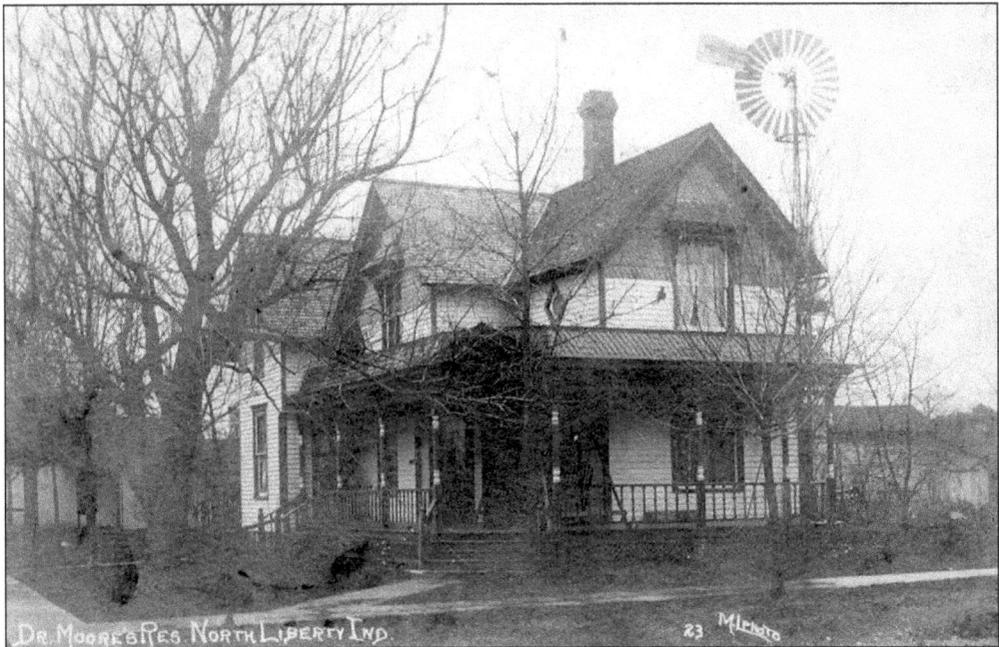

Dr. Walter and Sally Moore's Residence in North Liberty, Indiana, 1909. (Courtesy of Dee Fuchs-Weaver.)

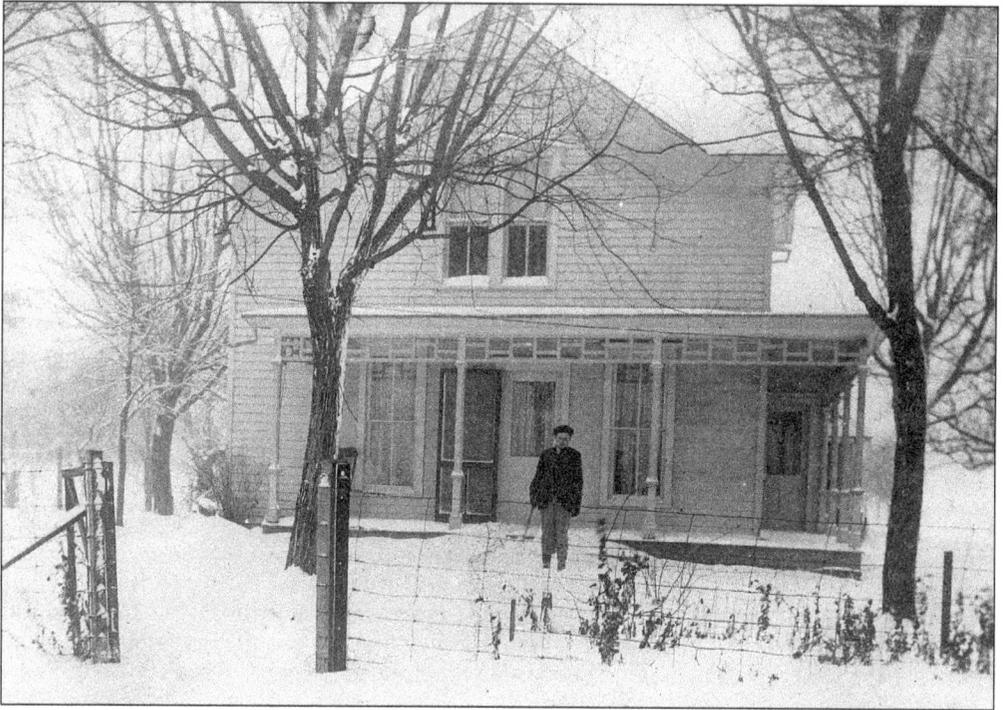

THE WILLIAM RUPE HOME IN WALKERTON, INDIANA, 1909. These photos show winter and summer scenery. (Courtesy of Dee Fuchs-Weaver.)

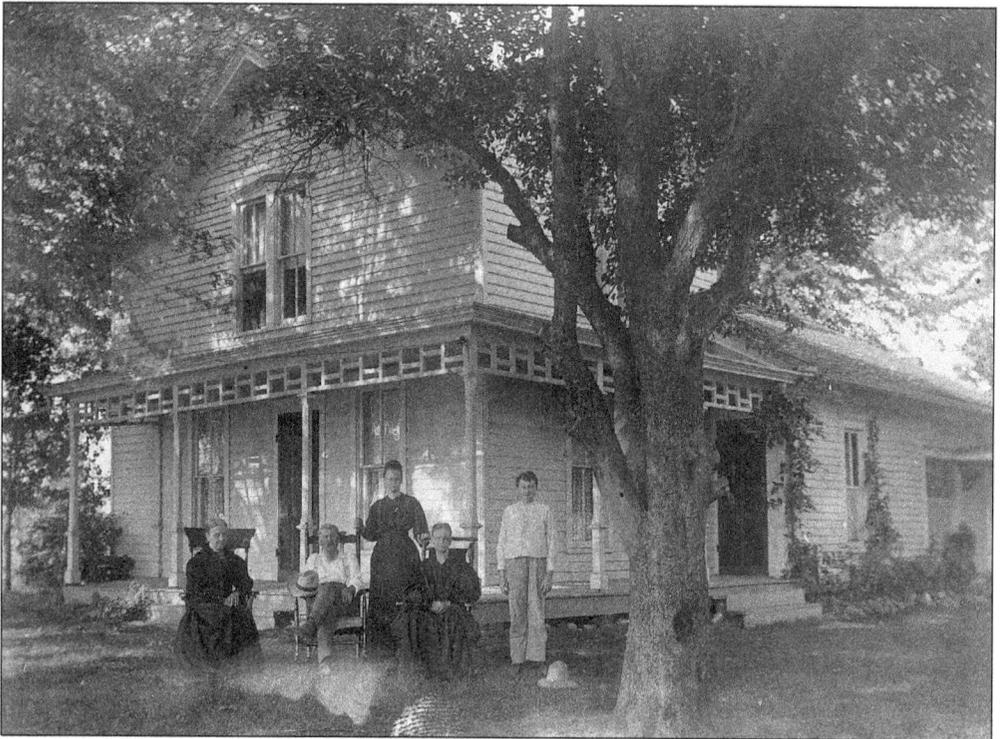

WALKERTON TRIVIA:

Charles Lemert of Teegarden purchased the first telephone exchange in Walkerton in 1897 for $850. It was installed in a drug store and area farmers helped to build the rural lines. In 1913, Lemert sold it to Austin O. Yerrick and Fred A. Lindecker for $30,000. The Walkerton telephone office was located in the Yerrick home on the corner of Van Buren and Illinois Streets for two years. United Telephone purchased the system from Lindecker in 1930.

The first Walkerton newspaper, the *Visitor*, was founded in 1874 by Ohio native, Henry Mintle. He published the *Visitor* until he died in 1886.

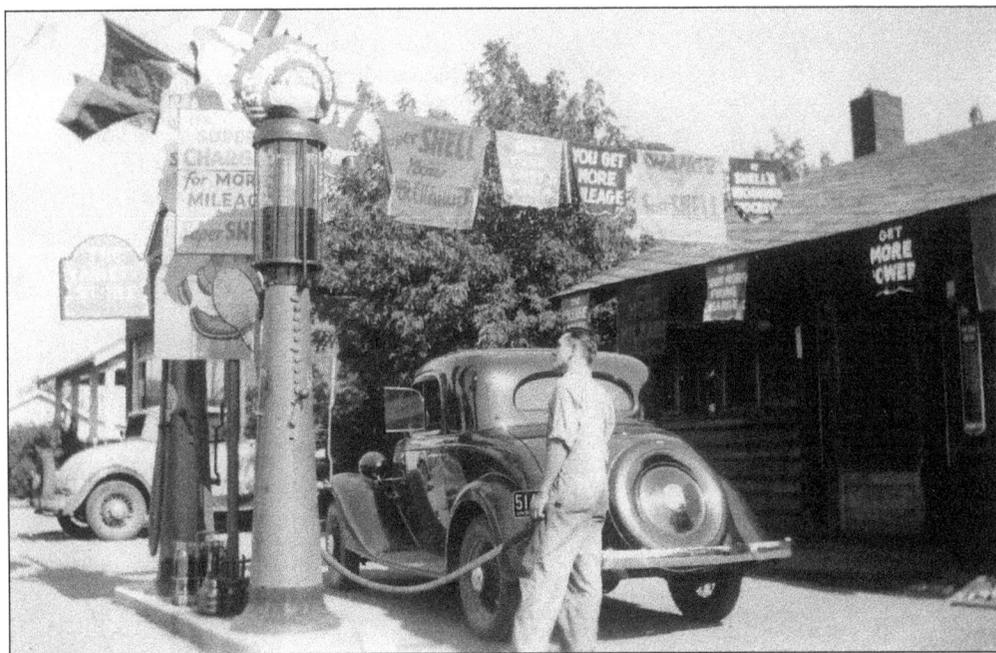

LESTER KUHN AND JOHN DILLINGER. Lester Kuhn was manager of this gas station that was located on Lincoln Way in Mishawaka, Indiana in 1934. Lester always told the story of John Dillinger's visit to the station when he worked there. A couple of men from Dillinger's gang, Harry Pierpont and John Hamilton, dropped Dillinger off for a donut and coffee. Pierpont and Hamilton left to go eat somewhere else so they wouldn't be seen together. Lester was too frightened to say anything and offered the food to Dillinger at no charge, but Dillinger laid the money on the counter anyway. A short time later, Pierpont and Hamilton pulled in to pick up Dillinger. Lester was helping another customer put air in his tire when the two men asked him where "their buddy" was. Dillinger came right out, got in the car, and drove away. (Courtesy of Lester and Nellie Kuhn. This photo is seen on the front cover.)

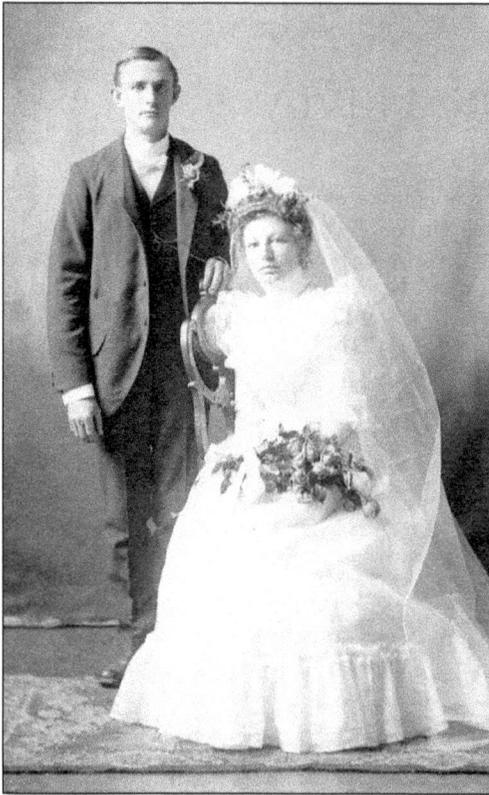

FRANK ZELLMER AND META BOCK ON THEIR WEDDING DAY, OCTOBER 23, 1901. Frank was employed by the Ball Band plant in Mishawaka for 47 years. He retired on June 30, 1946. Meta passed away in 1953 and Frank followed her in 1958. Many of their grandchildren went on to become very successful businessmen in St. Joseph County. (Courtesy of Frank Ronchetti.)

ST. PETER EVANGELICAL LUTHERAN CHURCH IN MISHAWAKA, INDIANA. This photo was taken in 1947 during their 100th anniversary. On May 24, 1847, Rev. George K. Schuster of Bremen, Indiana, organized the St. Peter congregation. The founding service was held in the Presbyterian church. In 1850 the congregation joined the Missouri synod. At some point in the 1850s, the congregation built a modest little chapel on East Broadway near Cedar Street. That building served the congregation for 10 years until 1862, when a new frame church, 26 by 40 feet, was erected on the southwest corner of Church and Front Streets. (Courtesy of Frank Ronchetti)

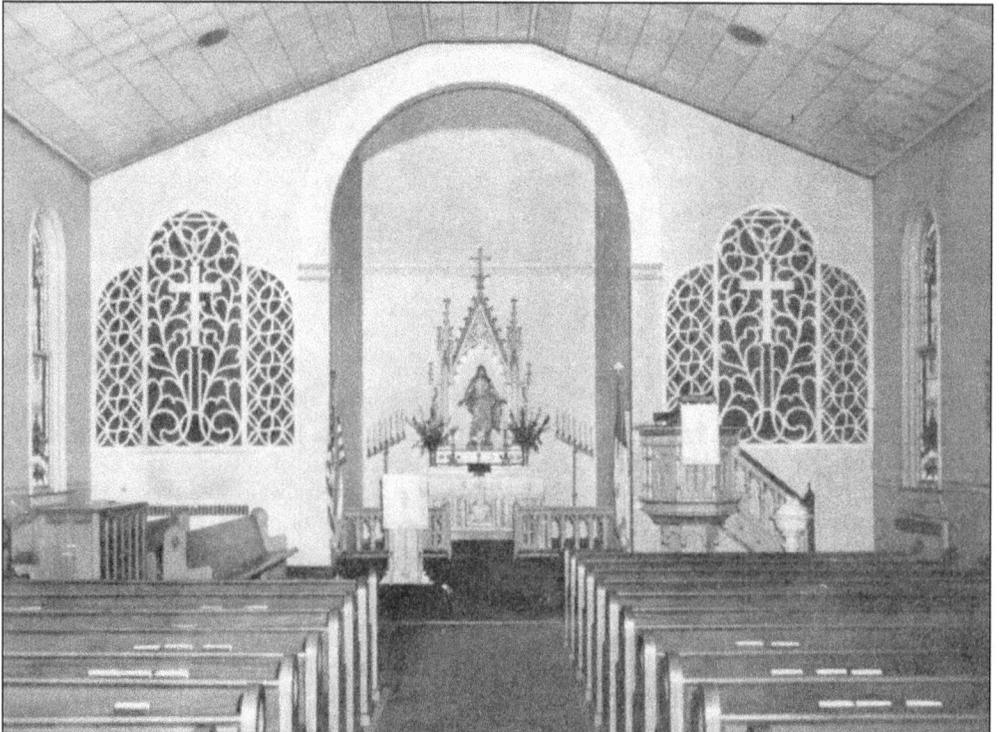

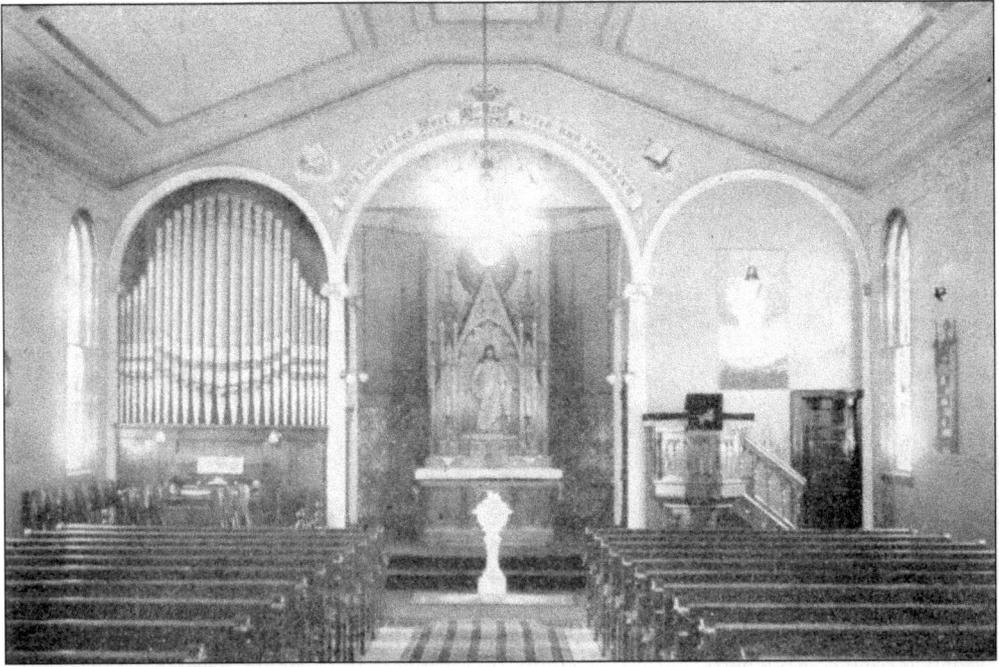

THE ST. PETER EVANGELICAL LUTHERAN CHURCH OF MISHAWAKA, 1902. This church replaced the one that stood at the corner of Church and Front Streets for 40 years. A church parsonage and school were built this year at a cost of about $15,000. This church was dedicated on November 23, 1902. (Courtesy of Frank Ronchetti)

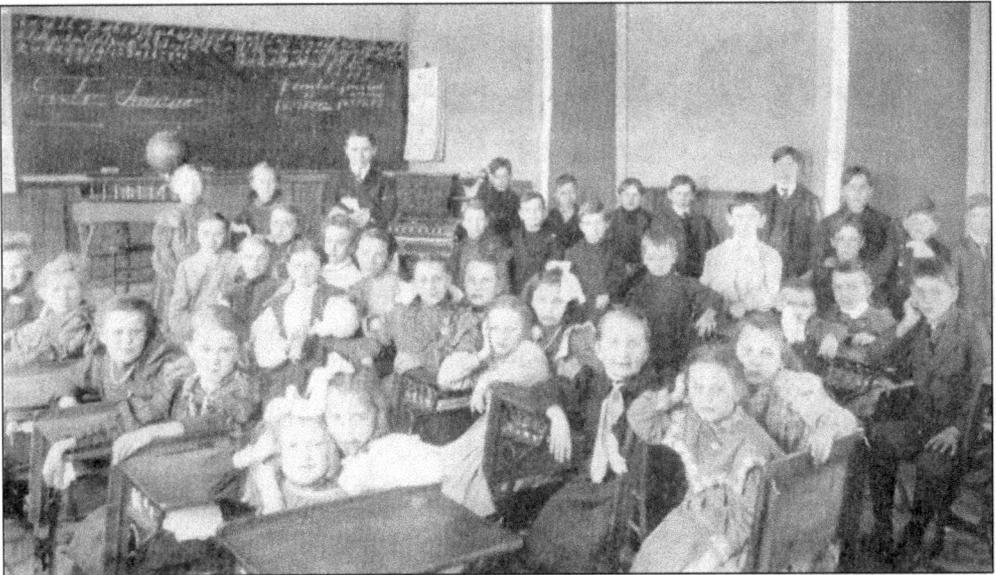

ST. PETER'S PAROCHIAL SCHOOL, 1906. H.L. Bode was called as teacher of the parochial school from 1905–1910. (Courtesy of Frank Ronchetti.)

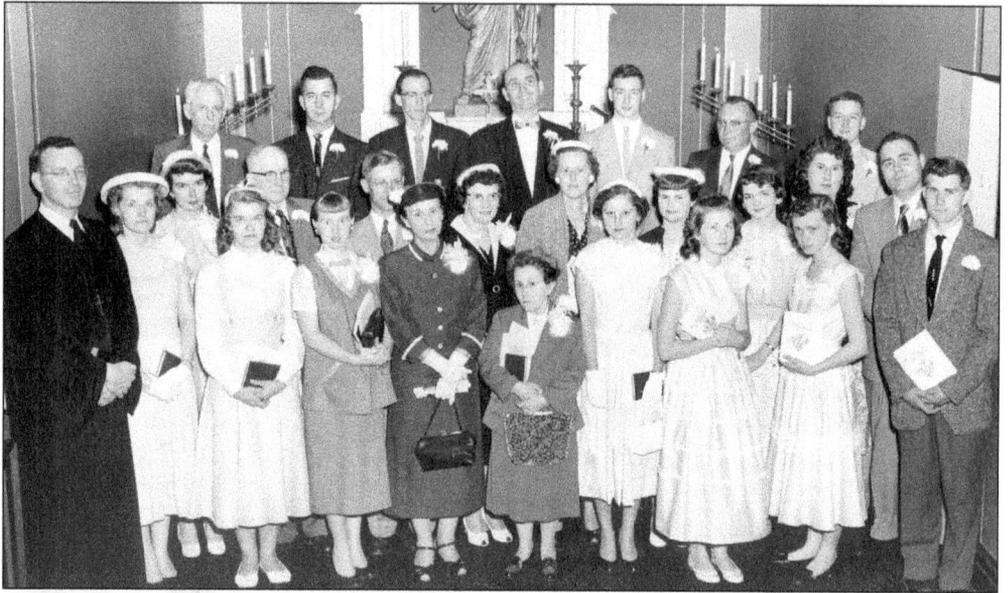

St. Peter Evangelical Lutheran Church in Mishawaka Installs Their New Members on May 20, 1956. Pictured, left to right, are: (back row) Warren Hanson, Marvin Miller, Darrell, Florian Jr., James Ronchetti, Larry Cox, John Weiswenger, and Donald Althoff; (second row) Norma Mark, Clem Fulmer, Lloyd Bates, Marybelle Bates, Frances Zellmer, Sue Ann Sturm, Josephine Kepler, Mary Harringer, and Robert Harringer; (front row) Rev. E.D. Busch, Virginia Walter, Constance Walters, Lucille Schmidt, Bertha Fulmer, Jessie Biggs, Betty Miller, Janice Franson, Anna Wills, and Henry Wille. (Courtesy of Frank Ronchetti.)

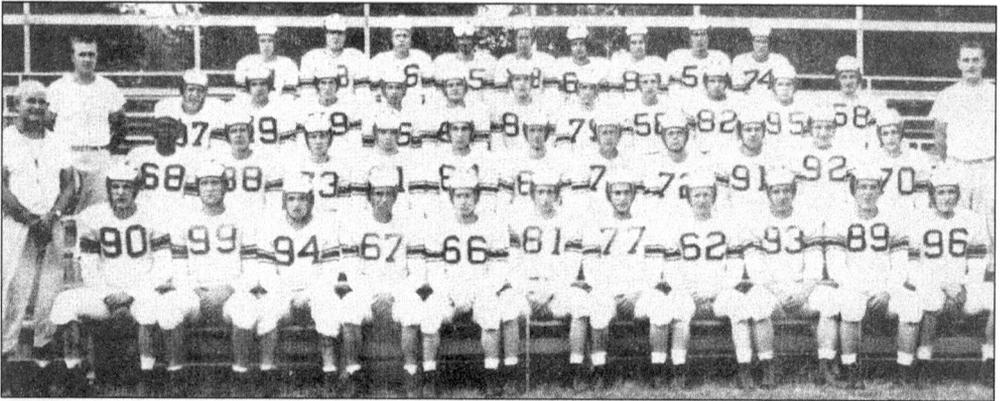

The Mishawaka High School Football Team in 1954. Although there is no order to the names listed here to the photograph, the members of the coaching staff were: Eugene Dykstra, Garnett DeBaun, George Wilson, Robert Smith, and John Chelminiak. The team managers were: Loren Seggerman and Larry Marshall. Members of the squad were (alphabetically): Jerry Allison, Don Amos, Glen Ankney, Tony Baldoni, Quinn Benson, David Bickel, James Bruynell, Ronald Case, Art Celie, Paul Daggy, Dennis Deal, Darwin Freeze, Pat Ganser, Joe Gersey, John Grasso, David Hintz, Art Hughes, James Jennings, Paul Jennings, Fred Kanouse, John Keller, Dale Kline, Don Kline, Don Lechlitner, Dennis Martin, John Musary, Tony Nasco, Bob O'Lena, Nathaniel Pittman, Chuck Proudfit, Daniel Ransberger, John Ronchetti, Don Rospopo, Ronnie Rowe, Glen Rupley, Alfred Siple, Danny Snyder, Don Termont, Gene Witkowski, and Bruck Yeakey. (Courtesy of Frank Ronchetti.)

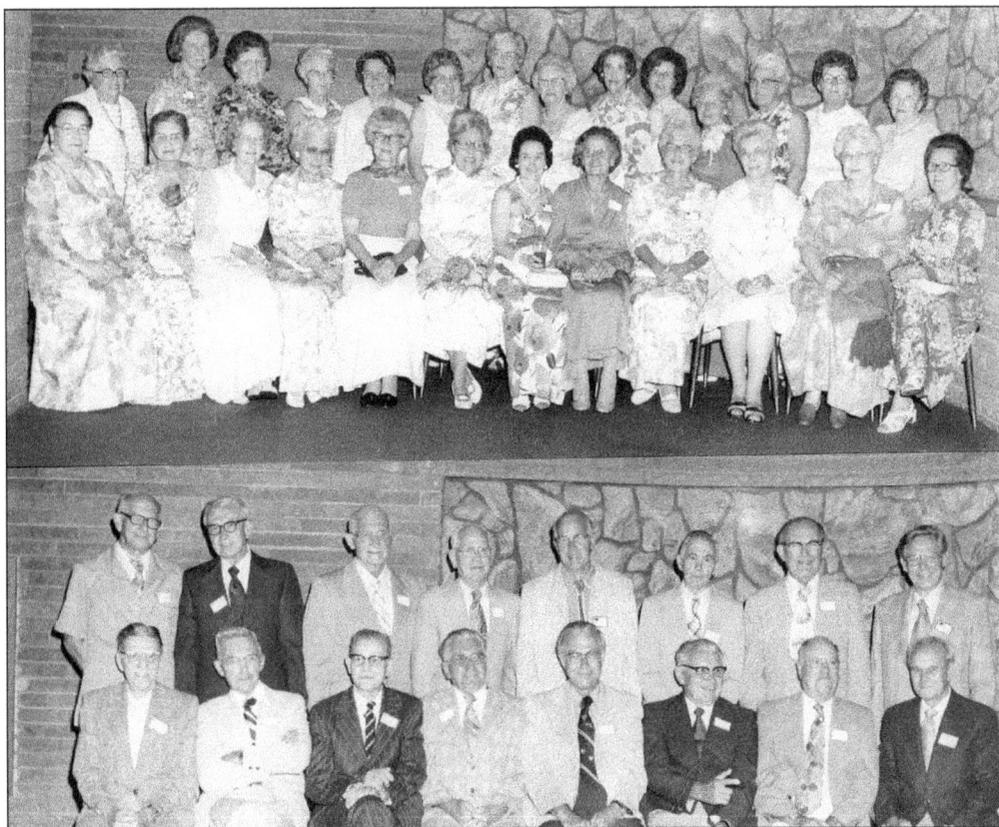

THE MISHAWAKA HIGH SCHOOL CLASS OF 1926 AT THEIR 50TH ANNIVERSARY REUNION.
Eighty-three members and guests attended. Those members present and in photo were: (top
picture of women, top row) Virginia Studebaker-Lightner, Eleanor Carlson-Kizer, Elvera
Chell-Anderson, Grace Kizer-Olmstead, Alice Burkhart-Erb, Bertha Robbins, Dorothy Smith-
Maxham, Virginia Wiess-Kleiser, Genevieve Miller-Kimmey, Margaret LaCluyse-Budnik, Alta
Shroyer-Brugh, Eva Houston, Mary Rogers-Getz, and Lillian Zellmer-Ronchetti. The bottom
row of women include: Mayor Margaret Harris-Prickett, Anne Sawyer, Mabel Gilderman-Gaul,
Alexine Philion-Schlotterback, Gertrude Bloomer, Jennie Laing-Neff, Vera Kronewitter-
Lightner, Arlene Johnson-Bryant, Elma Conrad-Metzler, Lela Diefenbaugh, Zola Zehner-
Taylor, and Ruth Gerlack-Bickel. The bottom picture of men on the top row include: Raymond
Myers, Howard Lowe, Earl Creager, Leon Mead, Robert Partidge, Carl Trippel, Robert French,
and Howard Peterson. The bottom row of men include: Edgar Fulmer, Carl Kleinrichert, James
Finch, Paul Custer, Elmer Faller, Thomas Phillips, Carl Garmire, and Virgil Healty. (Courtesy
of Frank Ronchetti.)

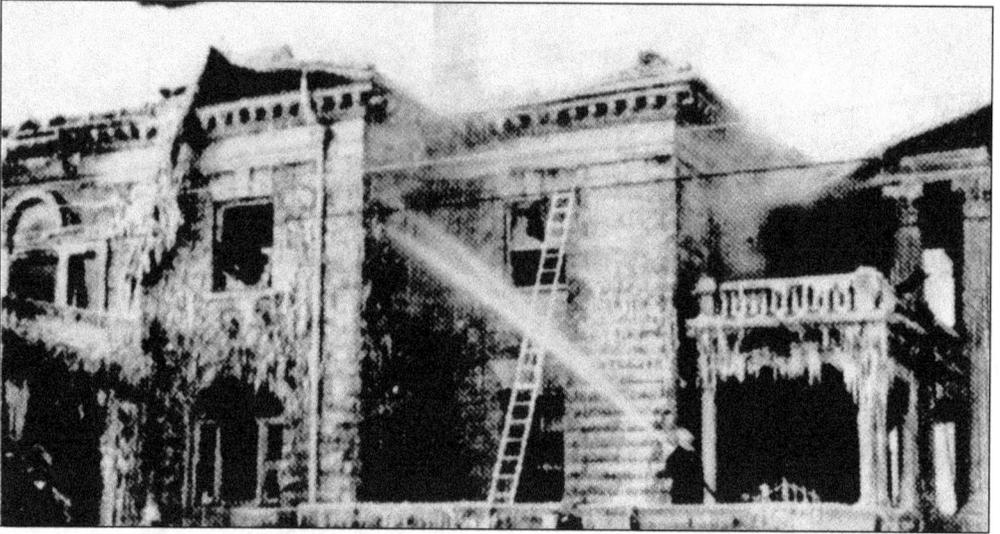

THE BEIGER MANSION. In the early 1900s, Susie and Martin Beiger transformed a dream into reality and undertook the building and furnishing of what became the most significant monumental example of domestic architecture in the city of Mishawaka. January 19, 1975, the Beiger Mansion in Mishawaka, Indiana was struck by a fire. The Beiger Heritage Corporation renovated and restored the beautiful home. It took $775,000 to complete the project. (Courtesy of Frank Ronchetti.)

THE BEIGERS. Martin and Susie Beiger married in 1875. In 1901, the Beigers contracted with the South Bend firm of Durham and Schneider to design and build this lavish home. The grounds were designed by the noted Danish landscape architect Jens Jensen. The house was named "Trameisus" a combination of the names of Martin and Susie spelled backwards. The house contains 22 rooms with furnishings from all around the world. (Courtesy of Frank Ronchetti.)

116

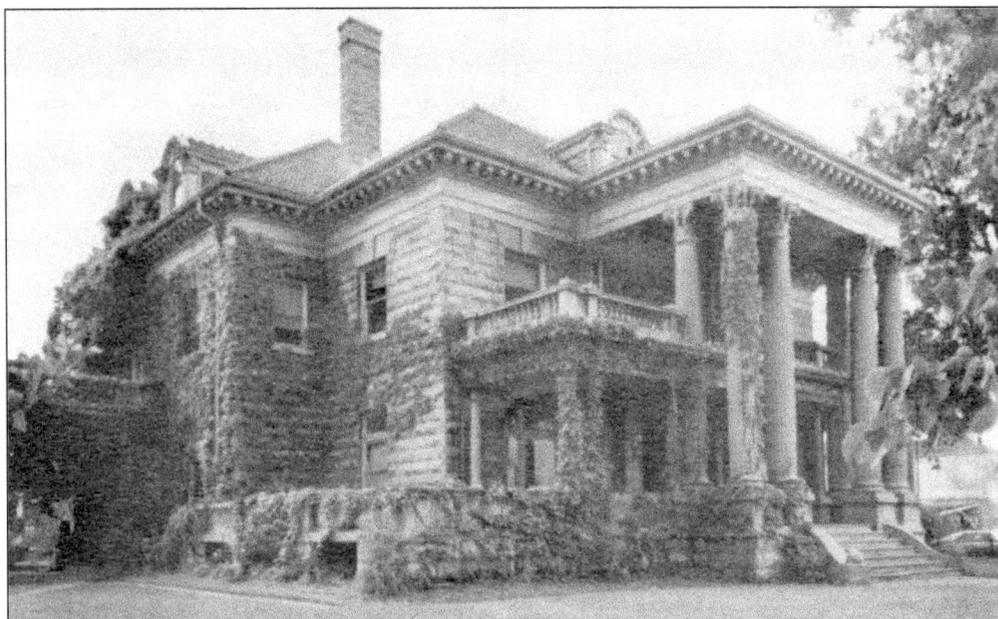

BEIGER MANSION EXTERIOR. The exterior of the Beiger Mansion is Indiana white limestone styled in Victorian neo-classic. The massive front porch is supported by Corinthian columns in the manner of ancient Greece while the influence of early Rome is seen in the cornices and other architectural features. The home includes 11 fireplaces throughout. (Courtesy of Frank Ronchetti.)

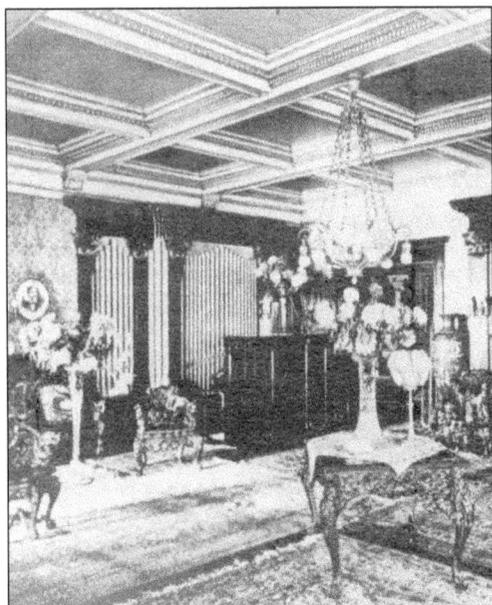

BEIGER MANSION INTERIOR. A magnificent Aeolian pipe organ is the focal point in the music room. An inventory of the Beiger Mansion furnishings would reveal an abundance of beautiful and rare items. (Courtesy of Frank Ronchetti.)

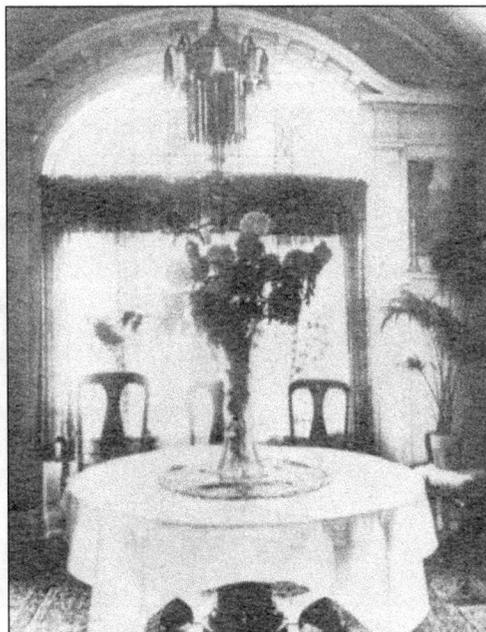

BEIGER MANSION INTERIOR This photo of the family breakfast room in the Beiger Mansion shows an English sunrise scene on the walls above the wall painting. (Courtesy of Frank Ronchetti.)

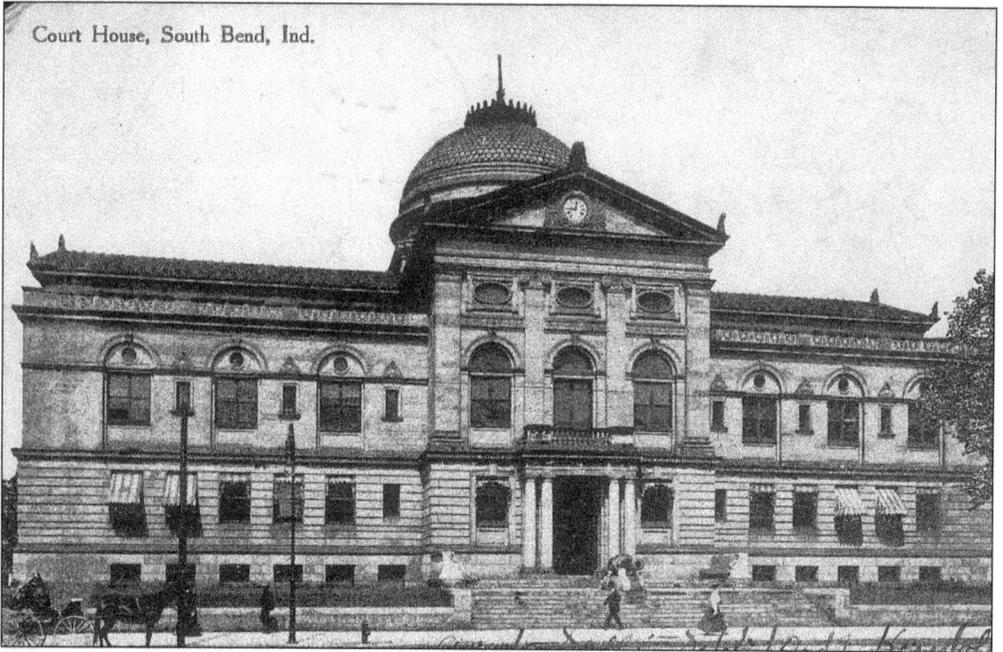

Court House, South Bend, Ind.

THE COURTHOUSE IN SOUTH BEND, INDIANA, IN 1912. The building still looks very much the same. It was located on Main Street and Washington Avenue. (Courtesy of Dee Fuchs-Weaver.)

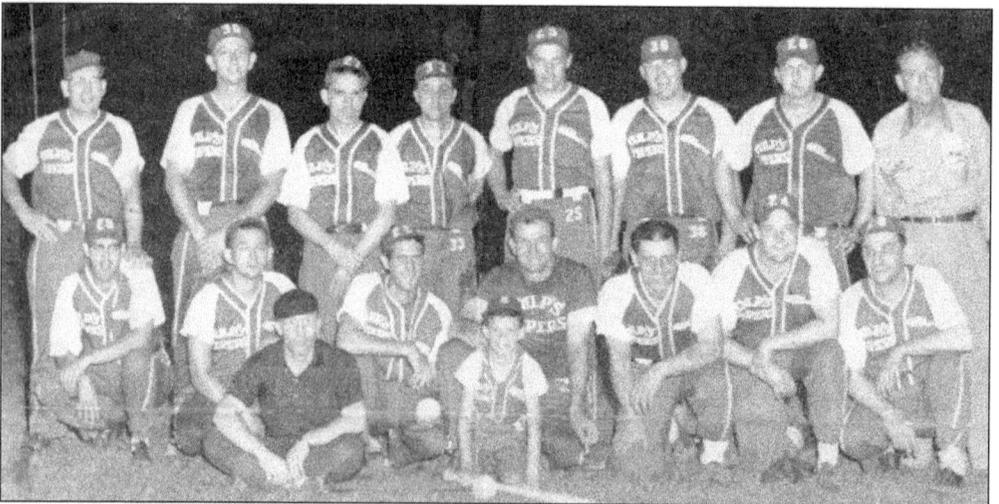

CULP'S PIPERS. Culp's Pipers posted a 5-win, no-loss record and were leading the Bendix National League at the end of the first half of the 1956 season. Pictured here are: (foreground) Red Conery, umpire, and Ronny Wise, mascot; (kneeling left to right), D. Dirks, E. Switalski, G. Wise, Spooner "Dep" Fuchs (the author's grandfather), B. Goetz, P. Cappert, and C. Dructon; (standing left to right) J. DeVon, G. Costello, C. Deardorf, D. Lower, R. Keltner, J. Hill, R. Hronek and V. Vurbridge. (Courtesy of Dee Fuchs-Weaver.)

118

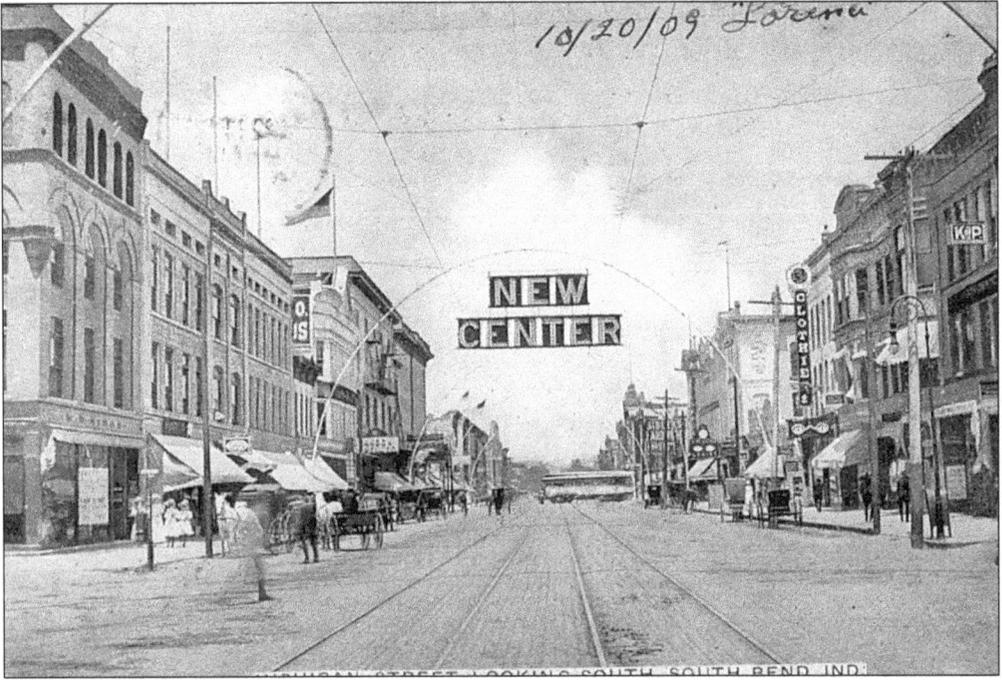

Looking South Down Michigan Street in South Bend in 1909. (Courtesy of Dee Fuchs-Weaver.)

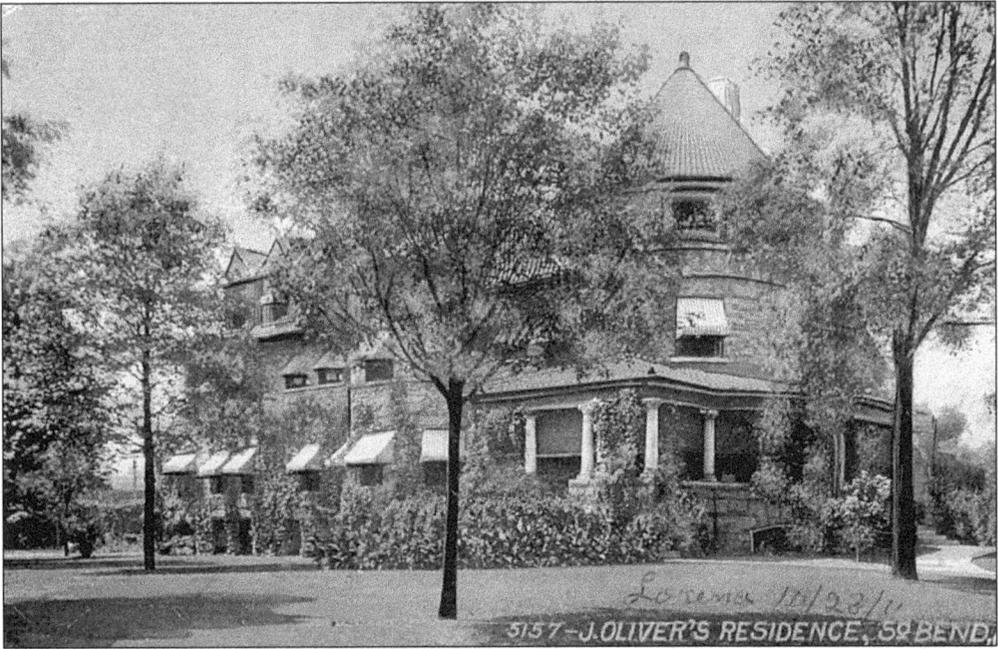

J. Oliver's Residence in South Bend in 1910. This house still stands in the same location and is now a museum. (Courtesy of Dee Fuchs-Weaver.)

THE BRITTENHORN'S HOME LOCATED AT 1309 MIAMI STREET IN SOUTH BEND, 1910. (Courtesy of Dee Fuchs-Weaver.)

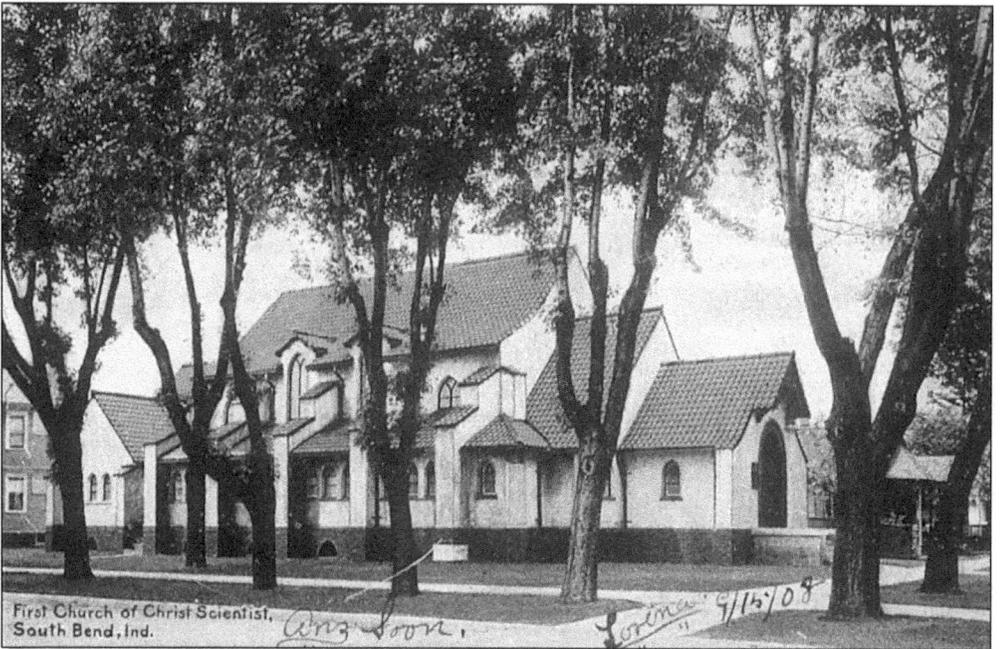

First Church of Christ Scientist,
South Bend, Ind.

THE FIRST CHURCH OF CHRIST SCIENTIST ON NORTH IRONWOOD DRIVE IN SOUTH BEND, 1908. (Courtesy of Dee Fuchs-Weaver.)

Five

MARSHALL COUNTY &
ELKHART COUNTY

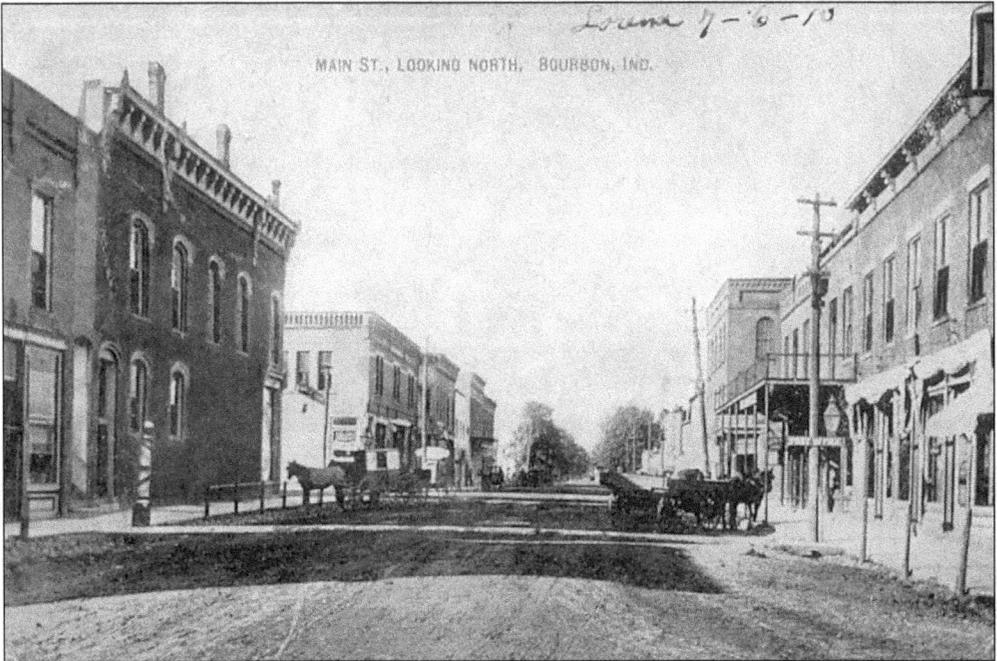

LOOKING NORTH DOWN MAIN STREET IN BOURBON, INDIANA, 1910. (Courtesy of Dee Fuchs-Weaver.)

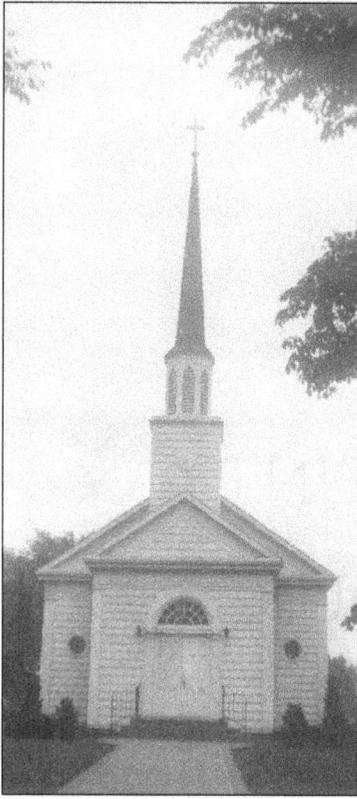

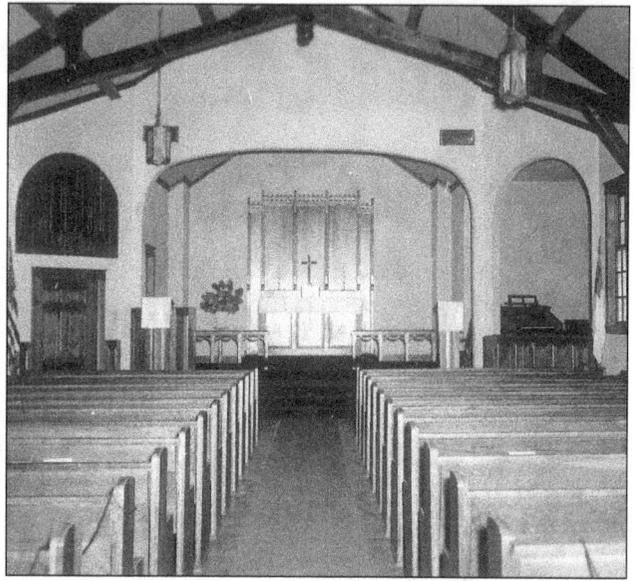

CALVARY LUTHERAN CHURCH IN PLYMOUTH, INDIANA, C. 1939. These two photos show an inside and outside view of the church. (Courtesy of Lester and Nellie Kuhn.)

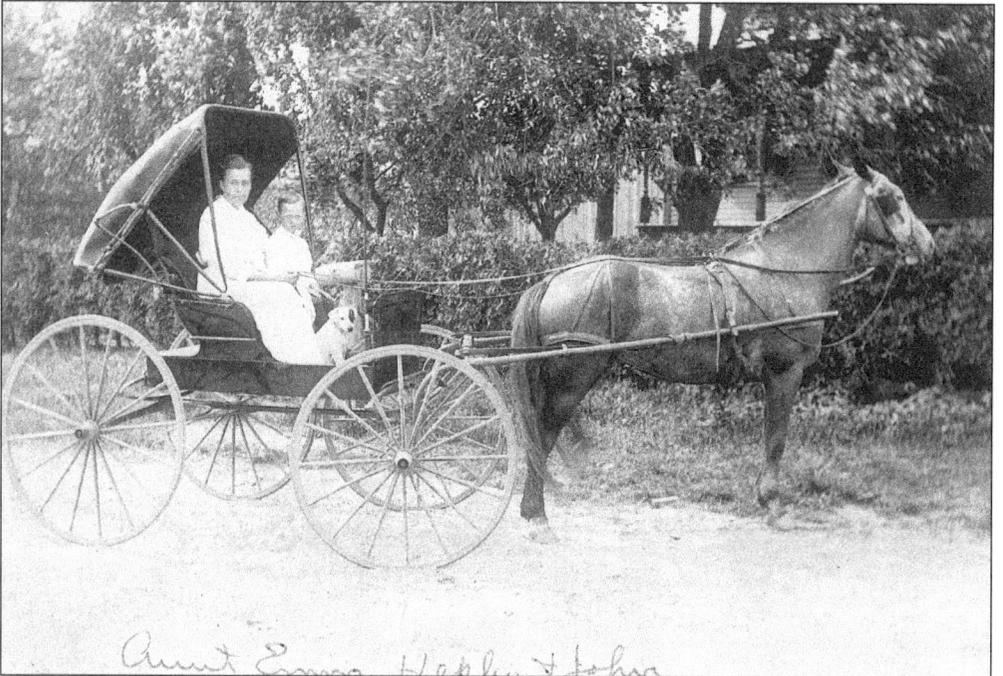

NAPPANEE, INDIANA. Emma Hepler and son, John, are seen here using the usual mode of transportation in 1919. (Courtesy of Lester and Nellie Kuhn.)

122

IRENA HEPLER. This negative of Irena Hepler was taken just before she married Adam Kuhn in 1896. Notice the advertising on the bottom of the photograph and on the back of the photograph. (Courtesy of Lester & Nellie Kuhn.)

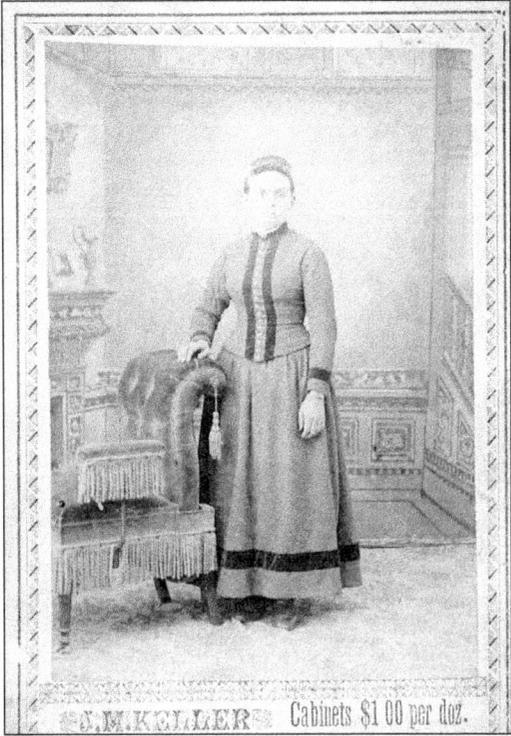

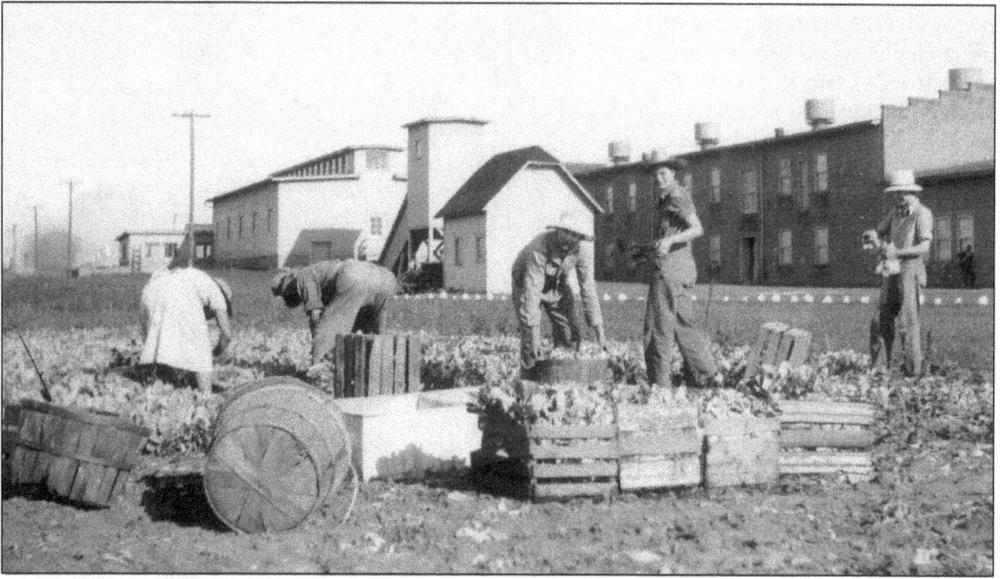

NELLIE'S FIRST JOB. Nellie Kuhn and her co-workers are seen here at the "Libby, McNeil & Libby" Sauerkraut factory in Nappanee, Indiana, picking cabbage. This was Nellie's first job. Women were paid 27¢ per hour while men were paid 33¢ per hour in 1934. Many workers had their skin poisoned from the cabbage. (Courtesy of Lester and Nellie Kuhn.)

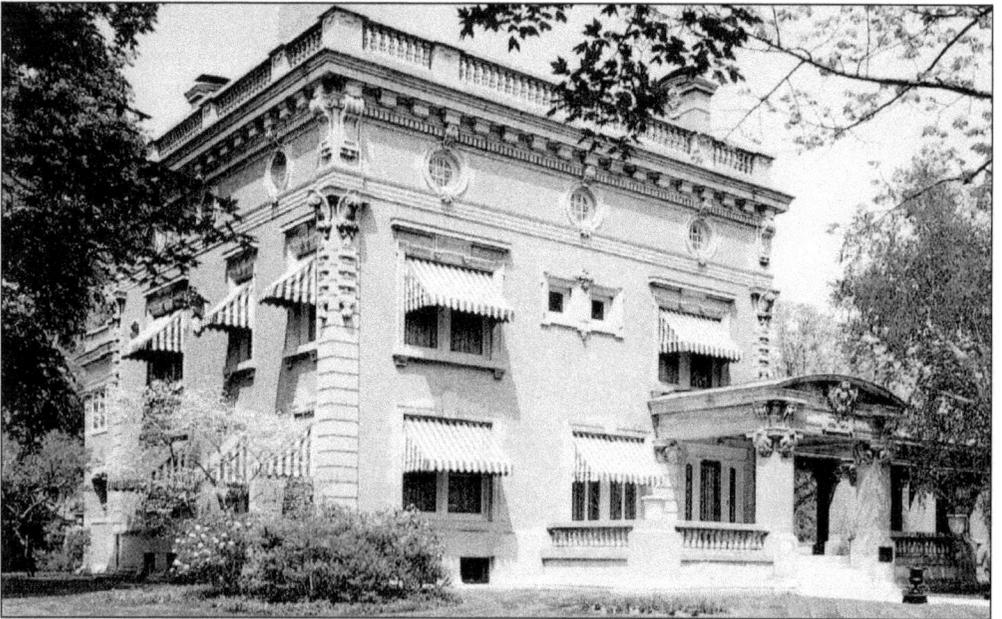

THE RUTHMERE MUSEUM The museum is an outstanding display of a Beaux Arts residence which is listed in the National Register of Historic Places in 1978. Albert R. and Elizabeth Beardsley commissioned Chicago-trained architect E. Hill Turnock to design and build Ruthmere in 1908. Ruthmere was restored by the Beardsley foundation between 1969–1973. Supervising the restoration project was Albert's great-great nephew, Robert B. Beardsley, an active preservationist. In 1973, the site opened to the public to be enjoyed by all. Robert Beardsley was the director. (Courtesy of Ruthmere.)

INDEX OF INDIVIDUALS
MENTIONED IN THIS BOOK

It is the hope of the author of this book that the following listing of names helps to identify the many people in this area that may have a genealogical connection to each other. Many of these people are listed several times in the book, and others may be listed only one time.

Cappert, P.
Carlson-Kizer, Eleanor
Carothers, Leroy
Case, Ronald
Celie, Art
Chandler, Uriah
Chell-Anderson, Elvera
Chelminiak, John
Conery, Red
Conrad-Metzler, Elma
Costello, G.
Cox, Larry
Crandall, Anette
Creager, Earl
Custer, Paul
Daggy, Paul
Deal, Dennis
Deardorf, C.
DeBaun, Garnett
DeVon, J.
Diefenbaugh, Lela
Dietrich, John Sr.
Dietrich, J.R.
Dietrich, P.
Dillinger, John
Dirks, D.
Doering, ?
Dructon, C.
Dykstra, Eugene
Eckert, Elmer
Eckert, George
Edel, W.
Edel, Captain
Edwards, W.
Eitel, George "Pete"
Elles, Siemon
Elliott, Duaine
Ellis, John
Ellis, E.
Eslinger, Elmer
Ewald, Clem
Faller, Elmer
Feitz, Maynard
Finch, James
Fisher, Peter
Fisher, E.G.
Fitz, Henry D.
Flatt, Russell
Florian, Darrell Jr.
Foltz, E.
Franson, Janice
Freeze, Darwin
French, Robert
Fries, W.
Fuchs, Spooner "Dep"
Fuchs, Charles
Fulmer, Edgar
Fulmer, Bertha

Fulmer, Clem
Ganser, Pat
Garmire, Carl
Gass, J.P.
Gass, E.
Geiselman, Joseph
Geiselman, Josiah
Gephart-Warner, Isabella
Gerlack-Bickel, Ruth
Gersey, Joe
Gilderman-Gaul, Mabel
Goetz, B.
Grasso, John
Gunterman, C.
Hamilton, John
Hans, Jenette Dar
Hans, Charles
Hanson, Edward
Hanson, Warren
Hardzog, ?
Harringer, Mary
Harringer, Robert
Harris-Prickett, Margarget (Mayor)
Harsock, Peter Jr.
Harsock, Peter Sr.
Healty, Virgil
Heckaman, ?
Heckaman, Jacob
Heim, Peter
Heim, ?
Heine, ?
Heister, C.M.
Helm, Uhlra
Helmlinger, William
Hepler, John
Hepler, Emma
Hess, Bolser Jr.
Hess, Bolser Sr.
Hill, J.
Hintz, David
Hoople, Charles
Houston, Eva
Hronek, R.
Hughes, Art
Hughs, Robinson
Hughs, William
Jennings, Paul
Jennings, James
Jensen, Jens
Johnson-Bryant, Arlene
Julian, Virginia
Julian, Mark
Kanegar, Philip
Kanouse, Fred
Kauffman, Rose
Keller, John
Keltner, R.
Kepler, Josephine

Kern, Milton
Kiefer, Jacob
Kiefer, Ray
Kime, Elroy
King, Grace
Kipfer, George
Kipfer, E.L.
Kizer-Olmstead, Grace
Kleinrichert, Carl
Kline, Don
Kline, Dale
Kline, W.
Knoblock, T.F.
Knoblock, Jacob
Knoepfle, ?
Knoepfle, A.
Koontz, ?
Koontz, Charles
Koontz, Jacob
Kronewitter-Lightner, Vera
Kuhn, Glenn
Kuhn, Nellie
Kuhn, John
Kuhn, Lester
Kuhn, Irena Hepler
Kuhn, Laura
Kuhn, Adam
LaCluyse-Budnik, Margaret
Laing-Neff, Jennie
Lashbaugh, George
Lashbaugh, John A.
Laudeman, Jacob
Laudeman, Elmer
Lechlitner, Don
Leeper, John A.
Leeper, E.
Leeper, Jacob
Legner, Doug
Legner, Dud
Leher, G.
Lemert, Charles
Lichtenbarger, ?
Lindecker, Fred A.
Listenberger, George
Lowe, Howard
Lower, D.
Macombers, ?
Madden, James
Manges, Balcer
Mangus, Richard W. (Rep.)
Marburger, H. (Jiggs)
Mark, Norma
Marshall, Larry
Martin, B.
Martin, Dennis
Matz, Stowe
Matz, W.F.
May, William

McIntaffer, Jacob
Mead, Leon
Metcalf, George
Miller, Betty
Miller, Marvin
Miller-Kimmey, Genevieve
Mintle, Henry
Mishler, Mim
Mochel, ?
Molebash, R.
Moon, Calvin
Moon, James
Moore, Sally
Moore, Walter (Dr.)
Moritz, Michael
Mueller, Raymond (Rev.)
Musary, John
Myers, Ramond
Myers, ?
Nasco, Tony
Neher, Charles
Neher, D.
Nussbaum, Dr.
O'Lena, Bob
Oliver, J.
Page, Edward M.
Parker, John
Partidge, Robert
Penrod, Roscow
Peterson, Dud
Peterson, Howard
Philion-Schlotterback, Alexine
Phillips, Thomas
Pierpont, Harry
Pittman, Nathaniel
Polson, ?
Pomeroy, George
Ponader, Fred
Proudfit, Chuck
Ramstead, Warley
Ransberger, Daniel
Ranstead, Laura
Ranstead, John
Redman, E.
Replogle, F.A.
Reppert, Fred
Rhides, Charles
Ringle, Lee
Ringle, O.
Ringle, John
Ringle, J.J.
Ringle, D.
Ringle, ?
Ringle, Daniel
Robbins, Bertha
Roberson, James
Rogers-Getz, Mary
Ronchetti, Frank

Ronchetti, John
Ronchetti, James
Rospopo, Don
Roth, Bill
Rowe, Ronnie
Rowe, Beuford
Rowe, Curtis
Rowe, Olive
Rupe, William
Rupley, Glen
Sawyer, Anne
Schilt, Christian
Schilt, H.
Schilt, William F.
Schlosser, ?
Schmachtenberger, Samuel
Schmidt, Lucille
Schneider, Don
Schneider, Harvey
Schuster, George K. (Rev.)
Seggerman, Loren
Seiler, Christian
Seiler, Erv
Seiler, Marv
Shroyer-Brugh, Alta
Siple, Alfred
Slaubenner, Sanuel
Smith, Robert
Smith-Maxham, Dorothy
Snyder, Danny
Soice, John
Steel, John
Stevens, F.
Stine, George
Stinmetz, ?
Studebaker-Lightner, Virginia
Sturm, Sue Ann
Sunderland, ?
Surges, George
Switalski, E.
Taylor, Lanthrop M.
Templeton, Howard
Termont, Don
Tipton, General
Trippel, Carl
Turncock, E. Hill
VanSickle, Wayne
Venable, Lacey
Venable, Ashley
Venable, Michael
Vollmer, ?
Vurbridge, V.
Wahl, ?
Wahl, Robert
Walter, Virginia
Walter, D.
Walter, Frank
Walter, Josh

Walter, F.
Walter, Billy
Walters, Constance
Weaver, Dee Anna
Weis, ?
Weiswenger, John
Widmar, Robert
Wiess-Kleiser, Virginia
Wilkinson, John Sr.
Wilkinson, John Jr.
Wille, Henry
Wills, Anna
Wilson, George
Wine, I.F.
Wise, G.
Wise, Ronny
Witkowski, Gene
Wolfe, W.
Wright, John J.
Wright, William
Yeakey, Bruck
Yerrick, Austin O.
Yockey, ?
Yockey, Henry
Yockey, Jacob
Yoder, Bernice
Young, LaVon
Young, Perry
Young, Clinton
Young, Theodore
Young, Milton
Young, Clara Ethel
Young, Mary
Zehner-Taylor, Zola
Zellmer, Frances
Zellmer, Frank
Zellmer-Ronchetti, Lillian
Zentz, Bob
Zentz, Butch

www.ingramcontent.com/pod-product-compliance
Lightning Source LLC
Chambersburg PA
CBHW080851100426
42812CB00007B/1987